FIRE CRAFT

FIRE CRAFT

ART, BODY, AND WORLD
AMONG GLASSBLOWERS

ERIN E. O'CONNOR

Columbia University Press *New York*

Columbia University Press
Publishers Since 1893
New York Chichester, West Sussex

Copyright © 2025 Erin E. O'Connor
All rights reserved

Cataloging-in-Publication Data is available from the Library of Congress.
ISBN 9780231218436 (hardback)
ISBN 9780231218443 (trade paperback)
ISBN 9780231562256 (ebook)
LCCN 2025003923

Cover design: Milenda Nan Ok Lee
Cover photo: Shawn O'Connor

GPSR Authorized Representative: Easy Access System Europe, Mustamäe tee 50, 10621 Tallinn, Estonia, gpsr.requests@easproject.com

For Sionnach and Réaltín

CONTENTS

Preface ix

Introduction: Arriving at New York Glass 1

1 The Glassy State: Setting the Pot of Man and World 27

2 Embodied Knowledge: The Ebbs and Flows of Skill Acquisition 57

3 Fire and Sweat: Calorific Bodies and Teamwork 85

4 Blow: Time, Space, and the Vessel 115

5 Quintessential Craft: Cup Making and the Turns of *Mêtis* 137

6 Materia Erotica: Love and Strife in the Hotshop 163

Conclusion: Heart of Glass 189

Acknowledgments 201
Glossary 205
Notes 213
Bibliography 231
Index 263

PREFACE

I have always felt most present and alive in life when making. By training, I am an ethnographer in the field of sociology, which means that I study the structures of society and the meanings of culture by conducting fieldwork. At any moment, however, you could find me drawing, cutting, and stitching paper collages; building furniture installations; or wandering the shores of Lake Huron or Rockaway Beach. I grew up in a family of tinkerers, craftsmen and artists, and practical problem solvers at home, in workshops, and out of doors. My childhood was largely a series of apprenticeships with family members who made worlds meaningful by making.

On my father's side, people made things like deer blinds and cabins but could rig a mechanism for just about anything — from a sailboat's jig to the pulley system needed to suspend a "wedding cake" piñata across the atrium of a turn-of-the-century brewery for a family member's big day. My dad and his brother and father taught me how to skip rocks, gut and scale a fish, refinish a wooden boat, build an ice-skating rink, cut trails, and shoot a rifle. On my mother's side, nearly everyone seems to be an artist. My grandfather was a neon glassblower,

and though I never saw him work, some of his large motel signs still stand at beach resorts stretching along Michigan's Lake Huron, where nearly all of my family lived. He was also a professional potter, painter, and theatrical set designer. He made countless art kits for me, and I remember his lessons in perspectival drawing and watercolor painting well. He and my grandmother had three children, each of whom is a professional artist, all with green thumbs; my uncle, a landscape designer, does both simultaneously. Both my grandmother's father and grandfather were artists. At her kitchen table, built by her grandfather, which now serves as my kitchen table, we would sit, eat her baked goods, drink milk, and talk about her father's artwork—how he built the frames, from where he mail-ordered flowers to be painted, his gardens, and the chicken dinner that he and his wife had served a famous actor who once purchased one of his still lifes. His paintings hung on the walls of her small house; they now hang on mine.

At her grandfather's table, my grandmother taught me how to knead bread. She sifted flour over my hands, and I rubbed them together, smooth like talcum. "OK, punch it down." There was nothing else in my life that I was invited to punch. After punching down the risen dough, she instructed me: "Now pull it away from the sides of the bowl and lift it up. I'll dust the table." She spread flour over the table as I stood with the dough draped over my hands, smelling the yeast and studying its strands. "OK, set it down," she instructed and continued, "Now, shape it up," giving the dough a few hugs with her hands by way of example. "Now we're going to make it like elastic. Are you ready to knead?" "Yes, yes!" I replied, my hands still covered in flour. "Ok, put the bottom of your palms in the dough and push out," she began. I did. "Now, use the pads of your fingers to pull it back." I tried. "Keep your hands cupped to the dough—not

PREFACE ❦ xi

just your fingertips, like rocking." Got it. "Now, rotate the dough one-quarter of an hour." I was around seven years old at the time. "Rotate the dough a quarter of an hour?" I wondered. She showed me, "You push out to twelve o'clock, then roll back. You need to always move from twelve o'clock to nine o'clock. . . . Push to twelve o'clock, pull back, and then rotate to nine o'clock, twelve o'clock and back, then to nine o'clock." I eagerly followed her instructions. Over and over. When I tired, she took over and set it up in the loaf pan. After the dough rose again, she put it in the oven, and I watched it bake through the oven's window.

I loved the smells of my grandmother's kitchen—yeast, ginger, scalded milk. Once the bread was baked and cooled, we'd sit at the table and eat still-warm slices with butter and her homemade cherry jam or a slice of the orange cheese distributed at that time by the government. Her lesson taught me not only how to knead bread but also introduced me to the feel of "dough"—that glutinous mixture of ground wheat, water, and yeast—and gave me both skills and the confidence to problem-solve so that I could "pursue flour." Through "becoming a baker," I bonded with her through the dough between our hands. There were many moments like that with her—becoming together with dough boards and flour, piping tools and sugar, sewing tables and scraps, string and wax bean plants, Mason jars and Bing cherries.

Until 2003, this life of making and material did not converge with my academic pursuits. I was a graduate student at the time and was enrolled in a course titled Sociology of Museums, though my academic focus was political sociology. The day came for us students to discuss our projects for the semester— "Collective Memory and Germany's Holocaust Museums," "Collective Memory and Poland's National Museums," "Social

Interaction and U.S. War Memorials," and then one student, Vince, said, "Detroit Artists" and explained that he was from Detroit and interested in the art scene that had flourished there in the mid-twentieth century alongside the booming auto industry. My grandmother, with whom I had baked bread, had lived with her painter father in Detroit at the time. Vince was a thoughtful man whose earnestness about seminar questions led to engaging contributions and discussions. After class, I approached him: "My great-grandfather was a Detroit painter," I said, and we chatted about old Detroit art institutions like the Scarab Club and the Detroit Artists Market.

When I arrived the following class, Vince slid a postcard across the table to me with a smile and raised eyebrows behind his heavy glasses. Taking it, I immediately recognized the style of the three paintings printed on the card. I wondered what year this show of his work had been held: 1945? Maybe 1960? I turned the card over and read: "Fred Papsdorf, American Magic Realist, Opening Reception, Friday, December 5, 2003, 5–8 pm." Stunned would be an understatement of what I felt at that moment. My great-grandfather had been a bottle checker at the Borden Milk Company—a nine-to-five gig—and had painted in his home in the evenings. I knew that his work had circulated on the Detroit art market at that time and been included in reputable museums, but I knew nothing of its contemporary life other than its place on the walls of our homes and the occasional eBay sale.

It was moving to see the fruits of his passion live beyond the memory and appreciation of family and dusty archives. His craftwork was abidingly true to the etymological meaning of the word "craft": strength or power. Primarily, my great-grandfather painted flowers, mail-ordered from around the world and grown in his own garden as well as those of his

children and their spouses; I remember standing among his rose bushes as a toddler. A 1945 *New Yorker* vignette quoted him waxing eloquent on the beauty of the weeds that pushed through the cement of Detroit sidewalks.[1] Attending to flowers, plants, paints, and scrap wood, he made, and through making, he created a world, namely, a social sphere of interaction. The letters that he wrote as an artist to all varieties of people, from the industrialist Henry Ford, to his NYC gallerist, Klaus Perls, were often accompanied by sketches and had everything to do with his style of perceiving, cultivated through years of attending and making.

I think of my father, mother, and their families as well as Lake Huron and all the varieties of materiality with which my life unfolded. This attention to the material world—indeed the very vivacity of that material world—structures the core of my being. Seeing the postcard of my great-grandfather's work atop the seminar table brought to the fore each neglected or forgotten aspect of my passion for that materiality and making.

This moment did more than urge me to move away from the discursive parameters of political sociology in which I had acquired and could exercise proficiency. It revealed the power of making, of embodied, lived experience. On one level, I missed the visceral experience of making, its textures and material excitement. On another level, I longed for the sense of achievement, community, and connection that making creates. Indeed, my great-grandfather's work reminded me not only of how making can create worlds through which a person can engage others and endure beyond their own singular life but also of the power—the craft—of that pursuit. The experience set the *craft* of crafting into relief and called on me to return to making. I wanted to explain how people experience making as meaningful such that they dedicate large swaths of time, if not a

lifetime, to its pursuit. At the same time, I longed to voice the vibrant materiality that had animated my life and social world. Within a month, I formally began researching New York City's craft communities, including at New York Glass. Within a decade, I came to understand that the power of craft, of making, in the contemporary United States had everything to do with the critical analysis of modernity with which graduate school had so well familiarized me—its concerns about alienation and anomie, capital and privilege, empire and settler colonialism, and individuals poised to make themselves and their worlds.

FIRE CRAFT

INTRODUCTION

Arriving at New York Glass

My T-shirt has sweat marks, and my back is wet. The rivets on my jeans burn my pelvic bones. Working at the glory hole, the furnace for reheating, is hot. I wipe the sweat from my brow while continuing to turn the blowpipe. The glass at its end begins to undulate rapidly. Just as I think, "Shit! I've overheated it again," I hear Paul, my teacher, call out, "It's hot!" I pull the pipe across the ball bearings of the yoke. Hair falls into my face, but I can't take my hands off the blowpipe to do anything about it. I reach for a wooden block. Diana, my partner, is already handing it to me—the right size for my unruly bubble. I cup the hot orb with the wet, ladle-like wood block and roll the pipe, sending a stream of steam into my face. With its skin cooled, I give the glass a quick puff. Implosion avoided.

I brush the hair out of my face and get up to heat the bubble. "Can you blow this time?" I ask Diana as I pull out the pipe, steadily rotating to keep the moving glass on center. I want to see the bowl through, to work with the glass, to be able to read its hot, its cold, its thick, its thin. When I can tune into the glass, things always go better. I pick up today's *New York Times*, folded like an oven mitt and soaked with water, and begin

shaping the glass while Diana blows. It has a decent heat and blows out steadily within the cup of my newspaper-lined hand. My body and mind keep moving toward the bowl, anticipating what the glass needs next. Without deliberation, I set the newspaper down and return to the glory hole to heat the now-cold bubble at the end of the pipe.

The time comes to tool the bubble into a bowl. "This time," I say to Diana. "Yup," she encouragingly replies. Blowing bowls is challenging—getting the hole open, pressing the bottom out into the curve of the bowl with a wooden tool that resembles supersized chopsticks, and enduring the heat, which radiates from the large surface area. I didn't even make it to the step of opening on my first try—the bubble overheated and imploded. On the second try, the nearly finished bowl fell off the pipe and shattered. My attention is not on my previous failures, however; right now I am working with and being through the glass. I hope that this third time will be a charm.

Diana and I had been taking glassblowing classes at New York Glass. In this public-facing not-for-profit glassblowing studio, professional glassblowers rented workstations to produce work, and students, artists, designers, and hobbyists enrolled in small "how-to" classes. Hoping to improve our skills, Diana and I had booked a day of independent practice time. At the time, I was working on a dissertation about embodied knowledge in glassblowing. My goal had been to understand how someone learns a craft, the bodily experience of learning, and specifically, in the case of glassblowing, how glass—hot glass—informs this process. In order to access these meanings, I decided to become a glassblower myself.

When I arrived before our glassblowing session, Diana was sitting on the sidewalk outside the studio doors, enjoying the unlikely summer breeze and smoking with a few other

glassblowers, young and predominantly white. Around the corner, where a high-rise hotel notorious for prostitution and drug dealing had been razed to the ground, an arts institution flourished alongside fried chicken shacks, dentists, and gold exchanges. The politics of Bloomberg's gentrifying NYC were omnipresent. I sat with my coffee and bagel from the bodega around the corner, Tommy's, and joined in the conversation. Soon, we would be jacking and blowing, marvering and necking, paddling and tweezing, stripping and tagging, puntying up and putting our blown glass objects away in the annealing kiln to cool.

We had hoped for a nice quiet day in the hotshop, that area of the glassblowing studio where the hot glass is blown, to practice some basic cup-making techniques. No such luck. Nearly every glory hole around the platform was lit, and three teams were already at work. Paul, our teacher, a stocky, gentle guy in his mid-twenties with strawberry-blond hair, was assisting an artist, Oren. As we greeted Paul, Oren called out to us with a cheeky smile, "Hey, check out how big my gather is," and directed his eyes toward the glass he had just gathered from the furnace at the end of his pipe. Also in his twenties, he was known to "blow big." The comment was in good jest; we had worked together and had a good rapport. Diana and I rolled our eyes and made our way to set up our workstation.

Zach, a shaggy, dark-haired guy who often collaborated with Paul and Oren, was working at the glory hole directly next to us; glassblowing is a choreography of production and requires teamwork. Heating his work at the glory hole, he asked us what we planned to make. Diana described a "drunken sailor" cup—a cup with an unevenly weighted bottom that wobbled on a flat surface. "And you?" he asked, turning toward me. "I'm going to work on cylinders," I replied. "You guys are just going to make cups?" he asked. I shrugged with timidity in the face of his

bravado, and Diana started to explain that she was "engaging" cylinders, messing around with them, trying to make them off-balance. Talking over her, as well as the din of fire and metal, Zach replied, "It's still just cups," and returned to his working team. Steeped in the art world of universities, critique in studio glass is par for the course. It's not just about making stuff but the meanings thereof—a debate in the hotshop that often oscillated between the paradigms of "craft" and "art." Zach's comment stung, but it was neither personal nor unwarranted. And he did what other good mentors do—push you beyond your comfort zone to grow. And we did, in conversation and practice, consider the meaning of cup making.

Although it was Tuesday, a team of "weekend warriors"—two retired teachers, a man and a woman, who were hobbyists—worked on the other side of the central platform alongside a professional, Ken, and his assistant, Casey, who bonded over the music of the Grateful Dead. Ken was an intrepid traveler and had gotten into glass after seeing the art plied while backpacking around the world for a year. Casey had enrolled in a weekend workshop in Philadelphia and, having enjoyed the hands-on aspect of the art, commuted to New York Glass from New Jersey to both learn and work. Aside from Ken, all were fellow students. Diana and I wished that we were on their side of the platform, where we would be less vulnerable to criticism. Over there, we could be amateurs left in peace to practice; we could be novice glassblowers away from the eyes of the more accomplished professionals. Caught up in the everyday banter and instruction, competition and camaraderie, and work and pleasure of the hotshop and sandwiched between Oren and Zach, we were forced to rise to the very real expectations of how to become not only proficient glassblowers but *good* ones.

We were relieved when Liza arrived and sat on a nearby marver, a steel work table. Her habit of sitting on marvers to watch male glassblowers blow and her prominent bust had earned her both the attention of many in the hotshop and the pejorative moniker "marver tart." All attention was focused on her, and she generously cooed over the glassblowers' labors. What Liza loved most about glassblowing was not blowing glass but rather watching glassblowers—male glassblowers (she ignored us). She stayed on the marver, positioned before the fiery glory hole for some time. I knew from experience (as did anyone else who had ever blown glass for long days or in the summertime at the windowless New York Glass) that she had "swamp ass"—sweat that had pooled between the buttocks.

Around the periphery, others were hanging out—friends and lovers of glassblowers, other glassblowers not working, and random people watching from stools behind the workstations. The intrigue of watching glassblowing, as Liza well knew, is in the glassblower's relation to and with hot glass—that "dance" to which many refer when describing the glassblower's art. Applause follows demonstrations, and sighs of relief, as when the "good guy" narrowly escapes the "bad guy" in a film, can be heard when glassblowers complete a piece. Amid the urgency demanded by the molten matter, the most proficient, charismatic, or ingenious glassblowers earn the status of "rock star."

GLASSBLOWING AND BODY

Understanding how one becomes a glassblower may not seem like a pressing concern. But understanding how people shape their lives and experience meaning through making constitutes

6 ❧ INTRODUCTION

a broad and rigorous research agenda. In this sense, glassblowing is not only a way of making things but also a way of relating and a vehicle for forming meaning, self, community, and a world. A broad swath of anthropologists have analyzed the crafting of self and culture vis-à-vis craftwork, including studies of woodworking, confectionary, pottery, textiles, food, urban craft, sports and dance, and music, as well as ways of knowing and sensing and the negotiation of citizenship and power.[1] Moving from an account of the transmission of skill to situated learning,[2] many explore what the sociologists Craig Calhoun and Richard Sennett call "practicing culture." Calhoun and Sennett's theory, which analyzes how people become more proficient cultural actors and innovators through doing, draws from Bourdieu's theory of "practical knowledge"; it is, they argue, the corporeal dispositions through which the world becomes senseful—what Bourdieu calls *habitus*—to which we must attend.[3]

In this vein, Loïc Wacquant, a French sociologist and student of the late Bourdieu, has been at the forefront of research *from* the body. In his book, *Body and Soul: Notebooks of an Apprentice Boxer* (2004), Wacquant chronicles his experience of becoming a boxer in a gym on Chicago's South Side, largely a community of African American men, and shows how becoming a boxer is a means of negotiating American racial and economic inequality and inner-city street violence. Through boxing, boxing becomes meaningful; that is, the practitioner develops a stake in the game, which Bourdieu theorizes as *illusio*. Employing the same Bourdieu-inspired method as a volunteer fireman in *On the Fireline: Living and Dying with Wildland Firefighters* (2007), Matthew Desmond explains how and why men volunteer as forest firefighters despite the risk of death. In such studies, the material world becomes meaningful through the body's interaction with the relationships—a social ordering—among

INTRODUCTION ❧ 7

things.[4] It is this homology—a mirroring, or reflection—of the person and social order that is of interest in a Bourdieusian theory of practice. Significantly, this shifts craft analysis away from craft markets and toward the practicing artisan and apprenticeship as a method.[5]

Fire Craft explores meaning making as practical knowledge. At the same time, it "follows the glass" beyond the confines of *habitus* and its social worlds to "making knowledge," material culture, and material agency.[6] *Fire Craft* could have stopped at revealing the constitution of social ties, value, and meaning in glassblowing, but the entwinement of practice with hot glass—an ever-moving and changing material that both demands attention and amends the glassblower's body and thought—urged me to pursue its meanings. I sought not only to include it as a player in *my* game but also to see and understand it as a participant in that game.

Before the glory hole, bombarded by heat and hot and bothered, I could not help but think about the constitutive power of hot glass. To get at the lived experience of craftwork, of glassblowing, I needed to map the "web of meaning"—to invoke Clifford Geertz—in which I had been caught, but I needed to do so not only "from the body"—assumed to be a human body—but from "vibrant matter."[7] Whereas Geertz followed the "linguistic turn" in twentieth-century philosophy and social sciences and held that meaning was symbolic/semantic, my analysis proceeds *from* my body *toward* a new materialist and posthuman turn, questioning the limits, boundaries, and constitution of the human body through what I call intracorporeality.[8] Intracorporeality does not designate the corporeality *within* a singular, discrete body; this would presume that any one body is self-contained—a convenient conceit of contemporary thought. In Latin, "corporeality" refers to "body" as tangible, material, or

matter; it is shared by and characterizes both humans and non-humans. "Intracorporeality" explores the entanglement of corporeality in a given phenomenon.[9] Becoming a glassblower, for example, is notably a matter of fire. An "intracorporeal" account of learning to blow glass, therefore, explores the hot entanglements, dynamics, and affinities of skill acquisition and embodied knowledge. Following the glassblower's fires, I was not an ethnographer of an *element* but an elemental ethnographer, drawing (*graphein*, "to write") people (*ethnos*, "people").

The French philosopher Gaston Bachelard (1884–1962) analyzed how fire catalyzed imagination in his eclectic and profoundly inspiring works *The Psychoanalysis of Fire* (1938), *The Flame of a Candle* (1961), and the posthumously published *Fragments of a Poetics of Fire* (1959–1962). Like Bachelard, I am interested in the experience of fire as *anima*, the source of imagination. But I move beyond his psychoanalytic framework by attending to intracorporeality in the hotshop. Decentering the "human" with regard to "nonhuman" agencies in critiques of the Anthropocene (variously defined as a period of Earth-altering human activity), scholars in the environmental humanities have explored human/culture assemblages, for example, of water, oil, animals, and fossil fuels.[10] As an ethnographer, I practiced a sensuous methodology to experience the coalescence of glassblowing's fiery furnaces and molten glass—elemental complicity—with the experience and formation of art, body, self, and world.[11] Therein, I give primacy to material agencies with which humans become in intra-action.[12]

In *The Human Condition* (1958), Hannah Arendt wrote of the "world alienation" that followed the Reformation and continues today. Defined by both our instrumentalization of the "world" for production and consumption and our mastery of it through discovery, "world alienation," she contends, is the greatest hallmark of modernity, rather than "self-alienation."[13] She valued

the craftsman (*homo faber*) because his "work" produces objects that endure. Their endurance erects a world of objectivity, which allows humans to "retrieve . . . their identity" despite an ever-changing world in which work is increasingly "performed in the mode of labor."[14] Herein, *homo faber* converts the earth into resources through extraction—an act that necessarily marks his work as violent and distanced from his felt, bodily experience of himself via the discovery, survey, and mapping of the World. Influenced by Heidegger, the earth is figurative in Arendt's thought; the earth is not just material converted into a resource (although the work of *homo faber* makes it so) but also a place to dwell. This attention to humanity's relation with the earth—a dynamic of mediation—misses the opportunity to unpack the intracorporeality with and through which "human" and "earth" variously emerge in ongoing change.

Staying with, as Donna Haraway advises, "the naturalcultural multispecies trouble on earth," *Fire Craft* rewrites the "story of craft" through the case of glassblowing from intracorporeality.[15] Materials must not simply be invited into human sociality but must be thought to undo the human-culture dualism that continues to infuse accounts of embodied knowledge and craft more broadly.[16] If I were to study one of the most challenging crafts, in which few achieve virtuosity, and understand the experience of "being-glassy" as well as the dogged investment glassblowers make to their practice despite small returns, I needed to become a glassblower, part of the glass-blowing social world, and, by all accounts, get hot.

THE GLASSBLOWING SOCIAL WORLD

When I told people that I was blowing glass for research, people sometimes asked if I would blow them a bong or told me of

their experience watching costumed glassblowers ply the trade at a "Renaissance Faire." In the beginning, such light-heartedness and dismissive skepticism occasionally caused me to question committing myself to learning to blow glass. Why pursue a practice that could be perceived as archaic or irrelevant or to be a withdrawal from the "real" responsibilities of adult life? If I had been a lone person pursuing glassblowing against all odds, I may have taken this skepticism to heart. However, becoming a glassblower in New York City in 2003 meant not only becoming part of a tradition that dated to the Roman invention of the blowpipe in the first century CE but also joining a contemporary landscape of institutions, formal and informal organizations, and a work and lifestyle subculture with pragmatic and ethical consequences. Situated alongside crafts such as butchery and bookbinding, the glassblowing social world participates in the contemporary resurgence of craft nationwide.[17] In urban centers like New York City, dense with young and educated artists and financial backing from wealthy industries like finance, insurance, and real estate, people, typically with means, whether from degrees, cash, race privilege, or otherwise, are taking up craft as both a leisure and professional pursuit.[18]

Far from being a lone pursuit, an aspiring glassblower joins a robust social world of academic glass programs, summer camps, studio technicians, collectors, museums, historical villages, art patrons, craft patrons, editorial staff of glass magazines and historical journals, and conferences and societies. The strength and resilience of the field are all the more noteworthy as it is one that, premised upon shared breath, survived the COVID pandemic. In the early and mid-twentieth century, artists built small "studios," understood as the antithesis of the American glass factory, in which to blow glass by hand after the early working styles of Europeans. The social world in which I

INTRODUCTION ❧ 11

became caught up shared a collective investment in a game—that *collusio* that Bourdieu argues arises from collaboration—and positioned players as makers of both things and themselves against mainstream consumerism.[19]

In this context, novices and professionals alike can be found watching other glassblowers, studying videos, enrolling in classes, seeking apprenticeships, sharpening techniques, analyzing mistakes, sketching future works to be made, experimenting with different glass melts and tools, and searching for the ideal partners and working teams. The project of becoming a glassblower reaches out from the practice to the broader social realities of American culture, economy and work, demographics and identity, and their environmental realities. When glassblowers are "for real," they have an unfailing commitment to the practice. Becoming a glassblower in America is a choice; it is rarely a family vocation and does not readily promise the steady support of a working- or middle-class lifestyle. Most often, its pursuit follows an unplanned encounter with the material.

When asked about "American glassblowing," a well-known glass artist, Noah Sparks, laughed: "American glassblowing? Gosh, I don't know. There are so many people doing different things. . . . About the only thing that you could say was distinctive about American glassblowing in the last fifty years is that Americans use color. That's about it." Some glassblowers blow bongs, and others are cup makers. Some hot sculpt; others cold cut. Some strive to emulate Old World masters; others, Marcel Duchamp. Some do all or none of these things. Glassblowing's diverse practices are far beyond the scope of any one project or the attention available to any one person in a lifetime. Yet contemporary American studio glassblowing is circumscribed by studio aspirations set against industrialization. Also within the

diverse practices of that field lies a class and racial homogeneity dating to the white, middle-class nineteenth-century British Arts and Crafts movement and, more specifically, the legacies of empire, settler colonialism, chattel slavery, and capital in the United States.

Glassblowing is expensive. In the early 2000s, a typical twelve-week class at New York Glass cost just over $1,000, and a three-week "summer session," which included room and board at the esteemed Pilchuck Glass School, set a student back about $3,000. At both institutions, the length of most classes has been shortened significantly. The tuition of a twelve-day course at Pilchuck in 2024 was $3,500, and an eighteen-day session was $5,250. Both institutions now offer scholarships, do community outreach, and have developed programs to promote and ensure wider accessibility. Even so, cost limits the number of people pursuing glass without working for a team, working for a factory, or enrolling in an academic institution. To build a private studio is a significant investment. Glassblowers are thus largely circumscribed by class and therefore, as Noah explained, race: "It's a really, really strange ultimately upper-class white activity, like really white, effectively 100 percent white." This has recently changed with the Black Lives Matter movement, institutional initiations, community-building programs, and partnerships among glassblowers of color. In 2003, when I began my fieldwork, there was little diversity among professionals at New York Glass, where three Asian Americans worked as professional glassblowers. Still, amateurs were largely white, white-collar professionals ranging in age from twenty-five to sixty-five years old who could afford the evening classes and pay for practice time on the weekends. I am white and middle class. At the time, I waitressed and taught adjunct classes to pay what bills I could and charged my glassblowing classes to a credit

card, the balance of which I would pay with private student loans. While I blew glass at New York Glass for academic purposes, many of the glassblowers in the studio, like Allen, initially blew glass in academic programs. Others, like Diana, came upon glass via classes, such as those offered by New York Glass, and eventually, given the challenges of learning to blow glass in this format, pursued it academically.

I met Diana, a self-proclaimed "recovering poet," on the first day of my second glassblowing course. As Paul, the instructor, and I chatted about his upcoming class, she approached us, and he greeted her in the same way he had me, "Ahh . . . Diana!" and gave her a big hug. "You guys know each other, right?" he asked us. We shook our heads and introduced ourselves. Diana had already taken a class with Paul at New York Glass, completed some summer programs, and worked for a glassblower. She told us, with bright laughter, about the work her employer would have her do, which included heating his food over the gas furnaces. The corners of her eyes twinkled when she laughed, which was often, and her sharp wit, warmth, and charm drew me to her. Diana was white, college-educated, and in her mid-twenties. I would soon learn her keen skills of observation. Stand with her in any clover patch, and she'll find a four-leaf one. One time, she found five within ten minutes! We teamed up that night and continued to work with each other for years.

To not be stuck heating her employer's food at a glory hole, Diana had returned to New York Glass to improve her skills and, she hoped, to get more instructive and meaningful work. She, unlike me, wanted to become a professional glassblower and artist. While many women regularly enroll in glassblowing courses as hobbyists, fewer at the time sought or achieved a robust professional glassblowing career. This has changed, especially with the widely viewed reality show *Blown Away*,

won by Deborah Czeresko in 2019, and broader social changes, including the #MeToo Movement. At New York Glass in the early oughts, only two female glassblowers gaffed, that is, were a boss, rather than an assistant, of a team. It was more typical for younger women, like Diana and me, to be invited to assist male teams, which meant working for free to gain experience. The hotshop was very "hetero," and the budding friendship between Diana and me, as well as our hotshop roles, were, to some extent, defined by it. We, too, must have been variously known as marver tarts. A few female hobbyists were regularly in the hotshop but did not depend on glassblowing for income and could hire teams to help them with their work. Again, as with matters of race and gender in the hotshop, so too has the climate of sexuality become more inclusive today.

Within weeks of her arrival, Diana started assisting teams, and she began working as a teaching assistant the following semester. I was her junior in glass wisdom but not age, and she encouraged me to volunteer in the studio and pursue teaching assistantships, and she was an abiding companion to both blow glass and rap about it. She understood glass, was sensitive to it, and was calm about her practice. For me, she was an ideal match for a blowpartner, not only because we both used shears made for smaller hands. When she assisted me, she always knew what I needed before I did, and I never wanted for tools, heat, protection, ideas, or help problem solving. When I assisted her, she worked with my skill level and gave me the opportunity to become a better glassblower. Together, we navigated the male-dominated world of the hotshop, and, to this day, I parse my most pressing queries about glass, craft, making, and life with her. Inspired by glass as a poetic medium, Diana has become a university professor of glass after earning a master's from the

INTRODUCTION ♋ 15

nation's most prestigious glass school, all the while creating her own work.

At New York Glass, Allen mentored both Diana and me. Allen, pale blond, covered in tattoos and piercings, and an avid rider of fixed-gear bikes, was typical of artistic types in gentrifying New York City. Hardly macho, he was quietly and tenaciously committed to becoming a better and better glassblower. Allen had first seen glassblowing when giving a tour to prospective college students when he was an undergraduate photography major. When he entered the hotshop with the tour group, Allen was astounded: "I had never seen it before. Like that was, I think, the only time in my life I can say that I've totally been blown away. He told the tour to continue without him: "[The tour] was like, 'OK, what's next?' And I was like, 'I don't know, just go that way,' and I just stayed there and let them go. I have no idea. I got in so much trouble." Following his chance encounter with glass, he went to the hotshop whenever possible for the remainder of the academic year to watch others blow glass. He enrolled in a glassblowing class for the following fall. During his first week of class, he was enamored with the skill of a "visiting artist"—Sarkis, who was then pursuing his MFA at a neighboring university. Sarkis was already a bastion of talent and charisma, as he would later be at New York Glass. Allen, like most glassblowers at New York Glass, went on to earn his BFA. His practice was like that—well thought out, methodical, precise, and with an ease that comes with deep contemplation. Within a few years, established glassblowers in the field noted that Allen was among the best young talent in New York City. Today, his skills increasingly enjoy international recognition, and having fabricated for leading designers for years, he now runs his own glass design and fabrication

business with a partner. To keep up with demand, he blows glass nearly daily.

Allen lived and breathed glassblowing, and he worked whatever jobs were available, including for designers. He also taught classes at New York Glass. Good-humored and kind, Allen could also be moody. At times, students felt judged by him, as I did before getting to know the sweet guy that lay under the brooding and contortionist facial expressions that he would get watching people blow "fucked up" glass. At the end of the day, he would adjourn to the local tavern—beer was his beverage of choice—which was the hub of studio social life outside the hotshop. There, his cutting humor would come out as he would share stories of blowing glass that either lambasted others' techniques or extolled their virtuosity. When the time came for New York Glass to participate in the Armory shows, where artists market their wares to private buyers and companies, Allen was chosen to display and promote his work. Of course, he wanted his work "out there," but pitching and selling it was not without effort. At the time, he just wanted to blow glass. And be good at it.

Allen's techniques were mesmerizing; he was admired by more than a few and seemed always to have a glassblowing girlfriend. He was a budding rock star—a young, handsome male, in eloquent command of the material and quick on his feet. Once, as his teaching assistant, I accidentally turned out the lights of the entire studio. Though it was the end of class and his demonstration had finished nearly three hours earlier, Allen took the opportunity to pick up a blowpipe and blow glass. The students stopped cleaning up and turned to watch. He blew in the dark—a drop-neck bottle from a double gather. The orange of the glass and the glory hole lit his tilted face, warming the forehead, nose slope, and left cheek with glow,

forming a type of triangle. The rest sank into darkness, save for the occasional emersion of the forearm, wrist, knuckles, and chin from the tuck of the collarbone in the glory hole's light. It was exquisite, sensuous. In the darkness, Allen's love of glass, which was palpable day to day, was set into relief.

Though there is no single glassblowing practice, becoming a glassblower helped me understand the extent to which all glass-blowers apprentice the glass—whether as a poetic medium or to get good. Thereby, it was easy to feel and experience how a sensibility for the material bonds the glassblowing social world. Talk about glassblowing—the glory hole heat, batch, cords, jacks, punties, rondels, tweezers, avolios, carbon steel, shears, chofes, one's own and other people's glassblowing skills, and what gets made—is grounded in the relationship of the glass-blower with the glass, a relation that I increasingly understood as a matter of intracorporeality.

GLASS, FRAGILITY, AND THE HUMAN CONDITION

Allen, Diana, and I were not the first to be seduced by glass and the choreographies of its art. Travel diaries describing visits to glassworks date from at least the fourteenth century, when Leonardo Frescobaldi, of the powerful banking Florentine family, visited Murano, the famous glassblowing island in the Venetian lagoon to which glassblowers were ordered to relo cate in 1291, en route to the Near East.[20] In a 1483 description of the same Murano factories, a German Dominican monk noted the works' impressive splendor and virtuosity of the craft: "Here they make 'with the finest art, glass objects of various shapes. . . . In all the world there are not glassmakers

18 ❧ INTRODUCTION

like these who make precious crystalline vases and other miraculous things."[21] Visitors to Murano became ubiquitous to the point that Marin Sanudo, a Venetian patrician, kept a diary of the glass workshops from 1496–1533, which noted the visits of notables including the queen of France (1502), the duke of Urbino (1532), papal legates, and archbishops.[22] On my own 2024 visit, the reality of these accounts was palpable: Murano's narrow streets teem with glass furnaces and wares.

While some visited to experience the spectacle of the craft, others sought out the technical secrets, like the Englishman James Howell, who, employed by a British glasshouse, moved to Venice in hopes of gaining technical knowledge and securing skilled labor for his employer's factory. On Murano, Howell was impressed by the concentration of the industry and the spectacle to which it gave rise, as he noted in a letter dated May 30, 1621, addressed to his brother: "'Tis a rare sight to see a whole street, where on one side there are twenty furnaces together at work."[23] Though charged with collecting technical knowledge to be used for England's industrial and economic gain, Howell fell to reading glass for meaning beyond its mechanics:

> But when I pry'd into the Materials, and observ'd the Furnaces and Calcinations, the Transubstantiations, the Liquefaction, that are incident to this Art, my Thoughts were rais'd to a higher speculation; that if this small Furnace-fire hath vertue to convert such a small lump of dark Dust and Sand into such a precious clear Body as Crystal, surely that grand Universal Fire which shall happen at the Day of Judgement, may by its violent ardor vitrify and turn to one lump of Crystal the whole Body of the Earth; nor am I the first that fell upon this Conceit.[24]

Glass begins as a mix of dry minerals and is transformed into "liquid fire," or "molten metal," by great furnace fires and then becomes a cool, noncrystalline form through the work of hand tools and breath. The arc of the life of glass is one of constant transformation. Some say that glass, as a "supercooled liquid," molecularly never achieves a solid state. Before glass, one falls not only for its spectacle, however, but also for the way that it uniquely embodies and gives form to the human experience of vulnerability and fragility, leading the late-seventeenth-century illustrator Giuseppe Maria Mitelli to depict the glassblower as blowing a human form (fig. 0.1).

The figure declares, "Of glass I am made and of breath," while onlookers remark on the difficulty of the art and foresee

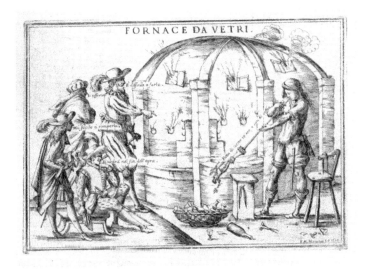

FIGURE 0.1. Giuseppe Maria Mitelli, "Fornace de Vetri," 1698. Etching 217mm x 317mm.

Source: Bertarelli 1940/Le Incisioni di Giuseppe Maria Mitelli, catalogo critico (237). ©The Trustees of the British Museum.

that the figure will break.[25] The British Museum interprets the figure as "Peace" upon which the men, representatives of the warring Ottoman and Holy League factions, comment.[26] Though frail, the glassblower's art demonstrates the beauty and strength of vulnerability. The likeness of glass to the human condition has inspired novelists, such as the Italian modernist Gabriele D'Annunzio, to use it as a metaphor for the arc of life's unpredictability, its joys and sorrows. In D'Annunzio's *The Flame* (1900), the lovers Stelio and Foscarina walk along the canals of Murano as Stelio confesses his admiration for another. At this moment, a master glassmaker, Seguso, invites them into his atelier. Noting their admiration of vases being tempered in an open furnace chamber, the master presents Foscarina with a vase made by his hands. Foscarina accepts the vessel, which, like her relationship with Stelio, has passed from a dynamic and malleable molten state into a static form. Stelio, like one onlooker in Mitelli's engraving, predicts its fate: "It will break."[27] No other art produces work that embodies human inhalation and exhalation.

So, while the fifteenth-century metallurgist Vannoccio Biringuccio extolled the possibilities of glass to take the form of an "infinite number of other ornamental things that satisfy the desires of man," he also warned, in the vein of Stelio's prediction, against placing too much value on the thing, which the breath had formed from the fire: "Considering its brief and short life, owing to its brittleness, it cannot and must not be given too much love, and it must be used and kept in mind as an example of the life of man and of the things of this world which, though beautiful, are transitory and frail."[28]

It is perhaps even the ever-present risk of implosion from excessive heat or explosion from excessive cold that makes the practice of blowing glass absolutely engrossing. Indeed, the

"epitaph of the toots of Chelmsford glassblower John Joseph Stickelmire, who died of 'dropsy by intemperance' in 1814," expressed as much:

> This verse reminds the heedless as they pass
> That life's a fragile drop of un[an]nealed glass
> The slightest wound ensures a fatal burst
> And the frail fabric shivers into dust.
> So he who in his art could none surpass
> Is now himself reduced to broken glass.
> But from the grave, and fining pot of man
> From scandiver and glass galls pursed again
> New mixed and fashioned by almighty power
> Shall rise a firmer fabric than before.[29]

As a *pyromenon*—a fiery puzzle of natural philosophy—a fragile drop of unannealed glass imparts a lesson not only of material but of life itself.[30]

CAUGHT UP IN VITREOUS BECOMINGS

Entering the hotshop, while spectacular and new, was in many ways like coming home, given that I had been raised in a family of makers and artists. As an ethnographer trained after the discipline's "crisis of objectivity," I knew that total detachment from self and world was a myth.[31] Nevertheless, an unspoken prohibition against the still-used idiom "going native" uncritically and problematically loomed in the air. What disciplinary hesitancy I experienced, however, did not trump my sense that making, albeit at the core of my sensibility, could be investigated. In fact, I saw my ability to be "caught up" in practice as

an opportunity to unpack the mechanisms of meaning *from* the body. Rather than eschewing the experience of "coming home," I wanted to get inside it and understand it. I became a glassblower, albeit modestly.

From this "apprentice-ethnography," I aim to elucidate the body-material dynamics of glassblowing from within the discovery and problem solving of learning to blow glass and extend this analysis to considerations of art, body, self, and world. The German philosopher Martin Heidegger understands craftwork to be a project of "relatedness."[32] This is marked by the craftsman's ability to listen to the material upon which he works rather than the achievement of technique or the accumulation of knowledge of customary forms.[33] The "relatedness" of Heidegger's craftsman overcomes the binary logic of Cartesian anthropomorphism, making thinking a matter of the extension of the hands.[34] At the same time, relatedness wrought in phenomenological appearance leaves the vital materialism of body, material, and thought unaddressed.[35]

Fire Craft is structured by the question of embodied knowledge while constantly explicating the material entwinement thereof. Chapter 1, "The Glassy State: Setting the Pot of Man and World," reveals that setting the pot, as it were, is a second beginning—a new ground—from and in which the glassblower converts living materials into the medium of the art. Far from neutral, this bears a logic of vitrification that abets imagining a "New World." By following the furnace through ancient, Renaissance, and both European and American early modern workshops, I map the connections of glassblowing and imperialism and settler colonialism, complexifying normative studio glass histories anchored in the nineteenth-century Arts and Crafts movement.[36] Chapter 2, "Embodied Knowledge: The Ebbs and Flows of Skill Acquisition," introduces a phenomenological

INTRODUCTION ❧ 23

account of developing proficiency through my struggle to make a goblet.[37] Therein I reveal not only the dynamic of apprenticeship but also the dynamics of failure amid daydreaming and reverie at the glory hole. The hot glass is already demanding analytical attention amid the "relatedness" of skill acquisition. Though well intended, I produce a "globlet"—stout and thick—rather than a goblet. In chapter 3, "Fire and Sweat: Calorific Bodies and Teamwork," Oren hires me to help produce large-scale vessels. I struggle to become part of the team—that "intercorporeality" of collaboration, which the philosopher Gail Weiss notes "is never a private affair, but . . . mediated by . . . continual interactions with other human and nonhuman bodies."[38] This emphasis on "corporeal exchanges" in the "ongoing construction and reconstruction of . . . bodies"[39] differs from the "distributed agency" of the social theorist Bruno Latour, namely, the idea that an actor is an "actor network"[40] made to act by many others, both human and non-. After a day of opening and closing the doors of the blazing glory hole, I'm exhausted. Salty and crusted with silica-like sweat crystals and the shared sweat, saliva, and grime of my teammates, an intracorporeal ontology emerges. Blowing with Diana in chapter 4, "Blow: Time, Space, and the Vessel," I cannot help but notice the intangibility of the breath in seeming exact proportion to the all-too-tangible heat. Luce Irigaray noticed the same of phenomenology; the "forgetting of air" permeates Western thought, including theories of embodied knowledge of "flesh and blood."[41] Exploring the failure to automate the breath in glass manufacturing, the breath reveals the vessel-like nature of the human project as the primacy of place challenges temporal accounts of the development of skill.[42]

My ability to produce the "globletta"—the finer cousin of the "globlet"—marks my development of skill in chapter 5,

24 & INTRODUCTION

"Quintessential Craft: Cup Making and the Turns of *Métis*." Enrolled in Advanced Glassblowing, I'm advised to return to the basics, which brings me back to the fundamental question of embodiment and practical knowledge. I recall my first gather, experienced as an "element" hitherto unknown. Connecting the cycles of return and reversal to the organization of the elements—those ABCs of the Presocratics, Plato, and Aristotle—I explore both the steps of cup making (known as the ABCs of the art) and the gather as the novice's "baptism by fire" and "quintessential initiation." Seeing a way forward, as Jude's accomplished goblet making and Sarkis's and Allen's cunning show, is not just mastery of *techne* but elemental complicity, *métis*. In chapter 6, "Materia Erotica: Love and Strife in the Hotshop," the Sisters of Glass love, talk about love, and make love.[43] Falling for Sarkis, I consider the socioerotics of recognition and its alignment with the production logic of the hotshop. Returning to the intracorporeality that I experienced working the doors for Oren one day, I consider an elemental erotics of consanguineous promiscuity. Self and world fall away to queer becomings. The paradox of "falling off track" to "stay on track" sheds light on the dyadic concepts of the "hotshop" and "studio." I exit a certain kind of "field" staked and sewn as a topography of action and recognition by social inquiry. This narrative journey is an elemental one, coursing from and through the grounds of furnace and pot; the ebbs and flows of knowledge; the viscerality of fire, sweat, and glass; and the air of the breath toward quintessential goals and erotic meanderings.

In conclusion, I journey to Murano like so many have before. Its legacy is palpable as I walk the canal of Stelio and Foscarina, flanked by glass factories and shops bursting with high-end lighting, both innovative and traditional vessels, and souvenirs, all of which must compete with wares imported from China

that sell at a fraction of the price. Blowing glass with a maestro of a Venetian glasshouse, the weight of all that learning and thought is real. Yet, with gravity, there is grace. The maestro places a red-whorled piece of murrine in my palm, and I radiate with the consanguinity of glassblower and heat, material, world, and others. Heart of glass, I now cannot help but to live, think, and become accordingly.

An understanding of glassblowing for its function in the social order, for its status in the art world, for example, or its institutionalization in the academy would not satisfy me. As an American researching an American craft community, my research orients the interest in the "traditional" craft practices of "other" places toward the contemporary United States and joins both the burgeoning field of the ethnography of contemporary arts, crafts, and design as well as debates defining the Anthropocene.[44] Informed by posthumanism, this effort joins "post-craft" in its attention to "new materialism, object-oriented ontology, and affect theory."[45] *Fire Craft* does not present a theory of craft that asks, "What is a craft object?"[46] Nor does it trade in analyzing the discursive "invention of craft."[47] Instead, *Fire Craft* theorizes the ontoepistemology of contemporary craft, revealing both the sociohistorical contours of its "human condition" and the living materialities of its making; it finds, after Heraclitus, that "The ordering . . . ever was and is and will be: fire everliving, kindled in measures and in measures going out."[48]

I am reminded of a T-shirt designed and worn often by an amateur-professional glassblower; it read: "New York Glass: Blood, Sweat & Tears." Readily, this asks: "How does glassblowing—a craft which most practitioners have no shot at mastering—infect people, such that they claim to have 'caught the bug' and willingly sacrifice blood, sweat, and tears in a

struggle for proficiency?" Yet it also asks, "How *is* the glass-blower and glassblowing social world blood, sweat, and tears?" This book unpacks how mistakes and failures are experienced, negotiated, and catalyzed; how concentration and attention are generated and maintained in the face of constant shortcomings; how love, the elements, and being-glassy challenge human conceptions of "body" and "world"; and how, in the midst of all this, one becomes caught up and committed to the game. Somewhere in the movement to and from the hot furnaces of New York Glass, I got hooked. The goal of *Fire Craft* is to find that hook or, more likely, hooks and, like any good angler, understand the parameters of the catch and how it gets reeled in.

1

THE GLASSY STATE

Setting the Pot of Man and World

Thunderbolt steers all things.
—Heraclitus

Before we enter upon the Art it's self, 'tis necessary to deliver the manner of their Furnaces.
—Antonio Neri

THE CRISIS

Eloise was poised to feed the fire, holding a shovelful of "batch"—the ingredients of glass. A bulky silver heat-resistant tunic covered her body from the waist up, making her look like an astronaut. She gave me a nod through the plastic face shield, and I fully opened the furnace door, stepping back as blazing orange tongues licked the gaping aperture and the interior's white-hot walls: It roared with voracious hunger. Looking as if she was conducting a religious rite, Eloise stepped forward, her silver suit mirroring the fire's demanding dance, and offered the first bag. Typically melted from silica (sand), soda (sodium), and lime (calcium carbonate), glass "batch" is a mixture (distinct

from a pure compound) and can include a variety of minerals. Silica (high-quality quartz sand) is the "former"—the primary component; soda (common salt) is the "flux," which lowers the melting point of silica; lime is commonly the "stabilizer," which prevents the glass from crystallizing and protects it from corrosion by water. Eloise continued diligently, shoveling one bag at a time from a cart stacked high. Flames began to retreat from the furnace's mouth to devour the offering. Within a day or so, the "crisis" would come: the moment when the "metal," that is, the molten glass, was ready.[1]

At the crisis, the furnace's fire would be dropped from inferno to a moderate 2,000 degrees Fahrenheit (approximately 1,000 Celsius), and the glassblowers would set to work. A small hip-height door stands at the furnace's mouth and is opened only a few inches for the glassblower to gather. Still hellishly hot, a new student dips her arms into the water of the pipe cooler before gathering; others wear cut-off tube socks up to their elbows. Proficient glassblowers, more nimble before the furnace, learn to outmaneuver its heat. According to lore, furnace salamanders lurked inside—monsters born of and fed on fire, which were said occasionally to consume those who ventured to close.[2]

Though I never knew a glassblower to be eaten whole, many did get nipped. Some suffered burns, which blistered and scarred, or the heat rash known as "roast beef arm." Others became dehydrated or developed blind spots from the fire's glare. Almost all are inconvenienced by the itch of dried sweat veined across dark T-shirts. Now and then, the smell of singed hair would waft across the space. And some did, like centuries of glassblowers before them, "go missing" for spells as they roved from hot furnace to hot furnace as migrant workers.[3] The salamander ransomed the glass for either skill or pain, and the

glassblower, able to pay, withdrew with his prize to work upon it. For the seventeenth-century Florentine glassmaker, chemist, and priest Antonio Neri, who wrote the first codified glassmaking manual and history, *The Art of Glassmaking*, in 1612, the salamander served as the glassmaker's mascot. Just as, in myth, the salamander is born of fire, so too is the art of glassmaking.[4]

PYROPHILIA

It is perhaps not without coincidence that many glassblowers confess a love of fire. Hattie, a professor of glass at a prestigious art school, saw a large urban dome on fire when she was twelve years of age and "was so into it" that when she later moved to a city where arson was a widespread problem, she would cruise the city by bike at night looking for fires: "It was a spectacle and fascinating. So, then when I saw glass—I really didn't connect the two—I wasn't like a firestarter as a kid, but there is this extreme situation, the heat, the physicality. I liked it all." Hattie's energetic expressions are framed by ringlets that fall from her buzz-short hair around her ears. It's hard not to feel her passion for and dedication to glass as she talks; everything about her seems animated and engaged by her belief in the transformative power of glass as a fiery medium. The first day of class I had with Hattie was much different from her own, in which old-time glass workers asked students to gather goocy rubber with a stick for fear they would be overwhelmed and distracted by the gleaming hot glass of the furnace. She climbed to the top of a tall ladder and poured ladle after ladle of molten glass from its heights, creating a lava waterfall, which pooled and cooled into a crystal pond on the floor beneath. In case the

extraordinary material dynamics of molten glass were lost on anyone, she next motored a giant molten orb with a drill while blowtorching it so that it spooled into midair flight like the threads of finely spun sugar-halva or cotton candy.

Working with hot glass lived out a fascination with fire for my beginning glassblowing instructor, Paul, as well. For him, glassblowing was like "making magic." Paul first saw a hotshop after unsuccessfully trying to meet his biological parents: "I peered through the windows of vases and could see the hotshop in the back—you know the furnace glow. . . . It was raining. They were closed." He laughingly added, with opened hands and a smile, "Look, all glassblowers are pyromaniacs to some extent." For Paul, "making magic" meant "following the glass": "Even when you've blown glass a thousand times, you never know what is going to happen—there is always an element of the unexpected." Glass is often referred to as a "supercooled liquid" because of its amorphous molecular structure and indicates a "state of matter"—substances *vitrified*, that is, made glass.[5] Beneath the hands of the maker, molten glass moves and undulates, and both Hattie and Paul, painters before they discovered glass, loved the chase that the material invites. As Hattie put it, glass not only "got her into trouble" and "invited her to mess around," but it also "talked back—a lot." As dialogue, glass presented the possibility of discovery.

Many glassblowers cite the "magic" of working with glass as a reason for pursuing it as a vocation, including Nick, who forsook an engineering career: "I like the heat and the extremes and the spectacle of it. I love it when people watch me glassblow, I love to watch people glassblow. Especially people who don't blow glass. Because I wonder if that person is having the same experience as me when I first saw glassblowing. You know, it is totally mystifying. I saw these guys working; it was all very

interesting, fluid, graceful. It blew my mind." When Allen first saw Sarkis blow glass, he basically skipped all of his classes to hang out there with him: "I went up and hung out and helped him for three days. I had blown glass for like a week at that point. Before I had given that tour to prospective students when I was still a photography major, I didn't know what the fuck the glass department was. I thought it was people doing shit with windows. Window painting or signs, I don't know. . . . The first time I gathered . . . it was the fire, the whole thing, the smell." What captures the imagination of those who "catch the glass bug" are not cool glass commodities that line store shelves but rather the undulating, ever-changing molten glass and the chase that the material invites. Hot glass and glass-blowers seem ever-poised and on the precipice of something new, and being a contemporary studio glassblower is, in part, a vocation of pursuit.

Accounts of awe from sojourns to glasshouses have a long history. Less than a mile from where New York Glass would be, Caroline Harrison visited Brooklyn Flint Glass Works in 1824 and wrote of her "astonishment" over "the red hot ball of Glass flying in all directions" and the manner in which the men seemed to "work into each other's hands."[6] More formally, in 1852, the British sociologist Harriet Martineau, writing for Charles Dickens's Victorian periodical *Household Words*, toured the Birmingham Glass Works, where the windows of the Crystal Palace had been produced for London's 1851 Great Exhibition. Martineau begins her journey among the raw materials—"masses of sulphate of soda," "heaps of chalk," "the greatest quantity of fine sand," "coal heaps," and "laborers treading the clay [of the furnace pots]." Wanting to see the great "metal" forged of these materials, Martineau enters the glassblowing area: "We find ourselves on a sort of platform, in front of six furnace mouths,

32 ❧ THE GLASSY STATE

which disclose such a fire within as throws us into a secret despair, despair for ourselves, lest we should lose our senses, and for the men, because it seems impossible to live through the day in such heat." She does not flee but instead stands on her tiptoes to catch a glimpse of glass. Overwhelmed by the power of the fire, "transparent with heat," she fantasizes about plunging her head into the trough of water in which the glass-blowers cool their pipes.[7]

Like Nick and Allen nearly two centuries later, Martineau is mesmerized by the choreography of work required by the ever-present need for heat: "Some of the men have bare feet and legs; some have no clothing but drawers and a blue shirt; one or two, indeed, add the article of gold earrings, being Frenchmen. All have glistening faces; and all swing their glowing cylinders as if they were desperate or demented; a condition which we suspect we are approaching, under the pressure of the heat, and the strangeness and the hurry of incessantly getting out of the way of red-hot globes, long pipes, and whirling cylinders." In the "fire-palace," Martineau's intellect hurries to comprehend fire's transformation of the glass ingredients into molten glass and then into form. She is astonished as a glassblower spins the molten glass into a crown window pane, a molten bowl spinning open into a solid plate: "We cannot in the least comprehend how and why the 'metal' we saw treated becomes the great and beautiful disc that we beheld it grow into. . . . It is considered the most striking and wonderful of all the spectacles of this fire-palace."[8] Martineau, like many to follow, is caught up in the transformative power of glass. A glassblower must produce precisely the form required within the limited amount of time that the glass remains hot, lending the craft a unique urgency, as well as the structure of a performance with a precise beginning and end.

The ability of glass to take innumerable forms and, in particular, as the Florentine Neri noted, to form a cavity, by means of the breath, unlike any other material, is part of its power to enchant—a seeming feat of creating ex nihilo.[9] In the time of Queen Anne's reign (1665–1774), the public was given notice, for example, of a "Rare and Curious ARTIST"—a glassblower—who "bloweth of all Colours in Glass . . . Swans, Ducks, Birds, Knives, Forks, and Scabbards, Decanters, Cruets, Bottles and Ladles."[10] In the late 1800s, *Scientific American* recommended a "troupe of glass-blowers" for "a very interesting evening's entertainment for those who are fond of practical things."[11] Into the nineteenth century, the American glass manufacturer Deming Jarves noted that the glassblower was "considered a magician" and looked upon as "an alchemist who could transmute base metal into pure gold."[12] In the alchemic spirit, the ancient Egyptians valued the ability of glass to imitate and counterfeit precious gems, metals, and stones.[13] In the twentieth century, heritage villages built stadium-style seating around the hotshop, while a theater-glassblowing collaboration in Brooklyn staged an interpretation of Euripides's *Medea* in 2014. Today, some hotshops on Murano are all but open glassblowing theaters for eager hordes of international tourists. The "drama" of glassblowing is not lost on students or audiences, who can be found applauding even the most basic demonstration.

Thanks to glass's ductility and malleability, it can be worked upon, unlike metals, without additional interventions such as quenching, and the experience of its transformation from liquid fire into form is thus immediate.[14] Drawn out from the furnace, passed between workers, and shaped by tools, the transformative process of shaping glass happens with neither pause nor belabored deliberation. Using his body, hand tools, and breath, the glassblower conjures an infinite variety of forms from liquid

fire, be they ducks, giant window panes, or imitation chalcedony and topaz.[15] Amid fire and smoke, he creates with that which could equally destroy and brings out an object of fragility and clarity—even timidity—in cathartic resolution, drawn into the problematics of transformation.

Distinguished from other admired substances brought to completion by fire, such as gold, glass "'tis Artificial."[16] As such, glassmaking did not, as early alchemists believed, improve, perfect, or complete Nature but rather changed and even surpassed it: Glassmaking is the quintessential *art* of fire.[17] Spectators like Martineau and Harrison marveled at the glass's hot flux. At the same time, those like Hattie and Paul pursued the question, or problematic, posed by fire's transformation as the development of an art. They, not sated by mere "fascination" and "astonishment," also *wondered*.

Far from a passive state or emotion, wonder is classically considered the origin of seeing and solving problems.[18] For Aristotle, wonder is the experience from which all philosophy starts: Man wonders upon being presented with the new— a moment of *aporia*, pathlessness—and, perplexed, pursues knowledge for the sake of understanding.[19] Over a thousand years later, Descartes similarly attributed learning to wonder but argued that excesses of wonder, namely, "astonishment," made knowledge "impossible."[20]

When Hattie climbed the ladder to pour glass from its heights, it was not only to astonish but also to generate wonder among her students and thereby hook them into the pursuit of discovery, as she explained: "If I do x—it is like cause and effect—if I climb up a ladder and drop it, what is going to happen? It rocks your world and makes you rediscover the world in a childlike way." The last thing that Hattie wanted her students to do was to produce cups: "If you just want to make a bunch of

cups, you can do that, but that's not what this is about." This query is not about "nature's glass"—volcanic obsidian and thunderbolt or meteoric fulgurites—but glassmaking and its possibilities. Caught up with man's questing queries, wonder bears a "new beginning"—a clearing from which to proceed. The crucible of this pursuit is the glassblowing furnace.

SETTING THE POT

A furnace can be stoked and allows continual study of fire's transformative power: the ground of the glassblower's art. In "primitive-religious" smithing, the furnace was understood to be a kind of artificial "uterus" in which nature's material was brought to completion, and the rituals that accompanied its construction could include abstinence, fasting, living in isolation, and animal sacrifice.[21] In glassblowing, Jarves describes one such ritual before setting the furnace "pot"—that crucible in which glass is melted and forged within a furnace. The glassblowers dressed "in the skins of wild animals from head to foot," added "glass goggle-eyes," and then paraded through the neighborhood as "the most hideous-looking monsters." With such rituals, Jarves notes, "the ground was thus furnished for very much of the horrible diablerie connected with the whole history of the manufacture."[22]

At New York Glass, furnace superstitions still loomed, such as when two newly built furnaces were named "Bubbles" and "Cords." "Bubbles," small air pockets, and "cords," veins of inconsistently melted glass, are both unwanted glass qualities that can appear in an improperly cooked tank of glass. Welding such namesakes atop the furnaces was hoped to work as an evil eye to protect against the curse of imperfection, looking for a

fresh tank of glass to infect. The furnace was no less than the heart of the art and was attended to with diligence, as when Eloise fed its lapping flames with measured and deliberate care. Historically, such rituals worked to control access to the furnace, its transformative power, and the vocation.

One of the earliest tales of "setting of the pot" comes to us from Pliny the Elder (23/24–79 CE), the Roman military commander, procurator, and author of *The Natural History* (77 CE), a purported description of "the nature of things, and life as it actually exists," dedicated to the emperor Vespasian.[23] Pliny begins by describing the River Belus as having sluggish tides, unwholesome water, and slimy deposits, making it dependent upon the agitation of waves to be "cleansed of impurities." Having introduced the reader to this material inconvenience, he tells of Phoenician merchants traveling by sea, who chanced upon glass when it flowed from beneath their cooking cauldrons set atop natural soda rocks in the vicinity:

> The story is, that a ship, laden with nitre, being moored upon this spot, the merchants, while preparing their repast upon the sea-shore, finding no stones at hand for supporting their cauldrons, employed for the purpose some lumps of nitre which they had taken from the vessel. Upon its being subjected to the action of the fire, in combination with the sand of the sea-shore, they beheld transparent streams flowing forth of a liquid hitherto unknown: this, it is said, was the origin of glass.[24]

We could note that the merchants observed the transformation and noted its wondrous beauty. They thought about it. Having thought about the process and the splendor it bore, they then gathered the material resources that they had observed

were necessary and went away with these to thereafter produce glass. Possessed of knowledge of cause rather than place, the merchants forged the art of glassmaking, portable and able to be disseminated. This is not a neutral story. Setting the pot was a matter of transforming land, place—that brackish Belus—into a causal logic. Displaced from land and placed into the pot, the logic of glassmaking could then be disseminated.

Pliny was among the first to use *vitrum* (from the verb *videre*, to see) to refer to glass, a shift in terminology from *hyalos* (glass as solidified water) or *crystallus* (glass as melted earth). This corresponds to the increased use of optical instruments, but so too does it appear with an imperial way of seeing the world. At the time of Pliny's telling, Phoenicia and Egypt (a robust source of *nitre*, or soda) were under Roman rule, with Pliny's understanding that Italy's divine providence was to become the "mother-country of all nations of the Earth."[25] Pliny's tale subtly reconfigures the "ground" of glassblowing from the brackish Belus to the imperial "pot." This shifts the forces of a "nature" from autochthonic becoming to a "nature" commanded by the Roman Empire. This story is all but unanimously told in studio glass histories as a matter of the *moored* merchants' discovery and consequent experimentation. But Pliny's account precisely *unmoors* glassmaking. Normative art histories focus on the tether of the ship to land. But what is happening is the untethering of land vis-à-vis the pot set upon it—that "ground" reconfigured anew, which foregrounds the logic of glassmaking, namely, vitrification.

Vitrification describes the process now understood as a mixture of substances transformed into a "glassy state." Of vitrification, Neri notes, it is "a thing that inlightens mans understanding with the means, and manner of making not onely

Glass . . . and so many other beautiful things which are made thereof."[26] The merchants did not understand vitrification via its scientific cause but instead thought glass to be an entirely new substance. This does not detract from the emergence, I argue, of a logic of vitrification; "setting the pot" evokes a new way of seeing the world, indeed of creating a New World. We might think of the "glassy state" as a transformed "state of matter" and a "matter of State"—a material-semiotics of becoming self and world.[27] Not without coincidence, glass furnaces and remnants are to be found at the farthest reaches of the Roman Empire. To gain insight into how glassmaking's logic of vitrification shifts the dynamics and practices of self and worldmaking, I turn to a selection of historical illustrations of the glassblower's pot and furnace.

FURNO-MUNDI

An early illustration of a glass furnace dates from an eleventh-century Carolingian copy of *De Universo* (*De rerum naturis*) written by a Frankish Benedictine monk, abbot, and archbishop of Mainz, Hrabanus Mauras (c. 776–856 CE). In the chapter titled *De Vitro* (one of twenty-two chapters organized in descending order from the highest good, God), an illustration shows a glassblower gathering through the front door of a round furnace (fig. 1.1). To one side, a sparsely clad worker holds green plants beneath a hovering vessel. In his explanation of the origins of the art, Hrabanus, drawing upon Isidore de Seville's mid-seventh-century *Etymologies*, repeats Pliny's account. Situated within a divine cosmogony of sacred semblance, the glassblower and furnace resonate with divine plans akin to those issued to Bezalel in the Book of Exodus.[28]

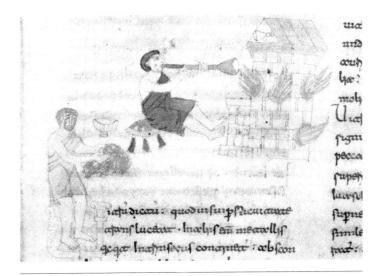

FIGURE 1.1. Hrabanus Maurus, "Glassblower and Furnace," from *De Universo* (1023).

Source: Cod. Casin. 132, Archivio dell'Abbazia di Montecassino.

The Germanic tribes of the Middle Ages, to which Hrabanus, a Frank, belonged, are credited with maintaining glassmaking knowledge in the "West" amid the decline of the Roman Empire and shift of political and economic power as well as actual glassmaking to Constantinople, the capital of the Eastern Roman, or Byzantine, Empire. Amid the changes of the later Holy Roman Empire, an early-fifteenth-century Bohemian edition of *The Voyage and Travels of Sir John Mandeville, Knight* (first published in 1356–1357) chronicles the Crusade-inspired voyage of Mandeville, an English nobleman, to the Holy Land and its environs.[29] Toward the end, following illustrations of popes and emperors, a glass master with enviably thick, tousled hair crowned with a braided sweatband blows glass from one of two crucibles, surrounded

by laborers (fig. 1.2). Vessels cool under indirect heat, monitored by a worker; a hunched assistant stokes the fires through a ground-level aperture. A wares-bearing peddler exits upper right, and an ash-bearing worker upper left—markets are just beyond.

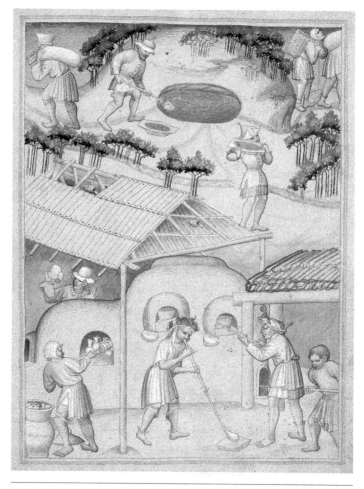

FIGURE 1.2. Sir John Mandeville, "Bohemian Glass Workshop."

Source: From *Illustrations for Sir John Mandeville, Voyage d'outer mer* (1410). MS 24189. The British Library.

THE GLASSY STATE ❧ 41

Foregrounded, the pot accentuates the work of the master and assistants, and relegated to the background of the illustration is the cyclical regeneration and toil of sand, linden trees, and extractive labor. The Bohemian glass master and pot, that is, make good on the land's promise of prolific production. Gone is the divine cosmogony in which man is of equal weight. Instead, man "steps out" into the foreground of his activity, leaving a background of world in his service. At man's behest, it is the transformative power of the pot around which the scene unfurls.

Over a century later, two works of metallurgy— one from the "southern tradition" of Italy and another from the "northern tradition" of Saxony—illustrate the glassblowing process with furnaces embedded squarely in human-centered workshops. In Biringuccio's *Pirotechnia* (1540), a left-forward master fashions an object from a round, near-centered Venetian furnace and eclipses a backgrounded assistant as well those who roll glass upon an interior marble slab to his right (fig. 1.3). An assistant carries a bundle of firewood to feed the furnace, the flames escaping through an aperture drawn in profile. To the left is a window, perhaps of the "rui" glass discs of the day, and, to the right, a feather-capped man, thereby distinguished as learned and cosmopolitan. Confidant, the master, as befits the book's title, demonstrates that glassmaking is certainly about man's capacity to produce vis-à-vis fire (*pyro*)—art/work (*techne*). This is Aristotle's *hexis*. Endowed of capacity, man can practice his art and thereby develop, improve, and progress.[30] The goal is the realization, or fulfillment, of man's potential. Echoing this soteriological perspective, Georgius Agricola's *De Re Metallica* (1558) depicts a workshop with a round Venetian-style furnace, collared master, his extensive division of labor, as well as shop life (fig. 1.4). Strikingly, the landscape outside of Agricola's workshop is leafless—trees rendered as if already firewood; the

FIGURE 1.3. Vannoccio Biringuccio, "Glass Workshop."

Source: from *De la Pirotechnia* (1540), Rakow Research Library, the Corning Museum of Glass (93699). Photo: The Corning Museum of Glass.

living "world" disappears in its appearance as ancillary to man's pursuits amid increasingly diverse goals within the broad social changes of the day—early capitalism, the discovery of the New World, and the Protestant Reformation. In the logic of void and plenum, man's development of his capacity through practice, vessel-like, assumes a world "at hand" for its fulfillment. The story of glassmaking, that is, is not just about the material or, to Hattie's earlier point, the stuff that gets made. Glassmaking also begets changes in man's relation to himself, others, and what he perceives a world to be. It is thus that we can understand that Biringuccio and Agricola variously dedicate these texts to messers, dukes, or Holy Roman electors, expressly directing the nobles toward safer methods of accumulating wealth and profit than warfare. As a capacity, they may each develop—a vitrifying world to a purpose, master-like.[31] Such does *The Medici Glass Workshop*, by Giovanni Maria Butteri (1540–1606) expressly unfurl.[32]

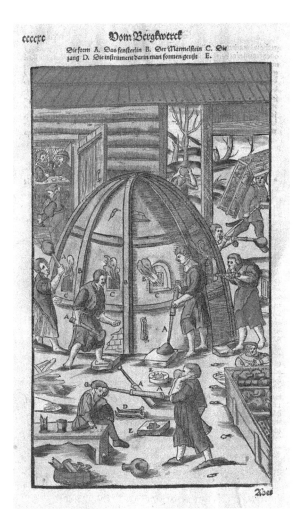

FIGURE 1.4. "Venetian Working Furnace."

Source: from *De re metallica* (1558) [*Berckwerck Buch*, Frankfurt-am-Main, 1580, cccxc]. Rakow Research Library, the Corning Museum of Glass (66820). Photo: The Corning Museum of Glass.

Francesco I de' Medici (1541-1587) of the Florentine Medici dynasty contemplates a blown glass vessel in the foreground while a man, likely his father, Cosimo I de' Medici (1519–1574), and his court's famed "dwarf," Nano Morgante, stand abreast of the master, seated at work before the roaring Venetian-style glass furnace (fig. 1.5). Workers prepare the raw glass, deliver fuel for the fire, make measurements, check and pack finished wares, and construct additional equipment. Others assist in furnace work and set out with bundles of goods to be peddled, while courtly ladies and sword-bearing male citizens enter through garland-adorned Romanesque vaulting. Man and woman, politics and polity, philosophy and art, and economy and work gather around the furnace, revealing them capable of transformation and development in the glory of humanism.[33]

The story of glassmaking is very human. Neri's text was translated into English in 1662—an event cited as contributing to the rapid rise of the English glass industry and its dominance by the late seventeenth century alongside expedient production and high consumer demand.[34] Given the license glassmaking permits for the constant transformation of "states of matter," it is worth considering how the logic of vitrification also intersects with "matters of state" in post-Reformation England. Technological innovation alone did not expedite England's ascension as a glassmaking giant; innovation must be seen as an aspect of the *logic of vitrification*—a material-semiotics of glass and vitreous becomings. When the Virginia Company of London sent Captain John Smith to establish a business enterprise in the Americas, they deliberately sent "eight Dutchmen and Poles skilled in making pitch and tar, potash and coal ashes, and glass" to erect a glasshouse.[35] Indeed, glassmaking and its logic of vitrification were primed for "plantation."[36]

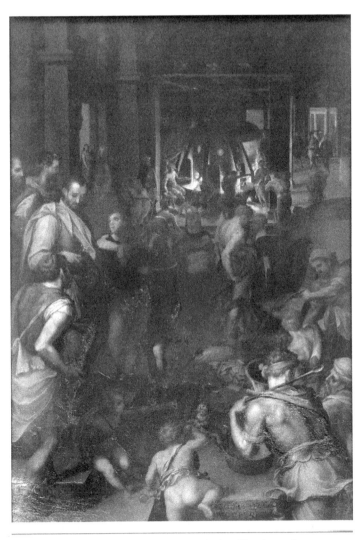

FIGURE 1.5. Giovanni Maria Butteri, "Medici Glasshouse," 1570–1575.
Source: Palazzo Vecchio, Studiolo of Francesco I. Photo: Scala/Art Resource, NY.

VITRIFYING AMERICA

Drawing upon archeological evidence, the 1608 Jamestown glasshouse is remembered as a river-stoned furnace with open walls and thatched roof betwixt the James River and an expansive forest of oak—"primitive," according to histories, in comparison to their European counterparts.[37] In a conjectural drawing (fig. 1.6), the glassblowers work as we see a ship returning to England with the "Trylls of Glasse" produced. Established as a commercial venture replete with invested stockholders, the

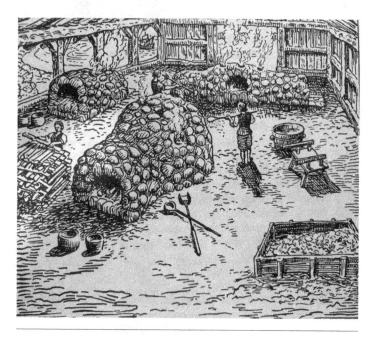

FIGURE 1.6. "Conjectural Restoration of Interior of the Jamestown Glasshouse."

Source: From *Glassmaking at Jamestown: America's First Industry* (1952). Image Credit: Eastern National.

THE GLASSY STATE ❧ 47

Virginia Colony was to deliver goods and profit. It is in this vein that the Jamestown glasshouse is regarded as "America's First Industry."[38]

Debates about the manufacture of glass beads and common green vessels at Jamestown abound, given the few extant objects still in existence, but little is said beyond the archeology of the hundreds of pot fragments there excavated.[39] One such pot sets the scene of a mid-twentieth-century commemorative publication, "Glassmaking at Jamestown."[40] Diminutive in perspective, the furnace smolders softly against a dark wilderness of towering primeval trees as two glassblowers dash from its shelter along the river, blowpipes in hand. They are rushing toward the Paspahegh werowance (chief) Wowinchopunk and Jamestown's president, Captain John Smith, who are wrestling in the shallows—this is nothing short of the archetypal battle between "savagery" and "civilization," Wowinchopunk bow and arrow and Smith's hat cast aside on the river's bank (fig. 1.7).[41] According to colonial histories, Smith brings Wowinchopunk to kneeling submission, knife to throat. This happens in the crucible—that social world set upon living materialities—of the glassblower's set pot. This transforms land into resources and consumes not only the wood the Virginia Colony explicitly sought but also America's first peoples. In plantation—that doctrine of colonization by cultivation and habitation—Indigenous inhabitants, like the soils, sands, and woods, too are subject to the material-semiotics of vitrification, that transformative "crisis" in which raw materialities are forged into the new through the glassblower's fire craft.[42]

The Jamestown glassblowers variously crafted glass for export or refused to work while abandoning the colonial settlement to live among the Powhattan Confederacy or revolt against the colony.[43] Two—Francis and Adam—were beheaded

FIGURE 1.7. Sydney E. King, "The struggle between Captain John Smith and the Chief of the Paspahege Indians near the Jamestown Glasshouse in 1609."

Source: From *Glassmaking at Jamestown: One of the First Industries in America* (n.d.). Image Credit: Sydney E. King Foundation for the Arts.

by the Powhattan werowance because, according to colonial histories, of their fickle allegiances.[44] The glassblowers' shifting allegiance to authority—par for the course with artisan rebellion across Europe since the fourteenth century—makes for a straightforward chronological story in which power and control oscillate between the colonial and Indigenous.[45] Most often, the story of the Jamestown glasshouse begins with its 1609–1610 "first attempt" and ends with its 1621–1622 "second attempt," both attempts of which are described in colonial histories as having "ceased production" following Powhattan "attacks" and "massacres."[46] This chronology misses the persistent continuity, however, of a material-semiotics of vitrification born of the glassblower's pot.[47] At the derelict glasshouse, after all, Nathaniel Bacon dug his trenches to lead his rebellion against

THE GLASSY STATE ⊗ 49

the colonial governor William Berkeley. And it was before the glasshouse chimney that some of the rebellion's conspirators were hanged.

The salience of the glassblower's pot in America's birth of a nation and the New World is part and parcel of pre-Revolutionary history. In the opening folio of a juvenile historical novel, *Nathan's Dark House* (1942), for example, a luminous glass workshop radiantly glows. The book's protagonist, a young colonial boy named Nathan, watches the master glassblower inflate a gravity-defying molten glass orb. His friend, John, a recent arrival from London, accompanies him—the two having just tried to peddle a satchel full of candleberries.[48] An apprentice boy stands ready at hand while two older fellows, advanced in apprenticeship, gather from the furnace for the vessel's handle. Common green glass hollowware lines the workshop floor, tables, and shelves, ready to stock a shop.

Upon close inspection, the initials "C.W." are carved into the side of the workbench, followed by the year "1739." This barely noticeable graffiti indicates that this is the Wistarburgh glassworks, founded that same year by the German immigrant-entrepreneur Caspar Wistar in Salem County, New Jersey.[49]

Nathan is there hoping to sell his berries to the Wistarburgh shopkeeper in exchange for window glass for his house, which he laments "is so dark within."[50] As described by Martineau in her consideration of the brilliance of glass and its ability to illuminate, American colonial homes provided ample proof of "the curse of the want of glass windows."[51] He is only laughed at and offered a bit of calico or sugar by barter. Noticed loitering, the master promptly shoos him away: "This is no place for idle boys!" he screams. "You'll break our glass! You'll set yourselves afire! Away! Away with you!" Nathan's journey proceeds along Alloways Creek, which, while taking the name of "Chief

50 ✌ THE GLASSY STATE

FIGURE 1.8. A lithograph depicting the Wistarburgh Glasshouse, c. 1739.

Source: From *Nathan's Dark House*, by Florence Bourgeois, illustrated by Ninon MacKnight, copyright 1942 by Florence Bourgeois. Used by permission of Doubleday, an imprint of the Knopf Doubleday Publishing Group, a division of Penguin Random House LLC. All rights reserved.

Allowas," serves to signal a distant past to the colonists, as Nathan reminds his sister: "Surely thee knows that there have been no Indians here for years!" Crossing Hancock's Bridge—marking the ascension of the prominent Quaker Hancock family—he encounters a forest fire, struggles to extinguish it, and succeeds. None other than Hancock himself, who owns and fells trees used for shipbuilding, rewards him by obliging his desire for glass panes.[52] No doubt Wistar himself, whose works were reported by his friend, Benjamin Franklin, to consume twenty-four hundred cords of wood per annum, was grateful.[53]

Nathan earns glass panes—illumination, or enlightenment—through the perception and preservation of the trees as resources

THE GLASSY STATE ❦ 51

leveraged toward the realization of his desires.[54] Wistarburgh was the first American glassworks to produce glass in defiance of colonial law for domestic consumption rather than export, and it served as a headquarters during the Revolutionary War.[55] The material-semiotics of the logic of vitrification—transformation onto the new, onto the revolutionary—beget a New World, a Glassy State.[56] In the Glassy State, resources—that unmoored land—aid the formation of a *modern* state, self, and world.[57] Wistarburgh—first among a handful of protoindustrial glassworks—"sets a pot" par excellence of vitrification, of man, world, and state, vitrified anew, modern. The revolution did not "return" to its origin or beginning but instead marked a new one.[58] America's "first industry"—the Jamestown glassworks— was not simply about attempted and failed production. The Jamestown glassworks was the crucible of the New World.

THE GLORY HOLE

At New York Glass, two furnaces sat atop a central platform. Alongside these were "garages," which are small open-faced kilns that fired parts of glass to be added in the process of blow-ing; "pipe warmers," which are gas-fed racks where the end tip of blowpipes were warmed; and "annealers," which, no longer powered by fire, are plugged into the hotshop's walls. Inter-spersed among these various fires on the platform were the glory holes, which served as auxiliary furnaces at which glass blowers reheated the glass, having gathered it from a central furnace to shape it. Sam, a builder of glass equipment, could not recall exact dates but remembered glory holes coming into use in the late 1980s to extend the working time of the material; a sidewise, hip-height barrel fired by gas, a glory hole's girth

varies and is just wider than the piece it is meant to fire, so that the piece is hugged by heat.

After gathering from the furnace, the glassblower takes the gather to the glory hole to reheat. Having established a working temperature, she withdraws to a workbench placed a few feet in front of the glory hole, sits, and manipulates the glass. When the glass cools, losing its malleability and ductility, she returns to the glory hole for another heat. In this manner, the work is defined by the back-and-forth dynamic between the workbench and the glory hole, with "heats" punctuating every step of shaping. At New York Glass, a glory hole could be booked by anyone with a modicum of glassmaking knowledge and enough cash to pay the rental fee.

In the mid-twentieth century, the Corning Glass Works historian Otto Hilbert suggested that the "glory" of the glory hole came from the religious idea of glory, given the halo effect its fire bath lends to the glass being reheated inside, while the *Knights American Mechanical Dictionary* (1872) defined it as "an opening in the wall of a glass furnace, exposing the brilliant white light of the interior."[59] By 1870, many glassblowers unemployed by early American glassmaking failures, including Wistarburgh, were reemployed in the American Midwest, where glassmaking industries "mushroomed" with the discovery of natural gas.[60] Alongside the new gas technology, which melted more consistent glass, innovations such as mold methods of production and higher-capacity and continuous-yield furnaces made the success of glassmaking less dependent upon a glassblower's ability to manage the variability of any given batch of glass, giving rise to a new organization of work, called the "shop system," in which the glory hole worker occupied a position outside of the work of the master-led team.[61]

THE GLASSY STATE ❧ 53

So identified was the glory hole—indefinite working stations manned by unskilled workers—with the shop system and its challenge to the master's authority and the prestige of the glassblowing tradition that associations, for example the Glass Bottle Blowers' Association, reported in 1901 that its members

Glory Hole.

FIGURE 1.9. "Glory Hole," pen-and-ink illustration by John Strudwich and J. R. Jobbins.

Source: From Apsley Pellatt, *Curiosities of Glassmaking: with Details of the Processes and Productions of Ancient and Modern Ornamental Glass Manufacture* (1849).

had been forbidden from working in a "glory-hole shop."[62] Here, the systematic undoing of artisanal autonomy by industrialization, in the tenor of E. P. Thompson's *The Making of the English Working Class* (1963), is clearly evident; the glory hole contributes to the automation of the industry.[63] At the same time, an analysis of workers and industrialists fails to contend with the dislodged crucible at the *source* of their contention; attending to social power, class analysis ignores the pot from and with which such social groups arise. The individuation of fire by the glory hole may be against the collective in one tenor, but in another, it belongs to the same ground that divides man from land.[64] The industrialization of the craft, which had automated the industry, is the relatively silent foil against which contemporary studio glassblowing, done by hand, situates itself, leaving its vast history in colonization and empire untold.

I learned none of this during my fieldwork—not because it was esoteric knowledge but because it's not a part of the shared history. The only and most extensive lesson I received in American glassblowing history was a succinct statement by Hattie: "Industry controlled it." The stories that I heard about glassblowing being essentially an oral tradition were about the "giants" of studio glassblowing: those American artists who had approached glass as a new medium of expression—Harvey Littleton and Dale Chihuly, among others—and the Europeans—Erwin Eisch and Lino Tagliapietra among others—who had taught them the hand tradition lost with America's industrialization of the craft.[65] When Paul discussed the origins of glassblowing with me in a class, he started, like most folks, with 1960: "Before the '60s, no one really understood how things worked. Even when I was in the university [he graduated in 1996], there wasn't really a textbook. When [one] came out, we were all so excited because we finally had the language to

THE GLASSY STATE ❧ 55

understand what we were doing—it made all the difference." He readily advised me to buy it: Ed Schmid's *Advanced Glassworking Techniques* (1997). It contained everything that *Ed's Big Handbook of Glassblowing* (1993) had, plus more. And if I wanted to nerd out on equipment and technical information, he added that I should get Henry Halem's *Glass Notes: A Reference for the Glass Artist* (1993). I bought Schmid's 1997 book. Folks did speak of Wheaton Village—a glass center in southern New Jersey with an industrial glass history—but nearly entirely in terms of its coveted artist residency (Sarkis was one).

In my 1975 copy of Ada Polak's *Glass: Its Tradition and Its Makers*, a dedication is written on the first blank page, dated May 1979, that speaks to the journey of two American glassblowers to Murano, which continues as a global glassmaking center to this day: "Dearest Chris, In memory of our brief venture into the 'old' world. The chapters on the glasshouses of Venice, Murano, and Torcello and the migration patterns that developed in the history of making glass were fascinating to me. The whole book was discovered at a time when it reinforced my developing thought patterns in the discovery of our European ancestors. Before you go to Europe again, I'll share with you an expanded knowledge of our deep roots! Luv You, M.M."

The inauguration of American studio glassblowing in the mid-twentieth century was expressly a movement against the industrialization of the craft. This is undoubtedly the case. But this statement does not take into account a critical genealogy of craft and colony, glassmaking and Jamestown, and glassmaking's collusion with the settlement empire since the time of Pliny. The glassmaker enacts worldmaking—a pillar of the "human condition" recognized by Hannah Arendt. But when left ontologically unexcavated, we fail to see that this worldmaking proceeds from a world first made by man's separation

from living materialities: the setting of the glassblower's pot. Contemporary craft is anything but a return to old European ways: Those ways, long unmoored, have harbored, pursued, and developed the New World.

I am both a scholar of glass and a lover of making. I became a glassblower in New York City to "get at" embodied knowledge. The pot, which had captured my imagination and from which I worked, transforming self and world in the doing, rested squarely—and unacknowledged—on Carnarsee land.[66] Unmoored from the land and minerals of glass, batch appeared in large fifty-pound bags that were emptied into the belly of the furnace by supplicants like Eloise, me, and the many who found themselves caught up in the problematics of fire work at the glassblower's furnace. Like so many before me, I wondered, and with the furnace's crisis, I pursued the logic of vitrification, of new and unending transformation of the glassy state. The tale of the origin of glassmaking is not simply of *techne*, that is, but the material-semiotics of self and world formation.

2

EMBODIED KNOWLEDGE

The Ebbs and Flows of Skill Acquisition

I had been advised by a colleague to read as much aesthetic theory as I could for a good year, starting with Kant. It was September 2003, and I was trying to concretize the research design for my dissertation on craft. I left the meeting disheartened and unsatisfied: Could the debates in aesthetic theory get at the tacit understandings, experiences, and skills of a craft? That evening, I contacted the educational directors of numerous craft facilities in New York City. By the end of the week, I found myself at New York Glass, a not-for-profit glassblowing studio, discussing the possibilities for research with the educational director.

"So, is your question on the difference between art and craft? Do you just want to observe?" the educational director asked me.

"Well, actually, I'd like to enroll in the course, to actually take the course. You see, I do ethnographic work, which means that I do my research through participation. It is not so much the question of the difference between art and craft that I'm interested in, as how we actually learn a skill, like glassblowing—I'd like to actually learn myself," I replied.

58 &? EMBODIED KNOWLEDGE

Though the classes for the semester were already full, I was permitted to attend a beginning glassblowing class starting the following week. I had been blowing glass for six months when I attempted to blow the goblet I mentioned in the introduction. When I arrived that Tuesday night, it was no surprise to find the glassblowers Sarkis, Oren, and Zach at their benches, crafted from forged steel and wood, blowing pieces, their assistants hustling about, top-loading finished pieces into the annealers and opening the furnace doors to unleash bursts of inferno-like orange. There were the glory holes, blowpipes with freshly gathered molten glass undulating at their ends, and, of course, that heady, smoky scent of burning newspaper and pure, clean heat. I had become accustomed to the place. I knew my way around and could prove myself to be a not entirely incompetent glassblower. I was comfortable. It was, therefore, all the more engaging, disquieting, challenging—basically thrilling— when we, that is, me and my eight classmates, after having Paul demonstrate how to blow a goblet with his teaching assistant Maureen, tried to do the same. In technique, this was a task exceeding anything we had yet encountered.

I had not yet started to volunteer to work for the studio or work for teams—two ways to more readily learn and gain competency. Even so, I had a basic set of skills: gathering glass from the furnace; blowing a bubble; forming cylinders, bowls, and plates; and using the basic metal and wooden instruments. Blowing a goblet required all of these skills. Up to a point, I was proficient. However, the challenge of blowing the goblet would be to combine what I'd already learned with things I hadn't. This presented me with my first opportunity to evaluate how glassblowing is read by the glassblower at varying stages of proficiency, specifically to reflect upon the ebb and flow of sensations, techniques, and modes of consciousness.

READING THE PRACTICE

A goblet begins with the invariable gather of glass from the furnace. I withdrew the blowpipe, a broomstick-length hollow steel tube, from the warming rack, where its tip rested in a row of low blue-orange gas flames. I no longer needed to think through my handling of the pipe—its weight, length, and red-hot tip. As the first step of blowing every piece of glass, I had long learned, following innumerable gathers, to let the pipe swing into a nearly vertical position before my body when removing it from the warming rack, gripping the cool steel just under the plastic tip with my right hand while lightly using my left to support the pipe from the middle. I walked in this way to the cinderblock furnace, a box about two feet deep inside and five feet in height and width, separated from the cement floor by an expansive metal grate. I knew I had the pipe gripped properly given the proximity of its unheated end to my face; its other end, orange with heat, had to be safely positioned just above my shoes—unlikely to burn myself or others or to knock over anything. But, I sensed the "rightness" of how I was holding the pipe and did not need to double-check; I had done it time and time again. All of my attention, therefore, was on getting a good gather of glass to start this challenging piece well.

Heather, from New Jersey, had dark, long hair and an inclination toward wearing sweatpants. As my partner for the night, she slid open the coal-chute-sized iron door at hip height. I quickly dipped the red-hot tip of the pipe into the water bucket to remove any carbon; a billow of steam reached my knees from the sizzling water. Between the door and the vat of molten glass was a small ledge, about six inches wide. I lifted the pipe with both hands to a horizontal position level with the ledge and gently rested the pipe, nearly at its tip, upon it. Withdrawing

60 �losed EMBODIED KNOWLEDGE

my left hand, I pushed the warm tip into the furnace until the edge of the ledge reached the pipe's midpoint, where my left hand had been, effectively becoming a midpoint of balance. It was here, at the ledge's edge, that I felt the pipe. I let my right hand, which still gripped the steel at the pipe's other end, become light until, like a see-saw, the pipe's warm tip within the furnace lowered toward and into the slightly undulating molten glass. The pipe, without the counterforce from the right hand outside, would have sunk, seized by the viscosity of the glass. Instantly, thus, my right hand set to work, the left too taking up a place just below the right, quickly rotating the pipe clockwise to both keep the pipe from sinking more than four inches deep and to "gather" the glass through twirling—much as one would gather honey by twirling a teaspoon in the honey jar at the breakfast table. I gathered confidently, but the strength of the grip of the glass on the blowpipe told me that the pipe had gone too deep. Pushing directly down on the end of the pipe closest to me with my right hand, I brought the other tip out of the glass and swiftly withdrew the pipe; a mango-sized gather of glass bulged its tip. Heather slid the furnace door closed.

I had seen gathering demonstrated, been instructed in how to gather, and gathered many times before this. By the fifth week of the class, we had chosen to stop following Paul, our instructor, to the furnace to watch his initial gather—an awful decision in hindsight. It takes years of observation and practice to gather well. The technique of gathering had been broken down into successive moments, as I had written in my field-notes during my first glassblowing days: "We were asked to individually step forward to the furnace with our blowpipes and 'gather.' 'Just rest your pipe on the little ledge here,' Paul advised, 'just like you would on a windowsill and then just lower the tip

into the glass with your right hand on the end of the pipe. Watch the reflection of the pipe in the glass rise to meet the pipe, then lower it in just a few inches and give it a few swift twirls—one, two, three—that's all you should need. Keep it on the ledge, and bring the tip of the pipe up. Place your left hand on the pipe just beneath the right, pull it up and out. Don't worry, you'll do it quick enough because this isn't the sort of place you want to hang around too long."

Bringing the blowpipe into the proper holding posture, twirling the blowpipe strongly and with a steady cadence, placing it at the proper leverage point on the ledge, lowering it at the proper speed, and placing its tip into the glass at the proper depth—these were all vital to a successful gather. We would also practice these components separately, abstracted from the actual process, as when Paul, my glassblowing instructor in the fall of 2003, recommended that we twirl broomsticks while watching TV at home to improve our finger dexterity. When learning to gather, the steps of the gather are explained and sometimes demonstrated distinctly, like successive points on a line, but gathering proficiently is not only a matter of linking together these successive actions.

The difference in moving from one step (lifting) to the next (lowering) to the next (twirling) and yet the next (lifting again) and so forth marks the difference between the gather of a novice and the gather of a proficient glassblower: the novice tends to proceed "successively," not "smoothly." Here, we see two possible sets of objects of attention for the glassblower to read amid her practice: (1) the part that is an end in itself and (2) the part as it serves a project, a whole. When gathering for the goblet, I looked to the gather's mass and its position on the tip of the pipe in anticipation of working it into a goblet. Toward this end, I registered the efficacy of the gather, not the successive

FIGURE 2.1. A glassblower gathers glass through the furnace aperture by dipping the end of the pipe into the hot glass and twirling it.

Source: Ed Schmid, *Ed's Big Handbook of Glassblowing*, 20. Drawing © Ed Schmid.

EMBODIED KNOWLEDGE ❧ 63

components or techniques of the gather, upon which my attention had been riveted in my first days of glassblowing. I did not consciously decide to continue to twirl when removing the blowpipe from the furnace; I only sensed that, though a bit deep, the gather had been proficient for the purpose of blowing a goblet. This represents marked progress for the novice, who, accustomed to serving the instrument, finds the instrument becoming a part of her.[1] In *Personal Knowledge*, Michael Polanyi discusses this process through which instruments recede from consciousness and become extensions of the body: "Tools . . . can never lie in the field of . . . operations; they remain necessarily on our side of it, forming part of ourselves, the operating persons. We pour ourselves out into them and assimilate them as parts of our own existence. We accept them existentially by dwelling in them."[2] I had what Polanyi terms a *subsidiary awareness* of the blowpipe.[3]

The objects of our subsidiary awareness "are not watched in themselves; we watch something else while keeping intensely aware of them."[4] Though my technical capability enabled my gather, I did not pay heed to each step, the distinctness of which had been insisted upon in my early days glassblowing, but rather attended the gather itself, the correctness of which informed, if necessary, immediate adjustments to my techniques: "In the exercise of a skill . . . we are aware of that *from* which we are attending *to* another thing, in the *appearance* of that thing. We may call this the *phenomenal structure* of tacit knowing."[5] I knew my gathering had been apt in virtue of the gather. The objects of subsidiary awareness are not objects of attention but rather instruments of attention. Polanyi discusses the instrumentalization of the objects of subsidiary awareness in the context of hammering a nail: "We *watch* the effect of our strokes on the nail and try to wield the hammer to hit the nail most effectively.

When we bring down the hammer we do not feel that its handle has struck our palm but that its head has struck the nail." Of the gathering of the glass or the driving of the nail, I have a *focal awareness*, which incorporates my *subsidiary awareness* of the instrument: "I have a *subsidiary awareness* of the feeling in the palm of my hand which is merged into my *focal awareness* of my driving in the nail."[6] Similarly, as I began the process of gathering the glass, my awareness of the blowpipe's weight in my palm receded and, in its stead, advanced the sensation of the ledge's edge at the blowpipe's midpoint, followed by the weight of the gathering glass on the blowpipe's tip, and finally the gather toward a goblet.

As our awareness of a practice shifts into focal awareness, so does that practice take on a *lived* character, a graceful extended movement, an arc of embodied techniques. Paul's instruction, intentional or not, had consistently encouraged a shift toward this *lived* type of awareness. While Paul, with his friendly smile, may instruct, "Bring the pipe up level with the ledge" or "Twirl the pipe at an even pace"—bringing our attention to what had been subsidiary—he often supplemented this with a quick counterinstruction to refocus on the project at hand, in this case, blowing the goblet. So while Paul, observing me warming my gather in the glory hole to blow out into a bubble, would call my attention to the pace of my twirling—"Slow it down there, cowgirl. Keep it steady"—he would also quickly return my attention to getting the glass to the desired end, calling out over my shoulder, "But keep your eyes on the glass! Don't take your eyes off the glass! It's starting to hang." Sure enough, taking my eyes away from my hands on the pipe, I would look into the glory hole and see my gather nearly dripping off the end of the pipe. By bringing the technique into focal awareness, we could hone it. But we were quickly urged to allow what had become a momentary object of focal awareness,

EMBODIED KNOWLEDGE ᧢ 65

the technique and tool, to slip back into subsidiary awareness, a movement of attention, which, having consciously attempted to make the technique more similar to the expectation, forged a slow process of restructuration.

This is the defining exercise of apprenticeship through which the apprentice fashions her practice by making an implicit technique explicit, improving and realigning that technique with its intended purpose and allowing the revised technique to again recede into unconsciousness. In the words of the social theorist Pierre Bourdieu, this affects the shaping of the still nascent glassblowing *habitus*, "the system of structured, structuring dispositions."[7] Paul's direction of our attention toward technique is an abstraction of a moment from the process in which it is embedded. This moment of reflection, evaluation, and decision may be referred to as *reading*, that process through which we retrospectively discern the meaning of, in this case, our actions or techniques. That an evaluation of the gather, a reading of the glass, would necessarily be retrospective leads me to suggest that reading a skill, say glassblowing, may be the mark of the novice and, while it can improve technique through bringing it into a state of exception, reading can never be an operative mechanism of proficiency. When gathering for the goblet, I did not need to evaluate each of the gather's constitutive moments to understand the deftness of the gather. Sense making happened otherwise than this retrospective meaning making.

MEANING IN PRACTICE

I "understood" gathering. This understanding was not an intellectual synthesis of successive acts by a discerning consciousness. Rather, it was a bodily intentionality. "Practical, nonthetic intentionality," Bourdieu writes

66 ❧ EMBODIED KNOWLEDGE

has nothing in common with a *cogitatio* (or a noesis) consciously orientated towards a *cogitatum* (a noema) [and] is rooted in a posture, a way of bearing the body (a *hexis*), a durable way of being of the durably modified body which is engendered and perpetuated, while constantly changing (within limits), in a twofold relationship, structured and structuring, to the environment.[8]

Bourdieu's point is that bodily intentionality emerges from and with a body that has both been shaped by and shapes its environment. Bourdieu was influenced by the work of the philosopher Maurice Merleau-Ponty, a phenomenologist widely known for his profoundly influential opus *The Phenomenology of Perception* (1962). "To understand," Merleau-Ponty writes, "is to experience the harmony between what we aim at and what is given, between the intention and the performance—and the body is our anchorage in a world." The body, he adds, "is that meaningful core" and can assimilate new significances.[9]

Philosophically, Merleau-Ponty is responding to theories of intentionality that precede him. Phenomenology's forerunner, Franz Brentano (1838–1917), drew from Aristotle and the Scholastics of the Middle Ages, like Aquinas, to argue that consciousness arises only with intention—orientation, that is, toward the world.[10] Brentano asked neither what the nature of the world is nor how we can know it, but rather, forgoing the possibility of achieving objective knowledge of an objective reality, he asked instead, "How does the world appear before active, intentional consciousness?" The German phenomenologist Edmund Husserl (1859–1938) moves intentionality from "cognitive consciousness" to "kinaesthetic consciousness"—consciousness, that is, is given in the "I can," namely, the body's practical orientation.[11] Husserl's student Martin Heidegger (1889–1976) shifts the inquiry of mind and consciousness (epistemology) to that of being

(ontology) vis-à-vis the hermeneutical tradition of Wilhelm Dilthey (1833–1911), which asserts the cultural historicity of being.[12] Being, Heidegger argues, is not a matter of consciousness but of "being with" (Dasein) the world—a theory of "relatedness" that, per hermeneutics, argues that the world appears in a certain manner.[13] Merleau-Ponty wrote under the influence of and in response to both Husserl and Heidegger and argued that the body is neither simply the conduit or catalyst of constituting consciousness (a Husserlian premise that maintains a mind-body dualism) nor the existential premise of being-world relatedness (a Heideggerian premise that does not account for the body itself) but is instead that aforementioned "anchorage in the world."[14]

An anthropologist, Bourdieu takes after the work of ethnologist Marcel Mauss (1872–1950), whose seminal essay "Techniques of the Body" (1935) argued that the formation of *habitus* emerges with the "work of collective and individual practical reason" as "a system of symbolic assemblages" rather than, after Aristotle, the "soul and its repetitive faculties."[15] Perhaps it's even in reference to Mauss that Merleau-Ponty notes in "Eye and Mind" that "every technique is a 'technique of the body.'"[16] In the manner of the social sciences, Bourdieu connects bodily intentionality and the formation of *habitus* to the internalization, practice, and reshaping of social norms and rules. It's in light of this perspective, he argues, that bodily intentionality "is a kind of necessary coincidence—which gives it the appearance of a pre-established harmony."[17] *Habitus* is an ever-developing capacity achieved through training and education.[18] In the vein of Bourdieu's theory of *habitus* and practical knowledge, my "understanding" of the gather came from aligning particular techniques with a goal with and through my body in practice. In bodily intentionality, that is, the particular techniques become *sense-full*.

68 ∞ EMBODIED KNOWLEDGE

As proficiency rises, the specificities and the particulars of technique recede and become, as objects of subsidiary awareness, servants of the whole. For Polanyi, we may "regard this function [of the particular] as its *meaning*, within the whole." It is in its attendance *to* something that the meaning of particulars is indicated: "All particulars become meaningless if we lose sight of the pattern which they jointly constitute."[19] The meaning of the particular is in its incorporated lived service, or functioning toward the whole, not within the abstracted retrospective interpretation and consequent understanding of its function. When the interpretive effort of "reading" the practice, understanding how the parts fit into the whole, remains salient to that practice, as essentially a semantic understanding of meaning, it forms an immense barrier to the *lived* experience of the craft as meaningful.

It is not so simple as either/or, however. In fact, reading and living are often coexistent, for both novices and masters. I have discussed how semantic readings of meaning are more or less necessary, depending upon the extent of incorporation of the practice. The difference between the novice and master lies both in the extent of the necessity to retrospectively read meaning into practice but also in the roots of the novice's and master's lived experiences of the practice. In the development of proficiency, the glassblower's beginning experience of the practice becomes the "fundamentals" of the craft, those embedded dispositions and schematizations of glassblowing. The novice, however, is without this operative "foundation," hence the oft-advertised "no experience necessary." But the oddness of this statement is that even that very first experience of the novice must be informed by some experience. She is not experience-less, though she is assured that "no experience is necessary." In fact, she arrives on her first day with already equipped

dispositions and schemata for handling the forthcoming situations. These experiences must bear on her very first moments of glassblowing to greater or lesser degrees.

For example, gathering involves the sensation of heat and the motion of retrieval, each common to my previous experiences of working a campfire and fishing, respectively. It was these past experiences that bore on my experience of first reaching toward a vat of molten heat and engendered a schema with which I could manage the task of gathering: I didn't burn myself, nor did I send molten glass flying by yanking out the blowpipe when retrieving it from the furnace. For the novice, her lived experience is likely to be informed not from a lived practice of the meaning of the particular technique as it serves the whole but rather from other areas of her life from which she draws to handle the newly encountered situation. Her adaptation is not conscious; it happens at the level of the body. Her body "catches" already-known components of glassblowing, like heat and retrieval, and with some adjustments, manages and gets through the new situation with greater or lesser degrees of success. These adaptations are specifically in response to what she is confronted with and, in this sense, lack an anticipatory quality. They do, however, in repositioning the body, set up the opportunity for the restructuring of the novice's *habitus*, that system of dispositions that can anticipate, in accord with the *field*, those rules of glassblowing. Thus, through the adaptations, the glassblowing *habitus* begins to take shape, and the novice develops a "feel for the game."[20] Gus, a glassblower at New York Glass, once casually commented that "glassblowing has to become something that's in your body and not something that you're thinking about, and that only comes from doing it. It doesn't come from thinking about it. And that's why it is important to go through the process again and again."

70 ᔐ EMBODIED KNOWLEDGE

As the novice progresses, her adaptations to newly presented situations in glassblowing are grounded less and less in previous nonglassblowing experiences and more and more in her solidifying glassblowing skills, accomplished through restructuration. Thus, that retrospective meaning-reading of practice, so vital to the apprenticeship, is required to a lesser extent as the novice's lived experience is informed by the fundamentals of the practice, glassblowing, itself: Significance is still, but to a lesser degree, grasped by an intellectualized constituting consciousness but becomes more and more a "motor grasping of a motor significance."[21] However, there is still always the encounter in practice of the new and the unknown. For the novice, this unknown truly may be unknown, not just unexpected. So, while she may be proficient in elementary skills of the practice, such as the gather, she may have no schematization with which to handle a new disciplinary expectation: Her dispositions may not yet envelop the discipline's canon, and she may therefore be in the position of handling points of blowing a piece proficiently while approaching other technical points only through harking back to nonglassblowing schematizations—the mark of an amateur.

In my attempt to blow the goblet, while I was able to complete the first steps, gathering and blowing the initial bubble proficiently, I found attaching the stem and foot extremely difficult. Sensing the inevitability of the upcoming technical difficulty, anxiety flowed into my hands as I carried the gather on the blowpipe back to the workbench from the furnace. I blew out the bubble, paddled its bottom flat, and asked my partner, Heather, to bring me a *bit*.

A bit is made by gathering a small amount of glass onto the tip of the punty and shaping it into a slightly tapered cylinder by rolling it, called *marvering*, on a steel table, called a *marver*

(once made of marble in the Italian tradition). I would then attach this finger-like piece of glass to the bottom of the bubble to serve as the goblet stem.

When Heather returned with the bit, I was waiting with my blowpipe positioned vertically before me, mouthpiece resting on the top of my right shoe, bubble positioned right in front of my face, left hand holding the diamond shears, which are used to pull, attach, and cut through the still-hot glass bit. Heather positioned herself to my left, aligning her right shoulder with my left, and centered the punty vertically in front of her body, the hot bit of gathered glass hovering just above her feet. "Check

FIGURE 2.2. A glassblower "marvers," that is, rolls a gather back and forth over the marver.

Source: Ed Schmid, *Ed's Big Handbook of Glassblowing* (1993), 39. Drawing © Ed Schmid.

your hands," I called to her, attempting to linger on that sense of assuring composure and exaggerated confidence that accompanies the initial posture of a practice. She did, consciously shuffling her feet forward, closer to me, lining up our shoulders, testing that the width between us equaled the length of the punty. She placed her left hand above the right on the punty and set it into a pendulum-like swing.

It needed to happen in a blink of an eye, as Paul and Maureen had demonstrated. It hadn't, and we had to reheat our already-too-cold pieces. Repositioned, Heather again swung the hot bit. Intense anticipation filled my body: "Paul and Maureen were both calling me, 'Take it with the shears! Pull it onto the bubble!'" Their words called for action: I knew I needed to do as they had demonstrated—I needed to take hold of the punty with the diamond shears (imagine large scissors with curved blades that leave a diamond-shaped hole in the middle when closed), pull it toward the bubble before me, and set the glass bit onto the bubble. I had no established rhythm, such as I had when gathering, to carry my actions. In response, my body searched—is this like catching a basketball? Playing hot-potato? Seizing jacks?—these all semiconsciously ran through my mind. A type of stage fright seized me: My body could not anticipate the right moment. Consequently, I *looked* for it: My eyes jumped between my stagnant bubble, Heather's swinging punty swinging with the bit, and the space passing in between. I felt impotent standing there, waiting for, rather than bringing about, the correct alignment of the swinging punty and bit with the standing blowpipe and bubble. I visually scanned the arrangement of the object's positions for the proximity necessary to take the punty with the diamond shears, guide it toward the center of the bubble, and finally, with a straight downward pull, bring the bit into contact with the bubble. I could feel the rapid

EMBODIED KNOWLEDGE ❧ 73

movement of my eyes—it made me even more nervous—they couldn't keep the tempo, were not the proper organ, could not anticipate, but waited to receive.

I did not and, in fact, could not catch the spatial synthesis for which I waited. I wrote in my fieldnotes that day:

> Heather delayed the punty in its downswing, it was stagnant. I grabbed onto it with the diamond shears, with the unease of catching baited game, and pulled it towards the bubble, and attempting to center the bit on the bottom of the bubble, began to pull it down. The irrevocable touch down of the bit upon the bubble happened before I could notice and Paul and Maureen were already calling, "Pull off! Pull off! You've got to pull the bit up and off the bubble!" My body was both numb and abuzz in the agitation of the unknown, hands shaking, heart racing. I drew the punty away from the bubble with the diamond shears so that the bit elongated into a semblance of a stem. They continued, "It's going cold! Cut it! Don't wait to cut it!" Not seeing the cold of which they spoke, but knowing that I had to act immediately, I hurriedly took the shears with my right hand, clumsily positioned them on my fingertips for leverage and clamped down onto the glass: quartz-like veins of opacity broke through its clarity, as I exerted as much brute pressure as I could muster; the glass moaning under the bandying shears like paper-thin ice of a frosted sidewalk puddle under foot on a February morning.

In my attempt to take the bit for the stem of my goblet, I had lost the ability to synthesize my movements with a greater movement toward the goblet. I could not attend to the technique, let alone to the goblet, by drawing from the particular techniques I had used in the initial gathering and blowing of

the bubble. There was no recession of a trained body into unconsciousness, operating of its own accord, as I had experienced in the gather for the goblet. In its stead arose the bare punty, blowpipe, and glass—each distinct—seemingly unrelated but needing to be brought together, as I had been taught. My efforts, however, to spatially read for the right moment of bodily intervention, to see when the time was right, were doomed to fail: "Motion perceived visually remains purely kinematic. Because sight follows movement so effortlessly, it cannot help us to make that movement an integral part of our inner lives."[22] Such efforts forsake what is essential to practice: temporality. Practice, whether novice or proficient, must be temporally, not spatially motivated, the hallmark of nonreflective corporeal readings. Therefore, Paul and Maureen, in their efforts to instruct with their calls to action, set me into motion and made me temporal—my temporality needed to be primary to my configuration. Though I answered their calls with motion, I could not find quite the right way to handle the situation and therefore crassly mimicked what I had seen in the demonstration—the reaching out for the swinging punty and adherence of the bit to the bubble—gauging this spatially with my vision, not temporally with my body. In my interjection into the process, I seemed out of time, an interloper.

The inability to experience the particulars within a lived relation to the whole—when the glass, pipe, and shears become separated from blowing the goblet and when we are frozen in a moment of *ek-stasis* from the practice—is not the only way in which the practice can become meaningless in Polanyi's sense. It need not be moments of anxiety, nonrecognition, and corporeal unrelatedness, for example, that usher in the meaninglessness of a practice. The amateur, given her relative competency, is more likely than either the novice or proficient glassblower to lose that constitutive connection of the particular to the whole

FIGURE 2.3. An assistant opens a door of the glory hole for the gaffer heating his piece.

Source: Ed Schmid, *Beginning Glassblowing* (1998), 26. Drawing © Ed Schmid.

and potentially misread the particulars in terms nonrelated to glassblowing. In class, the novice is constantly immersed in the dialectic of apprenticeship and rarely loses sight of either the particular or the whole for too long. At the same time, the proficient glassblower invariably links the particular to the whole, thanks to competency.

It is not surprising that following my experience of "meaninglessness" in attaching the stem to the bubble, I sought out a

moment of repose in which to recuperate—I went to what I knew. Placing the bit onto the bubble had been grueling, and I was exhausted. I turned, pipe with glass in hand, toward the comforting glory hole, that blazing barrel-like furnace, where the glassblower warms the glass on the end of her pipe with soothing rhythmic rotations.

Immensely relieved, my body fell into that familiar mode, my fingers automatically twirling the pipe to that long-established rhythm, my eyes looking nowhere into the glory hole, slowly becoming caught up in the flickering texture of heat—its white, orange, and gray hues running around the furnace's walls, framing the rotating glass—I became mesmerized, and I daydreamed:

> During the process of reheating the bit three times in order for me to "shorten" it, I had amazing visions at the glory hole. Not amazing visions, but I can't escape the glass constantly conforming to phallic or sexual images. The glass started to move, the heat of the glory hole awakening its fluidity, its rounded end making gentle revolutions. I could not act on it; it was too charming, too intimate: I wanted to follow it, to see where it was going, where it could take me. I just stared at these still timid revolutions, pleased that it answered within a moment my own gestures. I kept the bubble, the goblet's bowl, and the bit, the goblet's stem, rotating. My body faded away—into the rotating blowpipe, my eyes becoming increasingly captivated by the movements of the softening glass. My bubble became testicles, flaming orange, and the bit, the stem, on the end became a searching penis, swirling around as it softened with the heat. Though attached to my pipe, it seemed to swim outwards, bounded within the course white-peach-tangerine walls of the glory hole—the breathing red embers below, the roar of the bathing

EMBODIED KNOWLEDGE ❧ 77

gas flame—was it nice in there? Why did I seem to be cutting through the lake? Moving ever-outwards within the brilliant fiery red of the glory hole, the bit shortened, and the penis reformed to a sperm, swimming towards me, the short tail struggling to propel the head up my blowpipe. I withdrew the blowpipe slightly, leaving only the bit under the flame: it sauntered and swayed round and round, directing the piece towards me. The sauntering amused me—I didn't mind. I wanted to keep the glass in the glory hole: I was relieved to become a spectator, to become captivated. The stem recklessly overheated, sauntered and swayed round and round—an enraged white sperm swimming towards me.

"Ok, flash! You're going to lose the piece," Maureen called, waiting for me at the bench. "Oh yeah," I thought, both jumping and responding with lethargic reluctance to the call to make myself vulnerable once again to the unknown of blowing the goblet. I was interested in staying at the glory hole, turning and turning the glass, watching the configuration swim in the brilliant red, and feeling the warmth simultaneously. I was set back on task, knowing that I could no longer just heat, periodically holding the blowpipe semi-upright to shorten the bit. I now needed to continue on with the project of completing the goblet. I wondered if there were glassblowers, who just stand at the glory hole with the glass, never ever completing one object.

At the time, this visual fantasia seemed brilliant, inspiring like a muse, and I thought surely that it must be a salient aspect of the glassblower's pleasure in practicing her craft. However, when I asked experienced glassblowers about such experiences, the common theme of all their replies was that they only see the glass, that they watch the glass in terms of the end it is supposed to be achieving. Paul explicitly spoke against reverie, explaining

that it would prevent the glassblower from blowing good glass: "You have to keep your focus on the glass. When you lose it, you lose the piece. I can't think about anything but what I'm supposed to be doing." Though I had initially thought that they were withholding experiences that may be embarrassing to discuss, I came to understand, through a consideration of the experience of the meaning of practice, that such a reverie was essentially meaningless, as it could in no way relate the particular to the whole, nor was it embedded in the temporality of the practice. In the context of the development of proficiency, I had abandoned that oneiric relation to work when reverie is rooted in the material under hand and allowed the eye to gain ascendancy: I was "seduce[d] . . . in the direction of forms and colors, of varieties and metamorphoses, of the probable shapes of future surfaces . . . desert[ing] depth, intimacy with substance, volume."[23] I had lost the dynamic engagement with the material and allowed it to become an utterly decontextualized, detemporalized imaginative meandering.[24] This does not mean that imagination has no role in glassblowing. Rather, imagination is formidable in the work of *homo faber* as *libido*, as *willed* reverie: "It is the source of all the works of *homo faber*."[25] Lingering upon such pleasurable experiences, while perhaps periodically partaken in by the proficient glassblower, can only foil the purpose of the practice. This does not mean that there is no role for pleasure in the craft but rather that pleasure must be embedded in what is meaningful and what is experienced in that coherent relation of the particular to the whole. On the other hand, as will be explored in the next chapter, such corporeal sensations may exceed the relatedness of intentionality, skill development, and making within a situated context and environment. For now, I will keep, like those keen to acquire

EMBODIED KNOWLEDGE ❧ 79

practical knowledge, to the task at hand, an explication of the acquisition of skill.

PROFICIENCY IN PRACTICE

Having returned to the task with Maureen's help, the piece started to resemble a convincing goblet, and, inspired—once again finding meaning through related practice—I became reinvested. Perhaps still high from my visual and sensual fantasia, I began to dream again. This time, however, invested in the piece, through the recognition of its feasibility, I could see, in my working on the piece, an elegant goblet taking shape. In the opening of the bowl, I could see a beautiful curvature forming, ready to hug the aerating swirls of a vintage Barolo to catch its falling legs. I eagerly worked toward that end, sincerely evoking my skills to the best of my ability, confident that I could carry what had been a difficult piece into something great and significant. I centered the stem, smoothed the bowl, attached a foot with eagerness, and finally put the piece away in the annealer to cool. When riding the Manhattan-bound 3 train home, I was enflamed by the idea of a goblet, pondering its technical difficulty, considering that perhaps goblets were the only pieces of glass worth blowing, and enthusiastically sketching goblets fit for Venetians in my notebook.

You can imagine my shock when I returned to the shop that Thursday and found that my piece in no way resembled the elegant goblet I remembered placing in the annealer to cool. The glass hardly looked like a wine glass. Yes, it had the same components as a wine glass: foot, stem, and balloon, but it was more of a gesture toward a wine glass. My goblet, Paul joked,

FIGURE 2.4. The "globlet."
Source: Photograph by Erin E. O'Connor.

was more a "globlet": lopsided and stout, with a bowl like an inverted pyramid, the curvature of which could never gracefully aerate a valuable wine, a stem as straight as a piece of ginger, and a foot that resembled a silver-dollar American flapjack (fig. 2.4).

I recorded my disappointment and disbelief in my fieldnotes: "That the beautiful ballooned glass for Barolo was so sharp in my mind's eye, the movement toward it so absolutely intentional, the reading of the movements of the glass so clear, the tools so well used . . . my hands seemed as if they were issuing forth this vision, but what happened, what the result was, was so, so, so, so absolutely far from all those intentions."

I had misunderstood my actions—I had attempted to attentively read the movements of the glass and had acted accordingly,

as I had been instructed and had seen demonstrated. I had roused all my technical capability toward realizing that goblet. Paul and Maureen, though they would say there is merit in trying to achieve the form envisioned, never encouraged or played up the likelihood of it happening. Rather, they often, as already discussed, drew the students' attention, cast distantly toward the envisioned piece, back to technique. Each time we students would lament our failure to bring forth our envisioned pieces, they would patiently look at our pieces and read the faulty techniques inscribed upon them.

Looking at the inelegant goblet, I recalled each step of making the piece: blowing out the bowl, attaching and pulling out the stem, humming a smooth rhythm for the turns of the pipe to fall into, pressing the small glass disc for the foot of the goblet—in the end, everything seemed to fall together, but these memories and impressions were at odds with what I held in my hand. How did I go wrong?

I have already discussed how the novice or amateur may attend to aspects of the practice that do not directly bear on the purpose of the practice, such as visual reverie. Though this emerged in the blowing of the goblet, I was "brought back on track" by Maureen and able to finish the piece with not only technical competency but also attentiveness and sincerity. We have also already discussed how a reading of the practice cannot be an operative principle of proficiency, as it calls for an interruption of practice in virtue of the abstraction and reflection it requires. I have also shown that when confronted with a new type of interruption, an individual will draw from previous experience in order to manage the new situation, a type of corporeal adaptation anchored in the person's already established *habitus*. Proficient glassblowers are neither dreamers—cognitively reflective amid their practice—nor predominantly reliant on the co-option of corporeal knowledge from another

realm. Sarkis occasionally substitute-taught for an absent instructor—a favor of sorts. The wages paid to instructors of evening courses was not "worth it" for hotshop rock stars like him, whom leading designers and artists hired to produce work. Even so, when he taught, he did so earnestly, with care, and with reflective advice for those curious about the dynamics of becoming a proficient glassblower: "I can't talk and blow glass at the same time," he explained. "I can't stop to think about what I'm doing. I'm always way ahead, looking towards what will happen next. That's the only place I can be; I can't look back, nowhere else, just here. Anyway, I'll explain what I've done afterward."

Moreover, proficient glassblowers have often said that glassblowing is not about blowing the perfect piece of glass but about coming up with effective solutions to all the problems that consistently present themselves in the process of glassblowing.[26] The force of proficiency is *nonreflective anticipation*, not nonreflective or reflective adaptation. This is beyond the formation of practical knowledge or habit, that "knowledge in the hands, which is forthcoming only when the bodily effort is made."[27] Thinking back to the restructuration of *habitus* that defines the work of apprenticeship, it is an equipped *habitus* that can anticipate the future. For Bourdieu, this was that "almost miraculous encounter between the *habitus* and a field, between incorporated history and an objectified history, which makes possible the near-perfect anticipation of the future inscribed in all the concrete configurations."[28]

Proficient practical knowledge is this ability to anticipate the regularities of a system, learn the rules of glassblowing, and enact schemata to manage irregularities in virtue of having already incorporated the dispositions of glassblowing. Yes, it is corporeal knowledge, but proficiency is defined by the

EMBODIED KNOWLEDGE ∞ 83

interrelatedness of habitus and field and the body's consequent ability to anticipate: "[The body] is inclined and able to anticipate [regularities] practically in behaviors which engage a *corporeal knowledge* that provides a practical comprehension of the world."[29] This anticipation is possible only when the practitioner understands the world's imminence in which she operates and is therefore able to act immediately: The novice, though able to adapt, is not able to anticipate. Anticipation carries practice beyond the moment of action and is the faculty through which an envisioned piece can be realized. Though I had evoked my most sincere and well-executed technique toward a vision so tangible that I could see the Barolo swirling in the goblet under hand, that vision was an importation and, in effect, had no relation in its consequences—no more than the swimming penis in the glory hole—to the task at hand. Perhaps it arose from pouring hundreds of glasses of deep burgundy Barolo as a waitress, perhaps it was from the Netherlandish feasts on the walls of the Metropolitan Museum of Art, perhaps it arose from a confused remembrance of the words of Gide or Garcia-Marquez—whatever its origins had been, I could not have brought it to bear on the glass under hand. It is only corporeal *anticipation* that can directly bring forth the envisioned object of the practice. The anticipation that marks proficient practical knowledge is not a reflective, forward-*looking* gesture. It is a nonreflective corporeal forward-*going* movement beyond adaptation: This is the imperative of proficient practice. My body did not have this corporeal sight. Regardless of how brilliant that Barolo swirled, regardless of my sincerity and belief, I could only have misread my creating and creation: My body was blind.

I now remember the hesitance that flitted across the face of my instructor, Paul, when I suggested that he demonstrate how to blow a goblet: "Anything but that," he said, slightly bowing

84 ∽ EMBODIED KNOWLEDGE

and waving his hands as if before a daunting task. "For a goblet, I have to be warmed up. Maybe at the end of class." However, since no one else had another suggestion, Paul begrudgingly began the demonstration. "I guess that I could show you how to blow out the bottom for a goblet at least." But, he did it all, and the demonstration was more daunting than any of us could have foreseen; the complexity of blowing the piece was unparalleled to anything we had done before. I felt amazed and moved by something completely new. Then Paul asked what I was going to blow, and I answered with a semi-shrug—"A goblet, I guess." The shrug came not from my indifference but rather from the humility brought on by the complexity of the demonstration. I was unsure of my ability to navigate myself through the making journey.

I had not yet realized that "navigation," though perhaps seeing me through to the end and consequently landing me with a stout "globlet," involved an extremely complex set of readings informed by sensation, reverie, imagination, memory, reflection, and adaptation. Nor had I realized that it was not and never would be any of these readings, though necessary as they may be to the dialectic of apprenticeship, through which the *habitus* is restructured. Only through the arduous process of developing that corporeal sight does the glassblower become proficient and house the capacity to anticipate the necessary— the most meaningful reading of practical skill, the bedrock of proficient practical knowledge.

3

FIRE AND SWEAT

Calorific Bodies and Teamwork

If I myself am a grain of the saving salt which maketh
everything in the confection bowl mix well.
—Friedrich Nietzsche, *Thus Spoke Zarathustra*, 1883–1885

When I signed in to New York Glass the evening of my second semester, I happily and eagerly wrote "Hot" in the "Destination" section of the sign-in sheet without a moment's hesitation. This marked a stark contrast from the first time that I had done so, or, more accurately, was asked to do so. The receptionist had beckoned me toward her desk with a wave. Attached to a small gallery, a glass partition separated the reception area from where the glassblowers worked. As she phoned her boss, I turned to watch. Noting my interest, she suggested, "Why don't you wait out there?" My expression must have said, "Yes." "Sign in first, though," she continued, pushing a clipboard toward me. At the top of the paper, three categories were listed: Date, Name, and Destination. Date? Easy: 9/14. Name? Easy: Erin O'Connor. Destination? Confusing. Was I not already at the glassblowing studio? "What should I write for my destination?" I asked. Slightly

annoyed, she replied, "Hotshop." I dutifully wrote H-O-T-S-H-O-P and asked, "Hotshop?" "Yeah," she smiled with a look that asked, "What planet did you just come from?" Pointing through the glass partition, she continued, "That place in there where it is hot." Returning the smile sheepishly, I turned to enter.

Already exiting the elevator, the roar and scent of the studio had rolled over me. In the years to come, I'd get to know Leah, who, while working as the receptionist, also taught classes and worked as an assistant on teams. I would quickly associate the bounce of her mass of brunette ringlets, wide smile, and chuckle with her raw, brass-tacks talk about relationships, family, feelings, job prospects, and life. Her vivacity and poignant humor made it hard not to laugh when talking with her—it has the quality of a dare. As open-minded and generous as a summer meadow, she was a bad-ass glassblower to boot and could hold her own on any team, schlepping or otherwise. Though her skills did not match those of Sarkis or Allen, students regularly re-enrolled in her Beginning Glassblowing classes; she was a great communicator with whom people felt comfortable and supported in learning.

Now nearly a year into my fieldwork and well acquainted with the hotshop, I need not give "Destination" a moment's thought; "hotshop" and "glassblowing," in keeping with the history and discourse of the field, had become synonymous in my mind.[1] This evening—the first night of Intermediate Glassblowing—marked a return for me. It was my first day back at New York Glass following a summer in London. There, had I enrolled in and attended a glassblowing class. To my surprise, I arrived at the class to find the studio devoid of furnace and fire. The class, held at a college in the city's East End, had been advertised as "Glassblowing," which I had assumed meant

in the style that I had learned at New York Glass: offhand, freestyle, variously using teamwork, and beginning with a gather from a furnace. I arrived at a silent and neutral-smelling room, however, with rows of tall workbenches mounted with small blowtorches. As politely as possible, I asked if there was a hotshop. Negative. The room looked, sounded, and smelled like an unused science laboratory. I learned that each of the five students, including myself, would work individually at a torch, heating hand-held premade tubes of borosilicate glass into which we would blow instead of working in teams from a furnace. It was a lampworking class.

A public-facing glassblowing studio is likely to house multiple working methodologies in addition to a hotshop, which might include a coldshop, where glass can be cut or polished with diamond saws and belt sanders; a warmshop, where glass can be fused or slumped in kilns; a mold shop, where plaster-silica molds are made and dried; a flat shop, where premade glass can be cut and arranged; a neon shop; and a lampworking shop.[2] I produced a set of utensils in the lampworking class but longed for the fires, smoke, heat, and collaboration I had come to know and love at New York Glass. Everything that I had missed in the London lampworking studio—as charming as it was—coursed through me upon my arrival that first night of Intermediate Glassblowing. Writing "Hotshop" under the "Destination" category was a no-brainer. Luckily so this time, the clipboard was unattended. Never mind. Most coming to the hotshop were regulars rather than first-time visitors. I was, like many a glassblower, New York Glass or otherwise, going for the heat. Entering the hotshop, I knew I was exactly where I was supposed to be.

Before noticing that the studio had mounted new coat racks and shelves, I dropped my coat and bag on the cement floor along the wall and checked the time—a new silver-rimmed

clock, larger than the last one. It was nice to see these small gestures of investment in the studio, which, according to the everyday complaints of the instructors and professionals, fell short of being a state-of-the-art facility. Though I was early, the first to arrive for the scheduled class at 6 pm, I already anticipated its end; blow time was strictly regulated. By nine o'clock, workstations were to be cleaned and swept, tools stacked or put away, and glass fragments sorted for garbage or recycling as the studio technician promptly turned off the gas-fired glory holes—the outstanding monthly sum owed to the local utility company was rumored to be in the five figures.

Thirsty from the commute, I walked down the studio's central artery—a corridor of Plexiglass windows looking onto the smaller workshops of various warm and cold methodologies and counter-height lockers strewn with the professional glassblowers' vessels and sculptures, crumpled newspapers, rolls of bubble wrap and tape, water bottles, black plastic bags from the bodega, everyday office clutter, cell phones, date books, and invoices—and drank from the unusually cool and crisp water fountain. A few lockers were open, with coats, sweaters, and scarves hanging from their doors and their jammed contents—boxes of hand tools and bars of colored glass, tanks of gas and torches, and an assortment of specialized clothing, including face shields and heat-resistant Kevlar-lined gloves—seemed near to bursting their rudimentary plywood construction. Though no one was blowing in the hotshop when I arrived, the traces of life left from that day's work offered their tender welcome.

Paul appeared at the corridor's end: "Erin! How ya doing?" he called with a New Jersey twang and open arms. Beaming, I fell into the hug, touched to be greeted so warmly and enveloped by more than the heat, to be folded into the ordinary, to be someone it was no surprise to see and even to be expected there.

FIRE AND SWEAT ❧ 89

"Great," I said, "I'm so happy to be here." It felt good to be at the precipice of "scratching my itch" and, as glassblowers say, "getting my fix." My early fieldwork had engendered a yearning, which only the choreography of glassblowing, with its oft-exalted "dance" between and among its supplicants—hot glass, tools, equipment, and other glassblowers—could resolve. We meandered back down the corridor toward the platform of glory holes, meeting Diana along the way. This moment, as mentioned in the introduction, felt more like an encounter in that kindred-spirit, old-soul kind of way. We were already completing and expounding upon each other's sentences with a rapidity that bears breathlessness. Her power of connecting was not diminished by her tiny stature and had nothing to do with the fact that I stood eye to eye with her. Paul was surprised: "Oh, you guys should know each other?!" As we continued to plait the ways in which our lives were already coming together and unfolding, we didn't notice time pass. Talking about the studio's recent upkeep, I glanced toward the new clock and coat rack. "Woah! There's a bunch of students!"

A critical mass of students had gathered by the chalkboard, tucked into the corner between the annealers and locker of pipes. That area was the default classroom for the evening classes, after most of the professional glassblowers had completed their work and gone home. We joined them, and with Paul's characteristic clap—his cue to start we huddled into a circle for introductions. Paul introduced himself to the group by way of his path to glassblowing as a painter and open-handedly passed the baton: a midwife who had abandoned a PhD program in medieval studies at an illustrious university to get more "hands-on"; a young couple who worked in the finance industry but yearned to "get away from the screen"; two retired teachers who hoped for second careers; a barista who aimed to become a

working glassblower with a wealthy clientele; and a dentist who found his profession a limited medium of expression and, as we would all soon readily discover, had natural talent for glassblowing. For her part, Diana expounded upon her love of poetry and desire to improve her skill. Like the rest of us, she had already taken classes at New York Glass, but unlike us, she had also taken summer classes at Haystack Mountain School of Crafts in Maine. As she described the Haystack course and the instructor, we enviously "oohed" and "aahed."

Such summer courses are like camps; instead of attending a class once or twice a week for a few hours, the student lives, works, and learns there for a week or weeks at a time. Her experience working for a regional glassblower and ability to casually joke about it conveyed an additional familiarity with everyday hotshop life that set her further apart from the rest of us. Her spritely knack for text and texture was just as tangible in the group as it was when speaking one on one. I introduced myself first as a returning student and second as an ethnographer and PhD student who was learning to blow glass in order to write about it. I didn't love "talking about" my position as a researcher; I didn't want to give the impression of a lab-coated professional jotting notes of judgment about everyone. I preferred to talk about my research questions and writing instead.

Sarkis prided himself on his version of my double role as learner and researcher: "Ok, so imagine this," he would begin, "You walk into the hotshop with a clipboard and this cop-like coat that has a patch on it that says 'Ethnographer'—and it's across the back in all caps." He liked setting the scene of my "research" like that. "Then you stop," he'd continue, "raise your hand and announce loudly, 'Everybody stop. I'm an ethnographer.' But, then you're like, 'Wait. No. Actually, everybody keep

doing exactly what you were doing.'" He'd chortle, hand on belly, and thought it so funny and clever that he would retell it whenever the opportunity presented itself. I laughed, too. Part of Sarkis's charm was his humor, for which he spared no one. A few students asked about my research during class, and I explained my questions. Caught up together in the practical problematics of learning how to blow glass, such inquiries were palpable to most. Each of us was returning to the hotshop from different life experiences and with varying intentions, but we shared the sense that learning to blow glass was worthwhile. I did not need convincing. My field research had already reaped insights into the nature of making, which no amount of reading aesthetic debates would have granted. I, too, believed and, like most believers, found myself a member of a flock.

HOTSHOP

At New York Glass, glassblowers were typically self-proclaimed artists and strove to distinguish themselves from their proletariat predecessors in part by the setting of their practice.[3] Mid-twentieth-century American artists moved hot glass out of industrialized factories into studios, where the artists perceived themselves to have complete control over the creative process.[4] The nomenclature of the origins of studio glassblowing uses "studio" to distinguish glassblowing by singular artists, but in practice, early studio glassblowing was often done collectively in workshops. The first institutionally supported gathering of artists working in glass, held in Toledo, Ohio, in 1962, was called the Toledo Workshop. Similarly, in 1971 a No Deposit, Lots of Returns Glass Etc. Workshop was advertised to attract

students to rustic glassblowing facilities built by artists in the woodlands of the American Pacific Northwest; it became known as the Peanut Farm Glass Workshop. This site was officially named the Pilchuck Workshop in 1973 before taking its current name, Pilchuck Glass School, and it is today the global hub of contemporary studio glassblowing.[5] Four years later, as the use of hot glass by artists burgeoned, New York Glass was founded as an experimental workshop.

The challenge to factory monopolization of hot glass—and American and European conventions—was in intent launched from the studio. In practice, it emerged from workshops, where authority, as noted by Richard Sennett in *The Craftsman*, has historically been challenged.[6] As workshops proliferated and more people began to blow glass, "studio" functioned less as a noun than as an adjective, as described by Littleton—one of those giants mentioned in Paul's succinct account of the field in the first chapter: "Studio and glass were used in the earliest proposals [for grants] as two separate nouns, not as an adjective modifying a noun."[7]

At the same time, "hotshop" rather than "studio" was used to designate the area in which hot glass was blown. It is unclear when hotshop came into usage, as the American studio glassblower Fritz Dreisbach explained: "[Hotshop] is one of those words [in the 1970s] that we were just using, but who used it first, or where, I can't remember." When asked about the word "hotshop" in American studio glass, Noah, the aforementioned glass artist, suggested that it likely had been passed down from the American factory tradition, as no counterpart for the word "shop" exists in the Swedish or German glassmaking traditions from which American studio glassblowers also drew working knowledge. Noah had learned in Sweden as well as on Murano. Introduced to glass as a photography major at the Rhode

Island School of Design, he was drawn to glass not for "making new things" but for the "sociological system" of the "factory tradition" and the "story of [its] romanticized history of secrecy, oral knowledge, of nonwritten information" that he had heard. Considering the question of "hotshop" earnestly, he explained that the Swedes refer to the area as the "Hytta," meaning foundry, while Germans call it the "Hütte," meaning little hut or cottage. His approach to glass is like that—thoughtful, thorough, methodical, and connective.

In American protoindustrial glassmaking, "shop" refers to the "shop system," a division of labor that distributed production across multiple workers, subjected glassblowers to the principles of rationalized production, and diminished their autonomy, as introduced in chapter 1.[8] There, the issue was the glory hole—the portable furnace of individuated fire that allowed unskilled workers to labor outside of master-led teams. "Hotshop" is connected to the place of the "shop system"—a hot methodology intertwined with a division of labor. The nomenclature of "studio" in many artistic communities, including glassblowing, preserves and perpetuates the idea of individual intentionality, allowing artistic claims to authorship. In practice, however, glassblowers inhabit sets of relations choreographed as teamwork: the heat, roaring furnaces, handwork, sizzling and steaming tools, equipment, working properties, sweat, bodily capabilities, and more variously come together as the "hotshop." In the hotshop-studio dyad, the haptic space of making is circumscribed by the studio, imagined as independent of the hotshop processes constitutive of it; it enacts a social order in which the perception of the artist's intentionality and autonomy can reign. In order to better understand this dynamic, the significance and changing meanings of the hot relations therein, and its import for

theories of embodiment and practical knowledge, I will explore and unpack teamwork.

TEAMWORK: THE CHOREOGRAPHY OF PRODUCTION

In 1854, the American glass manufacturer Deming Jarves was struck by an unknown seventeenth-century writer describing teamwork: "The work passes through three hands. First, the gentlemen apprentices gather the glass and prepare the same. It is then handed to the second gentlemen, who are more advanced in the art. Then the master gentleman takes it, and makes it perfect by blowing it." Of this description, Jarves wrote, "Every glass-maker will perceive . . . that the same system prevails at the present time."[9] Four hundred years following the unknown writer's observation, when I landed my first assistant job on a glassblowing team, it was led, much as both the seventeenth-century writer and Jarves described, by a head glassblower, Oren, and teamed by two assistants in addition to me.

Although teams could be upward of seven or more people, teams at New York Glass are typically, like centuries of preindustrial teams, of two or three people and are led by a "gaffer," which broadly means "boss."[10] Gaffers direct assistants, shape the glass while seated on a workbench, and are regarded as the center of the game. In *Advanced Glassworking Techniques* (1997), the glass artist and educator Edward Schmid notes that gaffers "call the shots" and that "their wishes should be obeyed and carried out to the best of everyone's ability."[11] Unlike the gentlemen of the unknown writer's and Jarves's descriptions, who were likely *maestros*, gaffers at New York Glass are not necessarily masters of their art, since, in the studio context, which places

FIRE AND SWEAT ⁓ 95

hot glass in the hands of amateurs, the gaffing experience is available to all.

Oren, a professional glassblower with extensive training, was known for "working big." Both in the bench and out, he worked hard. His hands seemed to be constantly moving and could be found brushing his mop of hazel hair out of his eyes of kindred color, pushing up the bridge of his heavy glasses, polishing his finishing pieces, or packing up his wares to ship to clients. He'd often have paper and pen, checking lists, following a syllabus, or taking notes. Sure, "blowing big" is about personality differences in the hotshop, of which there were many. But, "blowing big" is also simply pragmatically part of the work of "incalmo" vessels—a technique in which two or more blown-glass elements are fused, which unambiguously demands teamwork for production. Oren excels at the technique, and he's a master of color. His incalmo vessels that day required that two bowl-like vessels of contrasting colors, each also made of multiple layers of color, be joined. Since two vessels are simultaneously needed, so are two glory holes, two benches, and at least two assistants, so neither bench would be without an assistant at any given time. His work was a big production, each vessel taking far more than an hour to produce.

On the day of work, I arrived early. Oren was already there, setting up both workstations with the required tools and equipment. In addition, he hooked up blowtorches and air hoses; it was critical to keep the *moile*—the rounding continuum of glass extending from the end of the blowpipe to the vessel—warm. In the initial gather and bubble, the *moile* and vessel are one. But in the formation of the vessel and its preparation for its transfer to a punty, the glassblower uses the jacks to squeeze that area, creating that valley with a centered line at the bottom on which water will eventually be dropped to knock off the

96 ⁊ FIRE AND SWEAT

piece. The tepid water shocks the hot glass, creating a fracture line along which the vessel can then "break off" the blowpipe. There are many etymologies of *moile*, but its resonance with the Jewish *mohel* (pronounced "moil"), the one who circumcises, is apropos. During the production process, the *moile* must remain warm so that the object of production does not pop or crack off prematurely. Sometimes a hot gather of glass is added around the *moile* to warm it. More often, the blowtorch is used to warm it when a vessel requires a good deal of time in the bench to be shaped. In this way, the blowtorch, along with the air hose, is used to regulate the heat of *moiles*, punties, as well as areas of the vessel of production (opening the lip, for example). Jarves and the seventeenth-century writer explicitly described the team of the choreography of production—the master and his assistants—but no doubt recognized that the heat assisted them all.

It was midsummer in New York City, which will immediately convey a visceral feeling to anyone who has been there at that time: hot, muggy, and sticky, with a layer of grime. Our team would manage not only the heat of the furnaces and glass but also of the day. Although it was only morning, the studio was already thick with humidity. I could feel it in my clothes and body, hair buoyant and escaping the tight bun at my neck's nape. Sweat broke from my temples, and my cotton jeans and T-shirt were already tacked to my body with weighted dampness. After putting pipes into the warming rack, I searched for the studio's fans, found them, and dragged out long extension cords to power them up. Though only blowing warm air, they nonetheless provided some relief. Paul arrived with his typical bodega coffee from Tommy's, in a blue and white paper cup emblazoned with Grecian columns and the pleasantry "WE ARE HAPPY TO SERVE YOU," wearing baggy shorts and a

T-shirt. I thanked him again for recommending me to Oren. Paul knew that I really wanted to learn, appreciated the limitations of doing so when only enrolled in the evening classes, and understood that working for a team was one of the best options for learning how to blow. He was giving me the "break" that I was hoping for, just as someone had done for him, just like good mentors, broadly speaking in studio glassblowing, do for those who want to learn. Grateful in a myriad of ways, but mostly to be invited into the camaraderie and production of their close-knit team, I was excited with anticipation and hoped that I could deliver.

Zach arrived soon after that, with his typical five o'clock shadow and black rectangular shades. All assembled, Oren took us through the day's game plan. Paul and Zach were the main assistants and expected to blow, assist with the handwork of gaffing, and gather. I was hired to "work the doors" of the glory hole, the hottest job (my jeans were for protection). Some glassblowers prefer quiet assistants who do not talk; others like those with good banter and trash talk; most want those who are helpful, considerate, and good at what they do. In addition to competence, in this case, the ability to tell good stories and jokes, preferably funny ones, was welcomed.

BLOWING AN INCALMO VESSEL

Paul was hired as the first assistant to start the bubbles for Oren to gaff. To gather, Paul heated the blowpipe, approached the furnace, and slid the furnace door aside, releasing its roar, fire, and heat. He extended the pipe over the sill of the opening, lowered its tip into the molten glass, and, playing on the ability of glass to grip itself (its viscosity), rotated the pipe as the glass

mounted on its heated end. Known for his strength, Paul was a workhorse who could heft and schlep fifty pounds easily. He could "gather big"—a skill that takes years to do proficiently (and, even then, can always be improved)—was broadly skilled and knew how to assist others in realizing their visions.[12] This combination made him an asset to many, not to mention his amiability and all-around good cheer. Paul withdrew the large gather needed to start an incalmo vase and carried the molten orb to the workbench to block.

Blocking uses a tool by the same name—a block—which, made of fruitwood, typically cherry, looks like a roughly hewn ladle. Sitting on the bench, Paul rolled the pipe back and forth over the steel arms, which extended outward just beyond arm's length from above the wooden bench seat, with his left hand while using his right hand to cup the gather with a large block that shaped the glass. He cupped the gather with the block like a palm, its wet wood changing the opaque molten red gather into a clear, eggplant-shaped orb. Having "skinned" the molten glass, that is, cooled the outermost layer and set the shape, he popped the bubble. Lowering the capped end of the pipe and raising the now-translucent orb before his eyes, he watched the air expand in the center of the hot glass, carving the cavity that would become the vessel's interior. As Paul prepared this bubble, Oren did the same for the second bubble. I alternately opened the furnace door, which I had learned to lift slightly as I slid it open to avoid it catching on uneven track parts, and handed them blocks.

Meanwhile, Zach prepared the colors—orange, white, blue, brick, and crimson. I knew Zach surfed year-round at Rockaway Beach; he both went with the flow and was sharply focused on building his career and work as an artist. He was once asked, for example, to make the centerpieces for the studio's

FIRE AND SWEAT ∞ 99

annual gala—an accolade. Zach's preparation of color involved a raised fire-fed box with two arched doors—a "garage"— where chunks of color from a color rod (imagine three-to-five-inch pieces cut from a solid, foot-long, inch-and-a-half-thick bar of colored glass) are warmed. First, he gathered with a punty from the furnace to make a "collar" (a ring of glass around the end of the pipe) with which to "pick up the color." Turning to the marver, Zach then rolled the glass back and forth, swaying as his left palm undulated in waves and his right hand rotated the pipe and buoyed the malleable hot glass against the cold steel of the marver. When some people marver, they might as well be lulling a baby to sleep in a hammock; when others marver, they might as well be parking a car with a flat tire. Zach belonged to the former group. His light touch not only minimized the loss of heat—steel steals—but also ensured the gather did not become lopsided. While the viscosity of hot glass allows it to be gathered, its malleability allows it to take on innumerable forms. With the cool steel, Zach marvered the glass into a flattish, mushroom cap–like collar, warmed it, and picked up the color, which meant touching the warmed collar to the warmed color chunk in the garage. Warm on warm, they tacked together. He then took the ensemble to the glory hole to heat.

Back at the first bench, Paul called out, "Blow!" I squatted to the level of the pipe's mouthpiece, extended over the left arm of the bench, and blew while watching the cavity expand. He rolled the pipe back and forth over the bench's arms as I blew and sculpted the glass with a folded wet newspaper that lined the palm of his right hand, sending up streams of steam and smoke. When the bubble lost its hot glow—color is seen, felt, and smelled as temperature—he yanked the pipe from my mouth and returned to the glory hole for heat. The gentle yank

as the assistant blowing is common, and I had come to expect and anticipate it.

After Paul had shaped the bubble and Zach the color drop, they met at the first bench before the larger glory hole, where Zach dropped the color onto the bubble. Imagine an extra-viscous glob of honey dripping from a spoon vertically suspended above a two-scoop ice cream cone. Paul then marvered; with each chilling pass, the red-hot drop smeared over the clear bubble, turning blue. Color, achieved by mineral additives—in this case, cobalt—becomes molten orange-red when heated but regains its mineral color when chilled.

Paul then gathered clear glass over the "color overlay," and Zach prepared and dropped more color onto the ever-growing

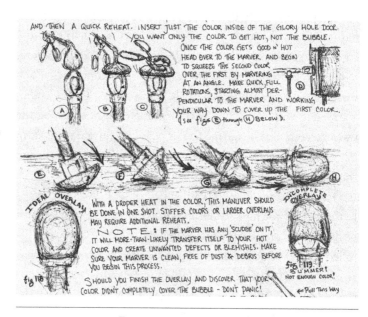

FIGURE 3.1. Dropping and rolling out a color overlay.

Source: Ed Schmid, *Advanced Glassworking Techniques* (1997), 101. Drawing © Ed Schmid.

bubble until enough clear and colored glass had been layered—blue, brick, and orange. A second bubble was in the works, and both were blown to the size deemed suitable by Oren. Large, like watermelons, the bubbles had exceeded the aperture in the center of the glory hole, formed by a half-moon shape opening at the inside edge of each door.

Typically, the least skilled person on the team, such as me, is given the job of working the doors of the glory hole. To open and close the doors, which are too hot to touch with bare hands, I lassoed a steel loop at the end of a long pipe over a peg welded atop the inside corners of the steel frames of the doors and pulled to open and pushed to close. Working the doors of the glory hole, fired to 2300°F (1260°C), is grueling: One stands just to the side of the barrel furnace of fire with only the glory hole's doors, the cotton of one's clothes for protection, and, depending on the access needed to the glory hole, the steel-corrugated shield. For large pieces like Oren's that require large glory holes and for the doors to be repeatedly opened and closed, it is especially grueling. As I worked the doors, Paul blew, and Oren finished shaping the bubble against the burning ash of the soaked newspaper while the sweet smell of honey wafted from the touch of the hot steel tools against the block of beeswax atop the tool table. With the two largest glory holes in the hotshop ablaze, we were thick in heat, swirling, arcing, and turning among one another, the hot glass, and the tools and equipment. Given the day's humidity and high temperature, the hotshop was downright swampy. Sweat poured.

An hour into making the vessel, however, the dance had only just begun. With the bubbles blown up (the first stage of blowing a vessel), we moved on to the second stage of vessel making—opening up the bubbles and making them into deep, bowl-like vases. Once the bowls were achieved, the defining

102 ❧ FIRE AND SWEAT

moment of making an incalmo piece had arrived: fusing. Oren, seated, called out from the bench to both Paul and Zach as they heated the bowls, "Ready?" Both nodded and immediately brought the pipes with the warmed bowls at their ends to Oren's bench. Paul set one down on the bench arms, which Oren took hold of and began to rotate, while Zach served the other to the right of the bench. Oren, who had donned a heat-resistant metallic sleeve and was blowtorching the bowl of the pipe resting on the bench arms, asked me to "shield" him, that is, hold wooden paddles between his forearm and the radiant heat of the rotating vessel. Setting the torch down, he grabbed the served pipe with the tweezers in his right hand and drew it toward the first bowl, each bowl constantly rotating. Ruddy-faced and sweating profusely, he grimaced and winced as he leaned over both bowls, the rims of which now almost touched. I could see the heat waves around the bubbles, blurring space. I felt my skin singe and struggled to inhale the burning air as I shielded him. Tears streamed from my eyes and down my cheeks. The situation was searing. Gloriously. With a concise pull, Oren touched the rim of the rotating served bowl to that of the one rotating on the bench arms—an eternal kiss from which neither could withdraw. Released of the main pipe, the two bowls, now fused, had become one bubble.

I dropped the paddle onto the bench, ran to the glory hole to throw open the doors for the fused bubble, and continued to lasso the pegs, opening and closing, as they shaped and opened the bubble, flattening it into a wide, hollow disc that required that I leave the doors fully opened as they heated. Having never worked on a team, the intricate work between two benches was dizzying, as I noted in my fieldnotes that night—the sounds, scents, sensations, and the total inhabitation by, within, and of heat. I loved it. When Zach finally carried the finished vessel to the kiln, where

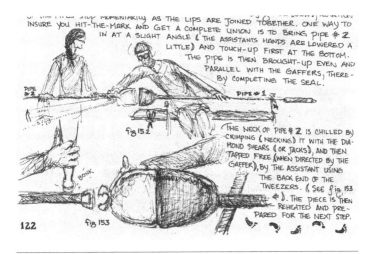

FIGURE 3.2. Assistant serves the second bowl to the seated gaffer, who attaches it to the lip of the first bubble.

Source: Ed Schmid, *Advanced Glassworking Techniques*, 122. Drawing © Ed Schmid.

it would anneal overnight, the relief of all three team members was palpable. We attempted to blow three incalmo vessels that day, but at the culmination of the second piece, the vessel popped off the pipe, and two hours of labor smashed into a thousand shards of glass across the cement floor. Two survived.

OF INTERCORPOREALITY

In 1824, Caroline Harrison toured the Brooklyn Flint Glass Works and noted in a letter to her husband that "every man seems to have his part to perform—they work into each others hands as it were."[13] For Merleau-Ponty, bodies in such collaboration "are like organs of one single intercorporeality"—the bodies belong, as it were, to one another and are of one another.[14]

104 ❧ FIRE AND SWEAT

As Nick, a glassblower whom I once interviewed at a summer school, described: "The dance of it—it really is a full-body thing. The team aspect of it—I love working in a team . . . I love it when you're working with a person enough so that they are doing exactly what you think they should do. . . . But when there is a disconnect there, I think I get pretty frustrated. It's one of those things where you wish that you could be that other person too. . . . When I'm assisting someone, I'm trying to think what they're going to do next so that I can help them."

While the gaffer is perceived to be the one calling the shots, teamwork is, in practice, reliant upon the ability of every team member to anticipate needs, as described in 1997 by Schmid: "A well-honed team understands what each member is doing, and what they are about to do."[15] Proficient production requires that the team members inhabit and extend themselves through one another's bodies in unison, contributing to the oft-repeated association of glassblowing techniques with a "choreography," that writing of a dance. I needed to serve the block as Paul reached for it, and Paul needed to take the color as Zach dropped it, and Oren needed to slide the bubble into the glory hole as I opened its doors. For the anthropologist Thomas Csordas, such corporeal interstices of interaction, wherein persons experience themselves as extended in relation to and interaction with one another, constitute intercorporeal meaning.[16] This blurring of bodily boundaries distinguishes intercorporeality from an actor network—that "distributed agency" of Latour.[17] Thus, the gaffer's directives and the organization of work according to the production needs of the object become meaningful with practice and among the interstices of interaction.

In this sense, the style of the choreography of production, that is, how the glassblowers interact, shapes the emergence of

the object. Like most days at New York Glass, multiple artists were at work. The three glory holes on the other side of the platform, for example, were variously booked, while those who had blown the day before were there to retrieve and coldwork their pieces. Others were in the flatshop or otherwise. Sarkis was among those there; he was one of the lucky ones, with steady, well-paying work from designers enabling him to produce his artwork. He had witnessed the failed incalmo. Whether from the culture of critique in the hotshop or his personality, which was known for its acidic criticism, Sarkis offered his account of the failed piece: "He doesn't make them [Oren's team] focus enough so that when the moment comes to actually focus, it is difficult, and mistakes are made and pieces are fucked up. A lot of the tempo and synchronicity of the team comes from the mode of communication, actually." Others had things to say about Sarkis and his various teams and assistants. No one was above or immune to this daily "crit." For Sarkis, Oren's team was "out of control." Different teams have different working styles, and Sarkis's crit was his opinion. For his part, Sarkis claimed to anchor a team's proficiency and focus in their attunement and ability to "follow the glass." Intercorporeality is not only about teamwork—a collaboration among people—but also about nonhuman bodies, notably the hot glass, the heat.

In the hotshop, the hot glass extended itself toward us— needing to be turned, heated, cooled, opened, etc.—as often, if not more so, than the hand of a teammate.[18] This gestures toward what I have previously written about as the "matterly constitution of culture," namely, the constitutive play of matter in language, affect, and social relations.[19] For Sarkis, glassblowers only became proficient with becoming "intimate" with the glass. The heat in glassblowing can be savored in visual reverie, as in the case of the globlet swimming in the glory hole, but it

must become part and parcel of practice to contribute to proficiency. Working once with Noah, for example, it was the *heat* of his technique that I had found striking. I wrote: "I have never seen anyone work this hot. There seems to be some imperceptible moment when the piece actually becomes the form—until then, that orange luminous glow is never lost, is steadily maintained." In contrast, my attunement to the heat while working for Oren could stand some improving.

Without knowledge of the heat required to blow an incalmo, for example, I did not always anticipate when the doors of the glory hole needed to be opened, leading Oren to regularly bark, "Open!" Once, I opened it too slowly, and the vessel touched the glory hole door, taking with it a chunk of its insulation lining, which Oren then had to cut out. Oren knew I was a beginner and would be learning while doing, hence the work-for-experience-rather-than-wage offer. Alongside my shortcomings, Oren also had to cut out unwanted bubbles with which the glass had been forged; professional glassblowers who booked production time in the hotshop sometimes had to work with a "bad" batch of glass. In addition, the largest glory hole's heat, controlled by studio technicians, had been unsteady—at first too cold, then too hot. Moreover, the air hose was not initially working, and the propane tank of the blowtorch ran out, so the malleability of the glass was inconsistent. On some teams, banter took precedence over tending to the glass and antics—including some people's heavily callous-enabled ability to slap a fresh gather of glass from the furnace barehanded, which required rounding out the slap mark, adding an extra step into the production process.

Considering this, blowing the incalmo vessel is less an expression and realization of Oren's intentionality than it is an intercorporeal adaptation of human and nonhuman bodies: tools as waxed tools, waterlogged tools, smoking tools,

fire-torching hoses, air-cooling hoses; equipment as open doors, closed doors, full tank, empty tank, hot kiln ready for annealing; bodies as blocking, sweating, turning, blowing, rotating, sitting, squatting, burning; hot glass as dripping, shattering, expanding, imploding; furnace heat, glory hole heat, molten glass heat, hot tools, hot skin, hot air, hot roar, hot color. It's in and with intercorporeality—the hot relations of the hotshop—that work like the incalmo vessels emerge.

OF INTRACORPOREALITY

The following day, Oren would not blow hot but instead retrieve the annealed pieces and, at some point, coldwork them—a practice of cutting and polishing at which he excelled. Not all glassblowers coldwork their hot-blown work. Not because the work doesn't require it. Most do. But they choose to hire it out instead. Paul, Zach, and I had no object to retrieve. But what we did leave with, as did Oren, is the heat. In *The Psychoanalysis of Fire* (1964), Bachelard concisely jots, "Heat penetrates."[20] Nowhere was this more obvious than in my fieldnotes from that evening:

> When I left the studio, I felt unsteady and weak. I was utterly exhausted. Although I drank my 1.5-liter bottle five or six times during the course of the day, I still felt thirsty. Could barely stand for the bus. Could barely stand on the bus. Held onto the handle on the back of one of the seats, just wishing that someone would stand up. I wanted to announce, "I'm tired. I've just been blowing glass all day. I've been standing in front of a glory hole that is over 2000 degrees Fahrenheit. My feet are tired. My mind is absent. Can you please get the fuck up for someone who has

worked and is tired and needs the rest, for someone who would appreciate it so much?" . . . I closed my eyes at one point, holding tight, and swaying with the rhythms of the bus. From the bus, I dragged myself up the stairs to the apartment, opened the door, came in, dropped my bag, and immediately started to take off my clothes. . . . I literally peeled off my pants and underwear, stuck together with the salt and dampness of my gum-arabic sweat. I could hardly manage, losing my balance as I stepped on the bottom of one pant leg to leverage the other leg out. I peeled off my T-shirt and unclasped my bra—it remained just as firmly in place as when it was clasped. Glued. I wedged my fingertips between my flesh and its cotton and pulled it outward and off. Everything was damp or outright wet; the back of my blue T-shirt was patterned by cascading white salt deposits. . . .

I had been sweating for over seven hours solid . . . I wanted to fall into bed, but went for the shower. The running water elicited an uncommon moan—the physical exhaustion. I could feel the water loosing the crusted salt of all the sweat, could literally feel the weighted crystals rolling off. My hands were so dirty that I didn't even want to wash my hair with them. I soaped up my scrub brush and scrubbed them for a long while and let the water run over me for an even longer time. I washed my hair twice. Out of the shower, I brushed my teeth—my mouth scummed-over with soot—slowly foaming up the anise paste with warm water. I came back into my bedroom, pulled back the covers off of the bed and collapsed. That's when the thunder started ripping outside and I felt so at home, and exhausted, and worked, and in my body—drawn in, or downwards, into the bed, by my own fatigue.

Contemplating "thermal delight" in 1923, W. H. Auden wrote of a "great financier and millionaire who, when his day's

business was done, would shut himself up in a room scared from intrusion, where, throwing off his clothes, he would lie naked on a rug before a huge fire and soak himself in the heat for an hour or so," claiming it to be "his chief happiness in life."[21] For Bachelard, this "calorific happiness" comes from "inner heat which always takes precedence over a purely visual knowledge of light."[22] Yet unlike the millionaire who basked in heat at leisure to fulfillment, I had been penetrated by heat beyond what my body could assimilate. I had been so hot and sweated so profusely that my body had become viscous like the hot glass, tacking to itself, to my clothes, gathering every dust fleck into ridges carved across my skin by currents of sweat. I had been so imbued by heat that I had begun to vitrify, that is, to become glassy, producing crystals large enough to be felt falling from my body under the shower's waterfall.[23] With this vitreous metabolism came an intimacy with hot glass that I had not yet known. With that intercorporeality arguably came intracorporeality.[24] The glassy state was shared as becoming hot, as vitrification.

The contemporary feminist, philosopher, and physicist Karan Barad posits that there are no independent objects with ontologically inherent boundaries and properties, only phenomena that are the entanglement of intra-activity, emergent and co-constitutive with materiality.[25] Building on Barad's concept of intra-action, intracorporeality captures the calorism at the heart of becoming a glassblower, becoming glass, and becoming hot. To acknowledge this is not to "democratize" a human social world by "invit[ing] nonhuman entities into [it]" but rather to theorize from constitutive material agency.[26] Writing for the environmental humanities, Stacy Alaimo's concept of "trans-corporeality" points to the "interchanges and interconnections between various bodily natures," such that the human is reimagined "as always intermeshed with a more-than-human

world."[27] Heat has long been considered a dynamic of *transfer*, from *trans*—"across, beyond" and *ferre*—"to carry."[28] At the same time, the intimacy of vitreous metabolism, of becoming glassy, of heat so deep and thorough that I began to vitrify, points to becoming anew from within.[29] This immanence is not "between" or "across" preexisting bodies. Intracorporeality, emergent and immanent, appears new—a "line of flight," forced to strike up new association.[30] Becoming a glassblower, that is, is not simply about "heating the glass" in order to manipulate it but of becoming hot; to think and act like a glassblower, any-*body* must be hot.

The intense reality of the heat in glassblowing was a deal breaker for many. In Paul's Intermediate Glassblowing class with Diana, he counted us one by one before the start of class, noting an absence: "So, who's here? Or, who's not here? There are six of you." He counted us again as two more students hurried into the circle. Paul realized that the missing student was the young woman who had been overwhelmed by the heat the week prior. "Hmmm," he worried, "I think we scared her off the first day." In my fieldnotes, I described her speaking of the furnace as an "airless tomb of heat" into which she felt like she was "falling" when gathering. In my Beginning Glassblowing class the year before, a woman was "scared to pass out [from the heat]" since she was "on antibiotics." Many students—whether my classmates or those I later served as a teaching assistant— "couldn't take the heat." They became dehydrated and suffered heat exhaustion even though they drank plenty of fluids and used the protective corrugated steel shield between the glassblower and furnace or glory hole as a buffer. I consistently wrote of the heat, the sweat, the blazes, being scorched and burned, thirst, deep slumbers following a day of wage work in the hot shop, but, notwithstanding, the deep pleasure of becoming hot, penetrated to the core by heat.

CAN YOU TAKE THE HEAT?

Paul was a profuse sweater, with beads constantly falling from the brow of his flushed, freckled face. Despite this, he explained with a beaming smile, he could "blow glass all day and night." Paul was one of the people whom Noah described in an interview as "constitutionally very easy or confident around [the hot shop]." For Noah, this was critical to learning to blow glass in a productive way:

> If you actually said that you wanted to teach glassblowing in a way that would lead to productivity or whatever and you wanted to actually encourage people to do that, the first thing that you would do is either do a bunch of activities to get people comfortable with the situation of the noise and the heat or do the converse, try to scare the hell out of everybody so that most people would leave . . . or you do things where you would make people watch a very small part of the process repeated like, let's say, a thousand times, literally a thousand times, and then try it once, do it ten times—and then have them watch it a thousand times again and do that motion ten times.

Noah's comment, couched in the context of developing proficiency, starts with the heat. Here, we might consider heat's inoculation as a primer without which the novice cannot learn.[31] Heat, if you will, is the radical immanence of the glassblower's art; you're either hot or you're not. At the same time, Noah "can't divorce the process of learning from the goal." When comparing how people learn to blow glass at New York Glass versus how it's normally done through work and apprenticeships, he surmised that "the only thing in common is that the glass is hot—the classes are different, the goal is different, the kind of people are different, how they learn has no relation at

all." Intercorporeality allows for an understanding of heat as an expedient of production (choreographed according to the goal); transcorporeality gets at the transfer of heat across bodies; intracorporeality centers immanent becoming, the calorism at the heart of glassblowing. I was hot. The glass was hot. The hotshop was hot. We were all hot. This demanded that I learn to think and write hot, be hot, tracing the becomings thereof and therefrom.

Understanding the play of heat's immanence and its harnessing helps explain the hotshop-studio dyad. As Hattie, a contemporary glass artist, told me: "What I do in the shop is one thing, but what I do in the studio is another. They are in dialogue, but they're different. As I gain knowledge about the material [in the hotshop], it becomes more evident how I want to use the material." For Hattie, this back-and-forth between shop and studio was mutually definitive, yet the studio had the final word: "After five or six years, I'm finally actually making the work that uses the hotshop in a way that I like." This stratification, based on notions of subjective intentionality and artistic "work" in the studio, does not dilute the fact that everyone who puts in a full day at the hotshop gets thirsty, often adjourning to the tavern around the corner. In the hotshop, every-body bore and was borne by the heat.

HOT MESS

Weeks later marked the last night of our class with Paul and Maureen. Diana had been out in the day to pick up the gifts: a pedicure/manicure for Maureen, a bottle of vodka and a book on the history of video games for Paul. Diana presented them with her mirthful smile at the beginning of class on behalf of all

of us. We had each chipped in about twenty dollars—a significant step up from the last class, when we had given him a box of tea tree oil toothpicks. We blew glass with music in the background. Music, as a rule, was not allowed, but the studio's holiday party was happening at the same time as our class. Diana and I danced as we gathered from the furnace and blew at the glory hole, etc.; the music made the rhythm implicit in glassblowing audible. Diana wanted to stop blowing at 7:30 pm so we could join the party, but it didn't turn out that way. Quite the opposite; we finished after nine o'clock. In celebration of our last night, our class decided to head to the local tavern, where, as it turned out, people from the holiday party were also going. It was a blast: a late night, a late morning, and an even later afternoon. The following day, we are all, laughingly and with some regret, a hot mess, connected in ways that did not necessarily align with that day's blowslot goals.

4

BLOW

Time, Space, and the Vessel

One sometimes discovers an old flask which remembers
And from which springs forth alive a returning soul
—Baudelaire, *Les fleurs du mal*

D iana went first. I hung out along the bench opposite
the side where she would be shaping the glass. When
she had finished warming the glass at the glory hole,
I squatted so that my mouth was level with the end of the blow-
pipe, which she had now begun to roll back and forth across the
arms of the workbench. We had booked practice time. In addi-
tion to honing our skills, we were nurturing those other out-
comes of daily life in the hotshop: camaraderie, community,
and futures. I was close to the pipe's opening and could smell
the aroma of old saliva and metal lodged in the channel. There
is the English Channel. The Beagle Channel. The Great Bras
d'Or Channel—famous straits between two land masses in
close proximity. All call for a crossing, a transfer between bod-
ies. The glassblower's blowpipe ferries no less. Yet, far from
bridging ground, it spans cavity to cavity, breath to breath, air
to air. Never landing thing-like but always diffuse and ambient.
"Ok, blow," said Diana in her melodic voice, resonant with

query and pursuit, as she attended to the "shoulders" of her bubble—that area nearest to the moile that needed to be rounded out and later opened up into the cup's lip. Moving on from the drunken sailor cups, she was now working on martini glasses. Even having considered Zach's counsel to think beyond cups, we continued to be focused on "the basics," with slight flourishes. I inhaled, drew back my lips and tongue slightly, and, coming onto the mouthpiece, enclosed the tip between firm lips. I'd been playing the alto saxophone for seven years, so the firm enmouthment of the blowtip seemed familiar. I blew as she began to shape the bubble with the newspaper.

Far from the image of a ruddy red-faced man with giant puffed-out cheeks, I blew with less force than one would use to warm cold hands on a winter's day. It was not unlike the measured breath of saxophone playing. I could feel the crevices carved into the hard plastic mouthpiece from years of wear and tear course over my lips as Diana rolled the pipe back and forth. I wished that the class used blowpipes like those of the professional glassblowers, which had tapered metal mouthpieces. They were smooth and seemed less likely to house germs. I wondered when the last time this mouthpiece had been cleaned and thought of the girl who had returned to the second day of class crying, with a giant cold sore on her lip. Paul had apologetically shrugged and said, "Sorry"; there was nothing he could do. She left and never came back. In the early 2000s, there was no systematic or even informal disinfecting of blowpipes in the hotshop, and the flu, common cold, and what centuries ago was known as the "glassblowers' disease," oral herpes, circulated in the studio. It was not uncommon or considered negligent—it was just how things were, and sharing blowpipes was expected and part of the practice. Today, unlike then, a more stringent protocol is in place.

Diana and I would eventually have our own pipes; she, a stainless steel small cup pipe, and I, a carbon large cup pipe. As we compared the heads, Zach asked us, "So, you guys have never used these before?" "Nope," we both answered. "Well, do you know what you have to do?" he continued. "Nope," we responded in sync again. "You see," Zach said, taking Diana's pipe into his hands, resting the blowing tip on the top of his shoe, "first you have to kiss it and then give it just a little bit a tongue, just like this," he continued, pretending to curtly stick his tongue into the tip of Diana's blowpipe. Skeptically but obediently, we both did as he instructed. "Now next," he continued, "You have to get the perfect gather. If you get the perfect gather on your first try, it's good luck for the rest of the time using the blowpipe." Zach cupped his hands in the perfect little avocado shape of a first gather, whetting my imagination and hope. "Yes!" I thought, "I could do it!" We both failed, having forgotten that it is impossible literally to gather on baby-smooth cold pipes. The baptism, though a hazing joke, is telling; the glassblower tempers the tool with the material for which it is intended. Though a tool of equal import, the breath could not be anointed in kind, elusively entwined as it is with the body's viscerality and the give and take of the invisible.

When learning how to blow glass, directions regarding blowing—"gently," "softly," "harder"—typically ride sidecar to other techniques. In my early fieldwork, I once arrived late to Paul's Beginning Glassblowing class. Everyone was, as usual, gathered around him at the chalkboard on the periphery of the hotshop. I stepped into the group, and Paul's pointer finger, which had been calling on people, immediately landed on me: "After paper and blow?" he lobbed curtly. The question caught me off guard. What came after "paper and blow"? "Uh, heat?" I offered, knowing that "heat" was a sure-fire answer. Paul gave

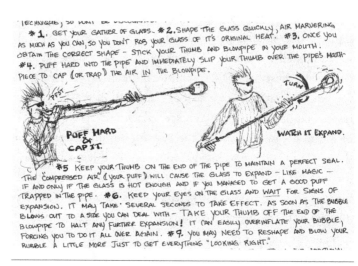

FIGURE 4.1. A glassblower "caps and blows" or "blows and caps" a bubble.
Source: Ed Schmid, *Beginning Glassblowing*, 85. Drawing © Ed Schmid.

me the patient look of a teacher who expects more from his student and moved his finger to the next person. "Block?" she ventured. "Yes," he replied, satisfied. I was tardy and deserved it. He continued to move his finger in a clockwise motion around the group until the proper six steps were elicited: block (heat), paper and blow (heat), marver and blow (heat), hang the neck (heat), paper and blow (heat), repeat paper and blow. "Of course, heat follows each step," he admitted. "It doesn't count as an answer." Heat commences every beginning, is part of every step, and even concludes the piece—the final flash in the glory hole, for example, and the overnight electric bath in the kiln. Paul sketched the techniques on the chalkboard. "So, there you have it," he surmised. If we were able to execute the steps, we'd have a "nice round sphere."

It is not always a blowpartner or assistant who blows. The gaffer often gives the glass a "short puff" while working in the

bench or pops the starter bubble using the "cap and blow" method (fig. 4.1). "Cap and blow" involves capping the blowpipe pipe's tip with one's thumb, having just puffed into it. An anachronism, "cap and blow" is actually "blow and cap" and happens after skinning the bubble.

> I then drew the pipe up to my mouth, put the mouthpiece, with my thumb over the hole into my mouth, drew my thumb open, parallel to my tongue, and blew tersely, heartily, immediately capping the hole of the mouthpiece with my thumb still in my mouth and withdrew it, letting my right hand fall downwards to my right hip, using the left palm as a rising cradle to bring the now-forming bubble up to eye level—all the while turning, trying to get the bubble to shoot out straight. . . . With the bubble lowered closer to my eyes, I watched it expand, and as it reached the skin of the gather, I uncapped the back of the pipe and let it swing down, extending the bubble, or rather elongating it, with what heat remained in the bubble. This whole thing—the two gathers, the marvering, the cap and blow, and the swing all happened, I'd say, in less than two minutes.

When the thumb releases, the trapped air is no longer forced into the bubble. Blowing works in tandem not only with handwork but also with the entire body-as-posture. For example, in Zach's Intermediate Glassblowing, he advised Diana to steady her body while heating the glass at the glory hole. "You have to remember," he said, "that everything you do with your body back here reaches the glass up there. So if you're jerking it like this," he continued gently, bouncing the pipe up and down, "that makes its way into the glass and creates stress." "You want to feather the glass," he continued. He took her pipe and slowly "feathered" the cylinder by taking it in and out of the glory hole.

"This," he said, indicating his torso, "has to be steady," and took a deep breath. Glassblowing instructors routinely coach their students with the word "steady," which, while directly referring to handwork, indirectly refers to the entire body. The breath, like in yoga or military training or any craft that requires focused attention, supports glassblowing postures.[1] I wrote of this similarity in my fieldnotes: "Like in yoga when the instructor constantly reminds you to breathe mindfully and pay attention to the breath. This loosens the breath and creates a more mindful bodily presence whatever the goal may be." Our attention shifted. We didn't discuss the steps of blowing a "nice round sphere" but rather tried to relax using the techniques to avoid "stressing" the glass.

Given the blowpipe, the work of a glassblower, though not all glassmakers, is, to some extent, inevitably a vessel. Thinking through my work in the studio, I once lamented my "inability to escape the vessel!" Glassblowers are defined by blowing. The words "breath," "blow," and "air" were written hundreds if not thousands of times in my fieldnotes, but the breath—air—in which all human activity is immersed rarely appears in theories of embodied and practical knowledge. In this sense, the anachronism of "cap and blow" versus "blow and cap" is telling; the breath, that is, is denigrated.

ASPHYXIATION IN THEORIES OF EMBODIED KNOWLEDGE

In the contemporary *New Oxford English Dictionary*, "body" is defined as "the physical structure of a person or an animal, including the bones, flesh, and organs," or as "the trunk apart from the head and the limbs." This definition conveys more

than the meaning of "body": It conveys a way of seeing and understanding. To define the body as including the bones, flesh, and organs means to define the body according to what is observable, whether via the naked eye, X-ray, microscope, or scalpel. Moreover, this is often taken to be the "aim, central, or principal part as distinguished from parts subordinate or less important." Our sentient and experiencing bodies provide us with firsthand knowledge; the body is understood as the "physical or material structure or frame of man"—stuff that can be seen and touched and at hand for scientific inquiry.[2]

In the social sciences in the nineteenth century, the ethnologist Mauss, famous for his work on gift economies, placed the body on the agenda of inquiry with his seminal 1935 essay "Techniques of the Body." As referenced in the discussion of embodiment and phenomenology in chapter 2 on skill, Mauss's essay approached the body as a site of social and cultural training, arguing against an evolutionary framework. Rather than attribute differences to innate capabilities, ethnology analyzed cultural practices outside of Europe with the aim of achieving comparative understandings of civilization and modernity.[3] Mauss advocated for social science to create a rubric to explain bodily differences causally.

If accepted as the first and most important site of the "education" of the individual, the body became much more than a sum of its natural functions; it was a set of relations—habits, gestures, expressions, etc.—a system of meaning, sculpted by society. Once social scientists had documented the body techniques of a given group, Mauss argued that he could begin to compare groups by using the variable of efficiency.[4] On this account, Mauss's rubric and method of comparison were intended to challenge European ideas of supremacy. Nonetheless, they bore prejudices of the day, including using "efficiency" (a value of

capitalism) to rank achievement among groups of people, cultures, and "civilizations."[5] Studies of the social constitution of the body have moved well beyond this paradigm, constituting an entire field with its internal debates and contributions across many disciplines.[6] Within this diversity, the idea of being "body," however, remains surprisingly consistent. Mauss's analysis of swimming serves as a ready example.

When Mauss was taught swimming as a youth, children were first taught to swim and then to dive with their eyes closed. The generation following his own, he notes, were first taught to dive with open eyes and then to swim. In addition, the breast-stroke had been replaced with forms of the crawl, and swimmers no longer took in and spit out water: "In my day," he writes, "swimmers thought of themselves as a kind of steamboat."[7] What is significant about the analysis of swimming is the emphasis on that fleshy, corporeal body. Even compared to a steamboat, Mauss's swimmer is all body and no breath—of legs, arms, and eyes. In this sense, the air or breath marks the temporality of being body in movement.[8]

This swimmer is revealing. In the endeavor to account for the social and cultural constitution of the body, the body that is read for "training" is the "physical structure" of the person, including bones, flesh, and organs—that which is visceral and observable. This is Merleau-Ponty's phenomenological body, Foucault's disciplined body, Bourdieu's practical body, and Judith Butler's gendered body. Differences in the *corpus* signal cultural variations in corporeal training. The word "corporeal" is often used interchangeably with "bodily," "embodied," or even "practical." Etymologically, however, it differs from these other words insofar as it is not specific to man, animals, and, sometimes, plants.[9] Whereas "body" typically references man's frame or structure—a question of form—"corporeal," from the

Latin *corporeus*, has the added connotations of "matter" and that which is "visible and "tangible." "Corporeality" can characterize man as well as the things that he possesses. Social inquiries into the body and corporeality address the very visible and tangible. This constitutes a robust inquiry—an inquiry into intracorporeality runs throughout this book. However, limitations in the perception of the corporeal in Western thought pose challenges and problems for consequent theories of embodiment and practical knowledge. In the case of the swimmer, for example, the inquiry will address kicking legs, crawling arms, and oscillating torsos but not what is not, to Western thought, corporeally visible or tangible. In this case, air, or the breath, is understood as something incorporeal.[10] But as an avid lap swimmer, I know that front crawl strokes are coordinated from and with the breath, not vice-versa. The breath-air, excluded as incorporeal, serves as the unseen—and untheorized—handmaiden of the fleshy reality of the body, embodiment, and corporeality.

In sociological studies *from* the body, in which researchers practice what they study so as to access embodiment,[11] a small cadre of sociologists has examined how the breath is shaped through cultural practices and contributes to practical and bodily knowledge, for example Brian Lande's study of military training and Michal Pagis's research on Vipassana meditation.[12] Cognizant of the breath as a factor of the body, coordinated, for example, by the swimmer, Mauss points to the work of Marcel Granet (1930), who studied breathing techniques in Taoism.[13] Granet, like Mircea Eliade's *Yoga: Immortality and Freedom* (1954), examines the role of the breath in cultivating character. Yet contemporary inquiries into embodied and practical knowledge, which stem from Mauss and Bourdieu rather than Granet or Eliade, tend to read the breath per the body. In sociological terms, the breath is not analytically significant.

To understand how the breath is rendered within such frameworks, I would like to think back to the "nice round sphere" that Paul directed us to blow. When he instructed us to blow, he did so in tandem with other techniques—"marver and blow," "paper and blow," and "cap and blow." The breath is parceled with handwork or a posture and, like the hands and the tools through which they extend themselves, attends to the glass. As such, it works as a proximal term of practical knowledge equal to the hands: The breath, no less than handwork, is part of the glassblower's *habitus*, as explored in the aforementioned chapter on skill. While the acknowledgment of the breath as a proximal term of practical knowledge and incorporation of the breath into a theory of practical knowledge advances an understanding of the role of the breath in embodiment and culture, defining the breath as a proximal term does not completely capture the meaning of breathing in making.

Unlike the hand, its extension through tools, or other forms of bodywork generally taken to be proximal terms of practical knowledge, the breath neither feels nor presents—as the blowpipe hazing joke readily revealed—like those terms. While my hand feels the glass against the tool through the sentient extension of itself in the tool, the breath has no such sentient experience upon exhalation. It is only the harnessing of the breath by the glass—the inflation—that makes the exhalation (and prior inhalation) known. The breath escapes our typical registers for knowing the body. Had Mauss written his account of swimming *from* the body, intending to access and theorize embodiment, he may have included breathwork. But even Daniel Chambliss's (1989) later study of the achievement of excellence among Olympic swimmers does not once mention the breath, breathing, inhaling, exhaling, or blowing.[14] Yet the heritage of Western conceptualizations of the body renders even an inquiry into

embodiment in terms of visible aspects of the body—the muscles, sinews, and flesh. Unlike the breath, *corpora* in contemporary thought (the Stoics thought all being was corporeal, including air and the breath) can be observed and operationalized within a framework that privileges an understanding gained via observation of effect and visibility.[15] In a corpuscular theory of practical knowledge and embodiment, namely, one of flesh and blood, the breath is read according to that conventionally understood as a material body or physical thing: hands, glass, tools, torso, etc. Air is pervasive, informative, constitutive, and very material in and of itself—it fills my lungs!—but in performance and service to the fleshly, visible world, it remains itself invisible, reminiscent of Newtonian "absolute space" through which all else—the real world of material and humans—moves.[16]

For the French feminist philosopher Luce Irigaray, this is the "forgetting of air" and is the great lacuna of Western thought: "That there is no fire without air, that the meeting with air is necessary for combustion, that something of a 'there is' of *physis* ensures the posing of man as man, without any recognition of this received provision—all this remains unthought." Irigaray continues, "Staying in the appearing, the thinker sees nothing there but fire."[17] In order to remember air, the breath must be understood beyond its role as a proximal term of practical knowledge or embodiment as an expedient of that to appear. Analyzing glassblowing can be a project of remembering air as a condition of possibility.

AUTONOMY AND THE BREATH

The "nice round sphere" that Paul had the class blow was not a perfect sphere. A perfect sphere is a closed sphere. A closed, or

perfect, sphere of hot glass would implode, however. In glass-blowing, a sphere always has a hole, even if small, and is always, therefore, a vessel. Only when a blown sphere has annealed and cooled can the hole left from blowing be sealed with the fire of a torch. This little hole may seem insignificant. After all, in the history of art and craft, it is not the hole that serves as the basis of interpretation and debate but rather the vessel walls. Yet in the history of glassblowing, this hole bears enormous significance; it was the last vestige of the glassblower's claim against the mechanization of his craft.

In 1820, the pressing machine was introduced and employed by the New England Glass Company.[18] "Pressing" used a side lever to press glass around the interior of a mold, eliminating the need for skilled glassblowers, who would fashion vessels in teams led by a glassmaster using a freestyle technique that depended solely on the coordination and handwork of the team members.[19] This technological innovation meant that more highly skilled laborers, largely Europeans, who had been persuaded to immigrate by American glass entrepreneurs, could be replaced by general laborers. Pressing began the shift toward unskilled wage workers.

The mechanization of handwork proceeded rapidly and culminated with the introduction of the glory hole. At the same time, attempts to mechanize blowing continuously failed. According to historians of American manufacturing, the blowpipe remained the glassblower's "indispensable tool."[20] While machines were fabricated to produce wide-mouth vessels by the beginning of the twentieth century, skilled blowers were still needed to blow bottles, which, like Paul's "nice round sphere," have openings too small to be "pressed."[21] Nearly a century following the first successful commercial mechanized glass production, the breath could not be uniformly mechanized. After

numerous failed attempts to design and manufacture a machine that could blow all vessels, M. J. Owens of the Toledo Group invented the "Owens bottle machine" in 1903–1905.[22] Each machine displaced thirteen to fifty-four skilled blowers, depending on the type of bottle produced.[23] By 1920, the entire glassblowing process—gathering, shaping, and blowing—was automated so thoroughly that only one attendant was needed per Owens machine.[24]

The control over their breath, not their hands, was the ground from which the glassblower made his last stand against the mechanization of his craft. Only with mechanized bellows did the total displacement of the skilled glassblower from American glassmaking arrive. The breath was the glassblower's capacity for autonomy and final recourse against the industry. A tool unlike the others in the glassblower's toolkit, the breath is not forged by the maker herself or any skilled craftsman, and unlike the already instrumental hands, which machinists could mimic, the buried breath, engaged by the lungs, managed by the glassblower's sensitivity for the glass, proved challenging to harness.[25] In a corpuscular theory of practical knowledge, the breath is read as a proximal term of practical knowledge within the temporal arc of action.[26] The history of breathwork in glassblowing reveals that the breath is related to more than practice and production: It is the condition of making and autonomy.

Contemporary theorists of craftwork and, more broadly, handwork attribute the achievement of greater autonomy to handwork—an argument with roots in Karl Marx's *1844 Economic and Philosophical Manuscripts*. Through handwork, that is, the objectification of the self, the maker can see herself, others, the world, and her human condition vis-à-vis the object of her production. When it is argued that handwork, in which one has control over both the labor and the object fabricated,

facilitates self-determination and well-being, Marx's labor ontology (man's being is defined and constituted by his labor) finds expression. Matthew Crawford's *Shop Class as Soulcraft* (2009) argues that working with one's hands feels good and delivers a type of satisfaction that the labor of the knowledge economy cannot. Similarly, Sennett's *The Craftsman* (2008) shows how thinking emerges from making and argues that a good society is developed through intelligent hands.[27] In the same vein, Douglas Harper's *Working Knowledge* (1989) argues that repair work engenders appreciation and knowledge of materials and, thereby, innovation and creativity, while Trevor Marchand's *The Pursuit of Pleasurable Work: Craftwork in Twenty-First Century England* (2021) makes the case for the reinstatement of vocational education nationally from the personal experience of woodworking and interviews with woodworkers. The case of glassblowing is no less a story of the relation of thinking to the hands or an account of the self-determination, creativity, and autonomy developed through handwork. That said, the history of the mechanization of glassblowing problematizes an account of embodied knowledge that yokes the breath to handwork. For nearly one hundred years, while handwork was mechanized in the glass industry, the breath escaped. Might not the opening of any given glassblower's vessel—that testament to breath and air—open theories of embodied and practical knowledge to the significance of that unseen?

A RELIC OF BREATH

Finally, months after our first meeting, I was starting my apprenticeship. Corey, Noah's assistant, had called me the night

BLOW ♋ 129

before to confirm that I should arrive by 9 am and that the team would be "blowing balls" that would be assembled into a chandelier for a West Coast art museum. Noah was currently building out a new hotshop in an industrially forlorn neighborhood with a growing art scene—a project with which I was helping. The furnace of the new hotshop was not yet complete ("hot"). Today, Noah had rented a private hotshop in another one of New York City's bygone industrial neighborhoods. Touched by one of those brilliant blue autumn morning skies, the white cement warehouses gleamed. Sun streamed through the quiet streets, radiant and sublime. When I arrived, Noah was there chatting with the studio's owner. Corey was responsible for my work schedule and the pragmatics of what I would do on any given day they might need me. In his absence, I waited and meandered. The private hotshop was small and intimate—a stark contrast to New York Glass. Tools hung from the old factory walls of exposed brick, and the bench, which sat on a platform, seemed well crafted of hardwood and forged iron. That sun illuminating the streets poured through large windows of old cane glasswork. I knew Corey would arrive soon; he bore a responsibility that aged him beyond his baby face of tufted blond curls and soft jowls. A glassblower in his own right, Corey wore multiple hats—assisting in production, coldworking, managing assistants, and being an all-around handyman, technician, and fabricator. He once told me he was a "have a hole, fill a hole" guy. When he saw a problem, he would fix it. Then. Not later. Not tomorrow. Not next week. He got things done and knew how to delegate.

Corey arrived hurriedly with a brown paper bag in hand. Fishing out the coffee and popping its plastic lid tab, he sipped and explained that he had hit some traffic. I'd become accustomed to taking his instructions, primarily concerning building

the hotshop: sweeping, painting, schlepping, washing, filling, hanging, sawing, holding, lifting, and handling a wide variety of buckets, materials, equipment, tools—raw labor that I found tremendously satisfying. He explained that he and Noah would blow the balls and that my job would be tapping off the balls, fire-polishing the crack-off line, and placing them in the annealer to cool: "You have to set them in gently," he said. "If they run into each other using their own momentum, that is fine, just as long as you don't drop them in, then the side that hits will dent in. So after we fire-polish it, just take this little metal thing with the tweezers and see if it fits over them. An engineer in Seattle designed these for the piece."

Before I knew it, Noah had gathered, and we were working. Noah was extraordinarily focused in the bench, and his ability to "work hot" yielded balls in rapid succession. No hemming or hawing. No banter. No antics. "Erin, can you blow?" I knew what it meant to overblow a bubble, and I was scared to overblow his, so I blew softly. "Blow harder," he said. The bubble blew out into a ball, Noah knocked it off, and Corey took it to the annealer. They had a quick conversation about how I should be blowing the whole time rather than knocking off the pieces, as Corey had directed me to do. He adapted quickly. I stayed seated in the little school chair, poised to blow. Again, Noah asked me to blow, and I did. I took in the scene: "How did I get here?! Amazing! Blowing air into the balls, which will become a chandelier destined for the art world!" I blew and blew and blew and not just blew again but breathed and blew, breathed and blew, and breathed and blew. I inhaled to exhale, received in order to create.

My breathwork was breathing Work. Arendt's distinction between work and labor is telling.[28] The balls, caught up in the dynamics, interactions, debates, and meanings of art worlds,

would have a life of their own. Like the carpenter's table, passed down through generations, the balls were not something to be consumed, like a loaf of bread. Blown vessels differ from tables, however. Unlike the table, the blown vessel is a direct and immediate relic of the maker's breath—that tool and condition that did not readily yield to mechanical mimesis.

To read the meaning of the balls in terms of their social life in art worlds would be to focus on the meaning generated from and in relation to that which is visible.[29] So, too, to read the meaning of the balls per the form of the chandelier would be to start interpretation and explanation from the seen. Both ignore the cavity of the form and the possibility of understanding the breath's meaning beyond, aside, or within the more corpuscular aspects of making. Heidegger, whose philosophy was both the target and inspiration of Irigaray's critique—held that the "thingness" of a vessel, namely, that which stands on its own, was due neither to the vessel's walls nor its void but its gathering.[30]

The glassblower blows a hollow with and from her hollow, a bellow-like metabolism of porosity. A blown vessel is not only an object—a thing like the jug that creates place or the table that endures. The blown vessel and blowing lungs are one and the same; body and vessel are not only flesh, sinews, muscles, and tangible matter but also air. The complicity of air, breath, and the body—the radical dependence and collaboration required to be human and alive—is practiced by glassblowing and the blown vessel. I think back to Hattie and Paul's pyrophilia, the centuries of glass tourists fascinated by the art, Allen's college tour that led him to a hotshop from which he never left, and the innumerable accounts of the magic of glassblowing from Pliny, Biringuccio, Neri, and any given contemporary article. This was never just a matter of the furnace's fire,

as the narrator of Stelio and Foscarina's love affair in Murano well knew, but also air. Fire, after all, requires it.

This complicity is not an embodied homology between the glassblower and the blown vessel. For the German philosopher Peter Sloterdijk, "blowing into a hollow" sets into motion the oscillation from which "language, intentionality, and co-subjectivity are born."[31] Blowing balls, that is, practices a birth of culture. It is not only the balls that take up life in a social world. Intertwined with them is air; air is the elemental power to carve and hollow as well as of self-determination and autonomy. The glassblower's breath is unique in this capacity, revealing the shortcoming of a focus on handwork in theories of craft, making, practical knowledge, and embodiment. The vessel practices inner and outer, creating meaning and manifesting difference. This differentiation creates the possibility of perspective and, thereby, that "oscillation" from which culture is born. Deleuze maps this dynamic as time.[32] Through the vessel-dynamic, perspective and interpretation are possible. The breath, or air, is the condition of the creation of the human, of human creation, of interpretation. Arendt ranked the life of politics and speech above that of *homo faber*, the craftsman, but as she realized, the made object supports the life of speech. Arguably, I specify this further: It is the vessel. This is not about recognition or self-recognition—it's not about a dialectic between phenomena, either ideal or material; it's not about objectification via the made object. Remembering air calls attention to the condition of that possibility. Vesselness is heurism; it practices the give and the take, the material dynamic of becoming.

The struggle of the industrialists to master the breath revealed that it was of a different order than handwork or other bodywork. Through interrogating this cue, the glassblower's

breath points to an airy corpuscularness, a hollowness, and its place, quite literally, in the theories of embodied and practical knowledge. The case of glassblowing makes visible the dynamic by which hollowness, air, catalyzes the temporal arc of social life, the temporality of production and making. In the human story—of narrative, meaning, and action—place precedes time.

SHARING A SMOKE

It was finally 8.45 pm, and Diana and I beckoned the students to clean up. I asked Diana if she would share a smoke with me. We had just finished TA-ing Oren's class. It had been a long day; all three of us had been there since morning working production. I'm not—and never was—a regular smoker but felt called to smoke that evening. Many folks in the studio did. Diana got her pack of Camels and, having gotten an OK from Eloise to light up in the tech shop, we headed there and shimmied up onto the welding table from which we could blow smoke up the ventilation shaft. Passing the cigarette between us, we chatted, smoked it down to the camel, and snuffed it out. Oren came in and offered us some chocolate. "You guys are smoking in here?!" he scoffed, smoke heavy in the air. "Man, it's not worth it," he continued. Diana explained that she had asked for permission. "So what," retorted Oren. "If the director or someone like that walked by, you could get banned from the studio—it's just not worth it. You guys shouldn't risk it. I wouldn't. It's not worth it." Oren was looking out for us—he typically did. Even so, I threw my hands into the air with childish indignation, "C'mon man, I never smoke! Let me smoke in peace!" But he was right, and we knew it. We shared some chocolate and chatted about that night's class. Unsurprisingly,

there had been numerous overblown bubbles among the fresh beginners. We slipped off the welding table and left the tech shop and its medley of C-clamps, nuts and bolts, shop vacs, wood, hammers, cabinets of drills, light bulbs, painting supplies, etc.

Diana and I gathered our things and bid everyone goodnight. Outside, the night was still so fresh from the strong wind of the day, and after a day of so much heat and fire, I wanted to linger. "Do you want to sit on the curb and have another smoke?" I asked Diana. "Sure," she said. "Do you want to sit on this part?" I asked, waving my hand at the gray cement curb, "or the yellow?" I continued, extending my hand to our left, where the curb was painted yellow. "The yellow," she responded, "It seems cleaner somehow." We plopped ourselves down upon the curb and lit up a smoke. It felt great to smoke that cigarette, to inhale, to exhale. I placed my bag behind me and leaned back on it, looking up at the sky. It was warm, the wind was blowing, and a storm was on the brink of coming down. We inhaled and exhaled, watching the smoke rise, exchanging the ever-softening filter between our lips. As folks left the studio, we said goodbye to them. It felt great just to be close, to be a friend, to sit in silence, and to smoke.

For some of the drags, we were just quiet, exhaling the white clouds, bellow-like. Other times, we reflected upon different teaching and learning styles—different strokes for different folks. In and out, cycling through the cigarette, each other, the skies. Allen came out of the studio and chatted with us about the warm weather, the wind, and the coat he wore that had been his father's. He was headed to the Q train, and so was Diana, so we stood to part ways and smoked the cigarette down to the camel. Eloise would later roll the dumpsters of glass and debris onto the curb for collection by a private waste company.

And Diana and I would leave the cigarette butt right there against the yellow curb, and tar would remain in our lungs as the smoke mixed with the air from whence it had come.

Turning left at the block's corner, I walked into the wind down the main drag of bodegas, pizza shops, restaurants, and bars. Raindrops began to fall after about five blocks. No matter. I walked anyway. I was ready for the shower—sky or otherwise—ready for something to eat, ready for clean sheets, ready to sleep. I arrived home to my walk-up apartment, where I was one of three renters, each of whom rented a room from two sisters, who were artists, and one of whom lived there too. Biggy Smalls (Notorious B.I.G.) grew up across the street and up the block. Like so many nights after a day in the hotshop, I fell into a quiet, peaceful, deep slumber.

5

QUINTESSENTIAL CRAFT

Cup Making and the Turns of *Mêtis*

Study me then, you who shall lovers be
At the next world, that is, at the next Spring:
For I am every dead thing,
In whom love wrought new Alchimie.
For his art did express
A quintessence even from nothingness,
From dull privations and lean emptiness;
He ruined me, and I am re-begot
Of absence, darkness, death; things which are not.

—John Donne, "A Nocturnal Upon St. Lucy's Day," 1633

I had enrolled in an Advanced Glassblowing class. New York Glass hoped for the course to be a truly advanced course, and registration required approval. I got it, but not without making my case: I explained that though I didn't have as much experience as some of those enrolled, I was dedicated, was working as a teaching assistant, was negotiating a work-study position, and knew that I needed to sign up for practice time. I had procrastinated signing up because of the cost. Seven hundred and fifty dollars was an enormous amount of money

for a self-supported graduate student in the early 2000s. Leah was planning to sign up (she was allowed to take one course per semester because she worked there), and Diana was already enrolled. The gatekeeping caused me to doubt my enrollment, and, seeing Paul in the hotshop, I solicited his advice. "Do you think I shouldn't be in the advanced class?" I asked. "I kinda got a hard time about enrolling." "Listen," he said, setting his toolbox on the marvering table next to me. "You're just as good of a glassblower as anyone in that class. Diana might be a little ahead of you, but you're going to be fine." "But," he continued, "You'll have to be more dedicated than you are to my class. You'll have to come in for at least six hours of practice a week." It was the first time that Paul had advised me rather than instructed me. I was surprised that I wasn't "dedicated enough" in his class, but it also felt great to know that he had confidence in my abilities, that I had learned from him, that I could take what I had learned forward, and that I could manage the advanced class with practice. His eyes are the crispest blue and were typically hidden behind sunglasses as we worked before the glory holes; looking at him directly, I noticed their piercing clarity. He knew my skill level well, and I trusted his counsel.

Advanced Glassblowing proved challenging—more challenging—than I could have imagined. Diana fared better than me—her practice typically exemplified minimal effort, whereas mine tended to involve maximal force. I tended to try too hard rather than let it flow. On the evening toward the end of the semester, I arrived late, having been at a conference earlier in the day. With a reliable seventy-five-cent peanut butter and jelly sandwich from Tommy's in hand, I threw down my bag. The demonstration was underway. Allen was assisting, elucidating as the instructor blew, "See how he is . . ." he began to explain. I kneeled behind Diana, seated on the floor. It was

our spot for every demo; we could see the instructor's hand, the tool, and the glass—up close—through a small triangular window created by his torso, outstretched arm, bent at the elbow, and the pipe and piece. I tapped her on her back. "Hey," she said, looking over her shoulder, "You look great. How did it go today?" "It went really well, thanks," I responded. "What are we doing?" I asked. She picked up her little notebook from the floor and showed me a sketch of the demo—a tapered champagne-like piece with an avolio from an optic mold and a deeply opened stem.

As the evening progressed, I didn't have much luck. I was blowing off center, not heating deeply enough, and blowing out the bottom rather than the shoulders. Allen helpfully pointed this out: "So, Erin, where is the hottest part of the glass when you come out of the glory hole?" "At the end," I said. "Yeah, and so what part do you want to come onto first with the jacks?" "The end," I replied. Allen was pragmatic like that. It's what made him a good glassblower and helped him help folks like me. Toward the end of class, I was heating "more deeply" at the glory hole, and the instructor appeared by my side. "You know what I recommend for you, Erin?" "What?" I asked, thinking he would have me slow down my pace, heat shallower, or something of the sort. "I think you should just take a break for a year from goblets. You know, just work on your fundamentals, and once you have those down, then come back to goblets."

At the time, I felt dizzy and thought of abandoning my dissertation—"If I can't blow glass and progress, how am I going to write about it?!" I wondered. I thought I was improving, so I nodded and managed to say, "OK." Taking the pipe out of the glory hole, I turned to the bench where Allen, giving me a thumbs-up, was waiting. Allen knew going back to the basics wasn't a failure, but this didn't diminish my feeling that it was

so. We had been organized regarding skill; Diana was blowing on the middle bench with the intermediate team, and Leah was on the far bench with the most advanced team. I was with the "beginners" of the "advanced" class; they were dedicated to the task at hand, more than congenial, and apt blowpartners. At the same time, it was hard not to be with Diana, who was more than a few steps ahead of me. In a chat that was really only half-joking, in the way that some earnest chats are, we agreed that we could "see other people." I wanted her to be able to learn and blow with folks who were at her skill level or above, to be challenged. We didn't need to be "monogamous," we concluded. And though it was an amicable and correct conclusion, I still missed her.

I sat back down in the bench with my team, consisting of retired folks from Long Island. After forming the goblet's cup, Alice, a wonderfully jovial retired teacher, served me an avolio—that tiny bit of glass that got "wound onto" the bottom of the cup to connect it to the stem—and, after I had shaped it, a blown foot. Alice was incredibly optimistic, with an energy that bounced like the gray ringlets that framed her pink-cheeked and bespeckled face. She wanted a second career as a glassblower, even if it was a hobby supported by her years of teaching and the plenty that retirement had brought to her. After I had shaped the avolio, she served me a blown foot, which I tooled open. The goblet was done. Alice and I had a good practical rapport and, knowing both me and the process, she appeared with the fork (*forcello*)—a fine, two-tined rod used to carry delicate goblets by their stems to the annealer. This position of the tines under the foot but around the stem of a goblet is readily observable in the manner in which any restaurant server carries empty wine glasses to a table. I tapped the pipe, and the goblet

QUINTESSENTIAL CRAFT ○₰ 141

released effortlessly. Alice, pleased on my behalf (as well as with her serving), carried it to the annealer and boxed it.

I had learned to work hotter and thinner; the "glob" of my "globlet" was less globby. I had acquired more skills—one had to acquire them when making goblets, with their many components of blown feet, avolios, moreses, and endless other flourishes—but my execution was a work in progress. More refined but not imbued with that fluidity of movement that marked proficiency, my practice no longer yielded the hearty flapjack-style "globlet" but its finer cousin, the "globletta" (fig. 5.1).

On my next try, Allen accompanied me to the furnace, watching me gather from over my right shoulder. "Faster, go faster," he advised. I tried to speed up my gather. "Ok, now counter-rotate." "Nice," he encouraged as I came out. "Hold it up, that's it. Now, just hang out a minute and go in and gather again." I hadn't gathered enough—a fact I saw upon retrieval but that he had already known by watching me gather. He smiled, putting his hand back upon the furnace door's handle, "I know your gathers." "Ok, go ahead," he continued, holding the furnace door open for me. Watching directly over my right shoulder, he advised, "Faster, faster." I noticed how slowly I was gathering, the resistance my muscles met trying to speed up, and the grip the glass had on my pipe. I felt the mound, the weight, and I pulled the pipe out. "Oh, too much glass," I worried. "Nope," Allen replied, "that's actually the perfect amount of glass for me." I returned to the bench to join my team and finish blowing the cup, but as Heraclitus notes, "the beginning and the end are shared in the circumference of a circle." Going back to the basics injured my pride, but it's precisely such returns that are ways forward.

FIGURE 5.1. The "globletta."
Source: Photograph by Erin E. O'Connor.

FIRST GATHER

I remember my first gather, standing at the cinderblock furnace, with an instructor, Theo, whose class I was observing: "Just go ahead and put it in?" I asked him, holding a solid "punty" pipe. "Yeah, just put it in," he replied, drawing the wheels of the hip-height door along their roughly routed steel tracks. His directive is not uncommon—"It's a pretty standard first class," a graduate of Alfred University in the 1990s quipped. I anchored myself in Theo's proximity, raised the pipe, and extended it into the small window-like opening, balanced its midsection on the opening's sill, lowered the far end, and parted the luminous, sonorous thickness: "So bizarre," I wrote, "Heavy honey" . . . igneous swells, pyretic aroma, torrid exhalation, livid and vivid. I yanked out the pipe with "fight or flight" immediacy, feeling terrifyingly thrilled. "Woah! You got it!" Theo cheered, sanguine in the face of both inferno and my dumbfounded marvel.

The glass had smeared at least seven inches up the pipe, whereas Theo's demonstration had begun with a nice rounded orb just a couple of inches up from and off of the pipe's end. I stared at the white-hot glass sheath. "That's it?" I asked, somewhat in disbelief that I had indeed gathered. "Yup, you did it!" he replied and shuttered the blaze with a slide of the furnace's unassuming little door over its mouth, unconcerned that I had not rotated. I thought of the materials I knew—beach sand, garden dirt. "It is foreign . . . unknown, totally unknown," I wrote in my fieldnotes that evening, thinking of the backyard dirt with which I had grown up, the snow of Michigan's nor'easters and water of her Great Lakes, Tawas and Paradise Bays, and elaborated, "It's like no element that I know."

144 *SO* QUINTESSENTIAL CRAFT

Glass is neither an element in the sense of an atomically unique substance that constitutes all other matter, like silica, nor synonymous with a classical element, those substances—earth, water, air, fire—with which the Presocratics variously thought the world made.[1] At the same time, my thoughts, words, and deeds hotly entwined anew, flickering.[2] Before the furnace in visceral mutuality with Theo, I did not know that "baptism by fire" is a trope among glassblowers, nor of the perfect contradiction of "baptism" from Greek *baptizein*, to immerse, dip in water and "by fire," nor of the recurring dream that I would have for years to follow of swimming toward and around the furnace through hip-deep water covering the hot-shop floor. I knew life would never be the same again. It never is. Even so, my gathers from there on out—officially enrolled in glassblowing courses—would always be connected to a goal—an object of production, generally a vessel, and almost always a cup or some version thereof.

QUINTESSENTIAL INITIATION

Jude, an artist, writer, accomplished goblet maker, and professor of glass at a technical university, wrote a poetic, untitled, and unpublished ode to cup making. In it, he explains that he "never use[s] the word goblet" to refer to his work but rather, "as a gesture of humility," uses "cup making." For Jude, as "a single form that consolidates every lesson glass could ever teach a glassblower about time, temperature, bodily force, and physics," the cup serves as the "focal point to build [his] thinking on (and around)." Cup making is ubiquitous and is often where glassblowers begin and return, if not literally, then by way of, in Schmid's words, "all those mechanics that learning to blow

tumblers contains." Enrolling in hotshop courses with titles like Beginning Glassblowing, Glassblowing I, Molten Glassworking, and Advanced Glassblowing typically means learning to blow cups. Cup making, in short, conveys, encompasses, and practices the essence of many "how to" classes and of contemporary studio glassblowing.

Course syllabi like Allen's 362 Easy Steps to Making a Goblet wryly reveal that instructors, like social theorists critical of the "fallacy of objectivism," know that cup making cannot be reduced to steps. In Schmid's words: "You have to try to remember at least like seventy-five steps to make a basic tumbler." Such "ad infinitum" clauses point to the fact that the "steps" of glassblowing, while articulated as succession—first, gather; second, marver or block; third, tool; and so on are anything but linear. Finn, a glass artist specializing in historical reproduction, emphasized that the goal of production organizes that production but, simultaneously, that journey varies: "The most similar thing is dancing or music—it can be spontaneous or choreographed. There are standards, like a jazz standard, but you can improvise on that. The goblet is a standard. The bowl is a standard, but you can improvise on that. The amphora is a standard. Most people will know the steps because there is a common language." For Schmid, the steps that constitute such a "common language" are the "ABCs" of glassblowing and, as with Finn, are organized around the goal, a form. When students who are eager to become glassblowers and make artwork ask Schmid, "How soon can I learn to blow glass?" he delivers the hard news: "I go, 'It can take you years, and the same thing with learning any musical instrument. You know, to become a first-chair musician, that's a call you know a serious commitment of hours and hours of practice.' That's again double-edge sword because you know you sacrifice creativity to learn the

146 QUINTESSENTIAL CRAFT

discipline of glass blowing, and in order to fly you need to learn you know the ABC's of the basic forms, and that's why the tumbler became kind of the object."

Schmid is not the first to discuss building blocks and fundamentals as a matter of the ABCs. In the commonplace of ancient Greece—the seventh to fifth centuries BCE—the elements were the "ABCs" that wrote the "Book of Nature." For Thales, it was water; Anaximenes, air; Heraclitus, fire; and Empedocles, earth, water, air, and fire mixed into compounds, such that one could regard the four as *rhizomata*, variously reaching into and constituting all.[3] The *stuff* of the world, that is, constituted not only things but the *thought thereof in vital affinity*: "For man's wisdom," Empedocles wrote, "grows according to what is present." Plato organized the self-authoring elements of the Presocratics with an external logic; each substance had its particular quality, but they were "fundamental," that is, true, only as a *stoicheion*—a word that means both "letter" and "element."[4] Only organized like the S–O of Socrates—abstractly, cognitively—could the "elements" truly be said to be the "ABC" of the Book of Nature.[5]

Informative of today's theories of practical knowledge and embodiment, Plato's student, Aristotle, was a dedicated empiricist and looked for this external logic amid the world of change and becoming. Noting that the terrestrial elements—earth, water, fire, and air—move up and down in the reversal of generation and corruption, while the heavens moved in an eternal circle without suffering change, he concluded that there must be a fifth element: *aether*, or, more widely known by the Latinate *quintessence*.[6] As the stuff of the heavens above—the realm of the gods and therefore *logos* (reason) and truth—quintessence must, therefore, he reasoned, organize the stuff of the terrestrial world below such that consistency and predictability are

observable. There must, that is, be a bit of quintessence embedded in all that belongs to the terrestrial realm, such that, for example, an acorn becomes an oak and an infant a man.[7] Quintessence as *logos*—the principle of becoming—distinguishes it from the baser matter with which it mixes; it guides potentiality toward actuality. Uniquely, man's *logos* does not unfold toward a goal in perfect identity; instead, he pursues various goals and improves, approximates, and aligns with those through trial and error.[8] Authored by quintessence, the ABCs of the Book of Nature become meaningful in relation to the phenomenon to which they belong. Man's goals can be more or less "good" or "true," depending on his aim and ability to adjust, align, progress toward, and achieve them.

As a principle of becoming, quintessence inaugurates a journey toward some good end. Ed Schmid's "how-to" book, *Ed's Big Handbook of Glassblowing* (1993), begins by way of introduction: "You're about to embark on a one-way voyage of information and practical experience, which will undoubtedly make you a more diverse and interesting person," he writes, alongside his illustration of a sunglasses-donned novice, who, holding a tool bag, waves from afar to a steaming and radiating furnace atop an almost wavy floor, calling, "hello hot glass, my name is . . ." (fig. 5.2).[9] Having gathered from the furnace and uncouthly left the door open, he watches hot glass stream off the end of his pipe and puddle on the floor below, exclaiming: "Oh shit! What is happening?!" (fig. 5.3).

Schmid's novice and ABCs, Finn's choreographed steps, my progress from globlet to globletta are resonant with quintessence. The ABCs—the "A" of the gathering, the "B" of marvering, and the "C" of tooling hot glass—become meaningful in relation to the good cup, and the effort to align them charts the journey of becoming a good glassblower. To become a good

FIGURE 5.2. "Hello Hot Glass, My Name Is . . ."
Source: Ed Schmid, *Beginning Glassblowing*, 5. Drawing © Ed Schmid.

FIGURE 5.3. "Oh Shit! What Is Happening?"
Source: Ed Schmid, *Beginning Glassblowing*, 6. Drawing © Ed Schmid.

QUINTESSENTIAL CRAFT ○₹ 149

glassblower, the beginner has to learn, think, make, imagine, and become hot. But so too does this need to be connected to a goal, quintessentially. When blowing both globlet and globletta, I looked toward the "good" goblet as demonstrated as much as my body allowed and did my best to align my practice with Allen's flowing technique. In both the globlet and globletta cases, my practical reading of the Book of Glassblowing was only as good as my ability. In Jude's words: "In turn, each cup I've ever made so far has only been as good and as sound as I was as its maker at that point in time of its making." It's within this arc from capacity to goal that earth, water, fire, and air are organized and made senseful. In my fieldnotes from Intermediate Glassblowing, I once noted Paul's seeming frustration with our ability to communicate with him: "Perhaps his frustration is because we can't talk to him, we can't recognize the signs that are to him so instantly inspiring, we can't see alongside him," I wrote, and added, "Of course, I think that we all can see alongside of him and that we do have our own visions, but it's elementary. It's not that we lack enthusiasm as a group, but that we don't express it in the language that Paul wants to hear: we don't know how yet."

Now I understand that the problem was not our "elementary" language but rather that the language was not elementary enough! We may have known steps, but these were not proficiently joined with other steps, like that S–O of Socrates in the Plato-Aristotelian *stoicheion*; we had steps, that is, but not the syllables, words, sentences, namely, a greater whole or "common language" to make them meaningful. The quintessential cup eluded me. It was hot, it was cold, it exploded, it imploded, it was off-center. I worked toward it, but it was variously a *rocky road*, paved by those self-authoring Presocratic elements.

Becoming goes off track, but there is that "irresistible analogy" to which Bourdieu points that, quintessence-like, sets things

right.[10] Becoming becomes like that which has become; the *aesthetiological is aetiological in analogical expression*. It only takes noticing the arc of becoming, its beginning and end, and the journey of improvement therein to see that there is a quintessential thread weaving accounts of embodiment and practical knowledge. It's not that the aethereal, the quintessential, does not belong to such accounts but that it belongs exactly as such. Theories of embodiment and practical knowledge that enact and account for skill development and progression belong to a quintessential cosmology.

It's such a quintessential becoming that makes Jude's ode possible. Quintessentially, he understands skill acquisition, for example, to be the reward for "devotion to those standards and rules [of cup making] . . . [and] . . . from pledging one's self to a cause and, in th[e] case [of cup making], committing [one's] focus on the mechanics of a very specific process (and style) of blowing glass." The first gather may be the novice glassblower's "baptism by fire," but with the cup (the goal) on the horizon, so too is it her quintessential initiation, that "beginning" of "becoming a glassblower."[11] There is not just a practical logic to becoming a glassblower but an elemental one; habits and field may be mutually constitutive but are also, nonetheless, aspirational; learning by way of becoming-toward, be it approximation or achievement, is quintessential. When I described embodied dispositions as "fundamental" and a "foundation" in the chapter on embodied knowledge, I enacted this elemental cosmology.

Jude "shoots" for the standards and excellence when in the bench. Yet this journey, as he readily admits, is not a straight shot. Quintessential craft, quintessential cup making, while aspirational, is neither about achieving an inevitably perfect cup nor conforming to a goal. Instead, mixed with the terrestrial

stuff of becoming, it can only be about navigating toward the good, be it cup, glassblower, or glassblowing, knowing that it is a moving target and that there will be many more misses than bulls-eyes.

Shakespeare's Hamlet is a morose fellow who, having fallen off course and lost all aim and thread of matter and meaning, bemoans the quintessential human condition: "And yet, to me, what is this quintessence of dust? Man delights not me: nor woman neither, though by your smiling you seem to say so."[12] In the passage of this famous quote, Hamlet has lost his mirth and has forgone all custom of exercises; the earth seemed sterile, and the air and its fires were nothing but pestilent vapors. Jude knows better; wellness, he claims, is to be found exactly in failings.

SHOOTING FOR EXCELLENCE

Cup making, for Jude, "embodies the philosophical essence of craft when speaking about craft as a verb: an action focused on objective standards of excellence (standards set by myself) and perpetuated by a desire to do a job well for its own sake (standards measured by myself)." For Aristotle, pneuma was "the analogue of the astral element," and while guiding humans like the North Star, they ultimately have to find their way. Skills fail, bodies fail, materials fail, and that which achieves glory can quickly become a source of demise. Failure, Jude writes, "gets a bad rap" for its association with incompetence, "wasted resources, and lost time." But it is exactly failure—dwelling in error, exploring mishaps, valuing muck-ups, and embracing faults—to which Jude attributes "any growth or accomplishments [he's] had so far":

As I continually get things wrong, I see those things as opportunities to understand their wrongness and, over time, make them right. My conviction to recover from my blunders has nothing to do with my personality or my character. Some of us are naturally more level-headed than others, but cup making has taught me that tolerance and patience are just as much a learned skill as is dropping a blown foot. In turn, my technique develops when my very high standards to perform a certain function the right way are influenced by my willingness to accept and investigate what's going on when conducting them the wrong way. Mental mess, clutter, and hitting dead-ends are a means of understanding wrongness . . . and that's where I've found improvement to reside.

"Excellence," he thus qualifies, "in no way, has anything to do with what perfection is generally understood to mean. If anything, it's the opposite. Excellence, instead, [is] better to think of as a graceful navigation through repeatedly blundered parts of our process." Navigation is a nautical term that means "to set a ship into motion with the strong connotation of steering, guiding, and charting its course." Ships get lost at sea, where disorientation can overwhelm coordinates and directions. Navigation is not about *knowing* the way but about finding a way forward from *not knowing*.

Amid gathering or otherwise glassblowing, many an instructor consoles the novice, "Don't worry, you'll get there!" and encourages, "You can do it"—each consolation banking on those building blocks, the ABCs that write the Book of Glassblowing, a tale of both cup and man. Working within this developmental logic, the novice is posited as a capacity that may someday reach plentitude with the oft-cited ten thousand hours of practice.[13] Glassblowers readily recognize the need for "bench

time" to improve and that for improvement to happen, it needs to be aimed at a goal and cadenced by repetition: "Look," Noah explained, "learning happens with repetition, and the repetition has to happen within the correct framework. It's no different in glassblowing than in anything else. You need ten thousand hours, and the only way you can do that in glassblowing is by working in a factory." The dynamic of not knowing and knowing moves within that trajectory of generation and corruption at the same time as being organized and informed by an encompassing goal pervasive of that pursuit.

For Jude, this marks "a devout and steady quest to satisfy [his] desire for understanding in tandem with [his] desire of knowing just what my hands are capable of allowing [him] to do." Seeing a way through failure is much more than the development of skill; it is also a development of self: "As a cup builds and grows at the end of my pipe so also do these attributes of my character build and grow. . . . I believe . . . the stuff that I may be really working on—is myself; an extension of what's going on at the end of my pipe." In his case, he developed tolerance and patience, concentration and attentiveness, and the ability to be occupied and work with tranquility. It is, in short, virtuous work: "Quality and working well is real and persistent" for Jude in the measure of trial and error, of approximation, of figuring out a way forward from seeming pathlessness, of those quintessential practices of quintessential craft.

LIGHTNING STRIKES

Over beers and pizza at the local tavern one night after a long day of blowing glass, Sarkis and Allen characteristically swapped stories of watching other glassblowers blow under the

cool light of the neon "Miller" and "Bud Light" signs, each priding himself on their keen skills of observation—that which enabled them to see the "how-to" of the glassblower's practices. Unlike many onlookers, who chatted and looked around during a demonstration, they would stand as close as possible to the glory hole and right behind the bench to watch. "Remember when Pino [Signoretto] made those two birds in a nest fighting over a cranberry?" Sarkis asked Allen with upturned hands, baffled. He stuck out his bottom lip, took on a face of indifference, and craftily undulated his hands and arms in a figure-eight, each movement flowing fluidly into the next. Allen laughed, "No, no, no, he was smoking, remember?"

Allen took a cigarette from his pack, stuck it between his exaggeratedly puckered lips, and dimmed his typically alert eyes into a sultry gaze. Nonchalantly, he swept his hands in a large figure-eight movement while fake-blowing smoke from the dangling unlit cigarette, winking and waving to an imagined audience. We roared with laughter. "It was like six gathers at the end of the pipe," Allen continued, suspending his performance to raise his hands in "what-the-fuck" disbelief. "Yeah, no problem!" he continued in astonishment, "He did it in like three or four heats." Sculpting two birds fighting over a cranberry in a nest in three or four heats might be equivalent to butchering a lamb with three to four chops. Allen and Sarkis continued in good humor: the Italian master who uses only the arm of the workbench to sculpt a skull, the American glassblower cum helmsman who wears a jacket of ice when shaping his full-body-sized figurines, steering enormous gathers with a ship's wheel mounted to the yoke rather than turning the pipe by hand. Though different in their goals, each moved toward their target.

QUINTESSENTIAL CRAFT ❧ 155

I grasped the humor of Sarkis and Allen's pout-lipped, dangling-cigarette imitation of the smoking European maestro and ambitious American. Still, the practical dynamics of making fighting birds in three or four heats eluded me. I pushed them to explain "how" Pino did it and received advice on improving my practice: "You have to know what you're looking at," Allen began encouragingly, only to be interrupted by Sarkis: "Rotate, rotate, that's right, keep it on center," he offered, air-rolling a pipe back and forth over the arms of a workbench with a wry smile. "Ha ha," I replied, unappreciative of his smirking sarcasm, and looked appealingly at Allen.

Ever eager to talk about how one actually becomes a better glassblower, Allen good-naturedly laughed at Sarkis but continued to dissect the skill of seeing rather than the mechanics of handwork: "What I was saying is that you have to learn to see, selective seeing is important, and you can't see until you are able to see." As was characteristic of his more philosophical moments, his bright blue eyes looked someplace over the pint of beer he held between his open knees with one hand as he talked, only occasionally glancing up at my own: "Like, think of this. I was just looking through old videos, and there was this one from 1981 that I watched a long time ago. I totally understood things that I didn't before," he offered by way of example, gesturing a vibrant recollection with his free hand that was invisible to me: "I'll be like, oh, that's how he did it."

The anthropologist Cristina Grasseni argues that novices learn to see through an "ecology of perception, cognition, and action" at once cultural, social, and material.[14] In the glassblowing social world, visual media, like the VHS videos that Allen watched, scaffold the learning process. In a later advanced glassblowing class, a retiree dutifully recorded Allen's demonstration

on a digital camera, burned the digital files to DVDs, and distributed them to those interested. The "focusing media" frame, situate, and organize perception and practice much more than they deliver content. Learning to see—the "enskillment" of vision—is artifact mediated and, conversely, the "organization of perception" by such "cognitive artifacts . . . brings forth a certain orientation to the world"—"a structure of intentionality"—that "creates a moral and aesthetic order."[15] The ancient Greeks also associated a good eye—*eusthochia*—with the ability to aim—to see a path forward, that is, through an empirical world "of movement, of multiplicity, and of ambiguity."[16]

A good eye and the ability to act upon it—a matter of an instant—defines a distinct type of knowledge for the Greeks: *mêtis*. Both the common noun and the name of the wife of the ruler of the Greek Pantheon, Zeus, M/mêtis denotes the ability to find a way through a world of constant change and instability through transformation, metamorphosis, shapeshifting, and substitution. Classic examples among animals include the fox and octopus, which catch their prey and elude predators by playing dead only to pounce on an unsuspecting bird or change color, respectively. Among humans, the ship captain who steers the ship into port by reading water, wind, and stars serves as a ready example, as does the doctor, who reads the patient's fluctuating body to steer illness toward health. In the chapter on embodied knowledge, Sarkis discussed the importance of "looking forward"—something I understood as corporeal sight. One of *mêtis* must perceive likeness between that which appears different and, through grasping the unknown through its resemblance to that which is familiar, "open up a path for [him]self."[17] This is an "intellectual operation," writes Detienne and Vernant in the definitive work on *mêtis*, that "lies half-way between reasoning by analogy and a skill at deciphering the

signs which link what is visible to what is invisible"; the one of *mêtis* exercises a reversal and suddenly binds that by which they were bound.[18]

Herein, the "nature of Becoming" is not simply of approximating quintessential ideals—always a matter of degree—but of transforming according to the immediate and changing particulars of a given moment (a difference in kind): "In order to find its way . . . and to master the Becoming by vying with it in cunning, intelligence must . . . in some way adopt the nature of this Becoming, assume its forms."[19] Becoming as each other—pilot and sea, doctor and patient, fox and buzzard, octopus and predator, hunter and hunted—*mêtis* is a matter of intracorporeality; the one endowed with *mêtis* transforms and shapeshifts as that to be overcome.[20] Tim Ingold understands making to "define the activity by the attentiveness of environmental engagement" and building to define "processes of production consumed by their final products."[21] As a matter of *mêtis*, making emerges not only from attentiveness to environmental engagement but from environmental—or elemental—complicity.

I began chapter 1 with a quote from Heraclitus, "Thunderbolt steers all things." With man, the transformative power of vitrification both bears self and worldmaking through "setting the pot" upon the very elemental chaos that gives it rise.

In chapter 4, I examined the marginalization of the air and breath in theories of embodiment and practical knowledge that build upon a very corpuscular, or fleshly, idea of corporeality. By revealing the elemental complicity of *mêtis*, this consideration reveals that the classic elements are not simply qualities (endowed with quintessence) but also bodies, or corporealities, in which the practitioner's transformation, becoming, and overcoming are caught up. *Mêtis* is woven by and weaves that

intracorporeality discussed in chapter 3, exceeding the quintessential arc of *techne* to find and forge new paths. One of *mêtis* sees *with* not *through* heterogeneous becoming.[22] Lightning strikes. *Mêtis* may open a path soteriologically, but this path invariably turns upon itself; the modestly advanced novice and the rock star may both find themselves "back at the beginning." The ability to see comes only with not seeing. As the "power and product of transformative intelligence," *mêtis* was understood to be "the mental and material process common to every *techne* 'craft,' to the work of every artisan."[23] The knowledge of glassblowing (*techne*) must also be vital (*mêtis*). Embodied knowledge is a matter of anomalous elemental complicity as much as quintessential progression.

The glassblower's *mêtis* plays with fire and air, felt and embodied, carrying the glassblower forward. It's not a coincidence that *mêtis* is associated with water and seas; the practitioner must be immersed yet elusive, follow yet swallow, crest the waves to see forward and strike when the moment is right. *Mêtis* belongs to the time of *kairos* (the measure of the decisive moment), not *chronos* (the measure of the goal and stadial steps). At the same time, the ability to seize the moment is a matter, in Sarkis's words, of "simply time." It is precisely in the time of *chronos* that glassblowers like Jude can find the opportunity to strike—the opportunity for *mêtis* to transpire: "There are moments in the seemingly redundant actions of cup making that illuminate new discovery—'eureka' moments," explained Jude. "[They] provid[e] much-needed clarity when aspects of my cup making go into a foggy spot for a while. Yet, those 'eureka' moments aren't out in the open; they are hidden in the monotony of repetitive work and need to be found. Tripped over, in fact. 'Eureka' moments after years of not dropping feet on center. 'Eureka' moments after years of not rolling over the

first part of a two-part avolio in a symmetrical way. 'Eureka' moments after years of using the same optic mold and never understanding why my ribs were coming out so dull."

The ability of Sarkis, Allen, and Jude to see a path forward from the unknown, transform themselves accordingly, and thereby gain the upper hand in the achievement of their goals imbued them with "rock star" status in the hotshop—a concept uncannily resonant with the terrestrial-celestial arc of pneuma and quintessence. Being a rock star is not about the perfect identity between rock and star, pneuma and quintessence—cosmological—but about the elemental complicity of an intracorporeality not necessarily "on track." Pragmatically ubiquitous, *mētis* is nonetheless left out of contemporary accounts of craft knowledge, embodied knowledge, and skill acquisition.[24] Why?

FROM *MÊTIC* CUNNING TO PHRONETIC VIRTUE

I would like to return to that surviving fragment from Empedocles in consideration of the ABCs of the Book of Glassblowing: "For man's wisdom grows according to what is present." In *The Metaphysics*, Aristotle cites this fragment as a point of "distressing . . . confusion" caused by mixing the sensory and knowledge.[25] Instead, he seeks the certain knowledge of reason, albeit embedded in the empirical world. In the original fragment, the ancient Greek word, which is translated as "wisdom," is *mētis*. Aristotle does not leave it as such, however, but rather substitutes *phronesis* (that practical knowledge evoked in so many contemporary theories of embodied knowledge). Glassblowers practice *mētis*, a knowledge entwined with elemental

160 ℘ QUINTESSENTIAL CRAFT

anomaly and uncertainty, with intracorporeality, in the hot-shop. When this fire craft is explicated within a quintessential cosmology, one in which becoming and change are choreographed according to rational, good goals, *mêtis*—feminine weaving—is subsumed within *phronesis*—virtuous production—as process to product. When Aristotle substitutes *phronesis* for *mêtis*, he performs his own *mêtis* whereby craft knowledge gains certainty and moral veracity. In quintessential craft, *becoming* becomes *method*. By framing questions of skill acquisition in the context of proficiency, contemporary theories of craftwork, skill, and embodied knowledge, drawing upon phenomenology and its Aristotelian heritage, perform the distance that Aristotle quintessentially drives between the vital affinity of sensory experience and knowledge. This has been extraordinarily *productive* for and of the theories thereof.

BEING BURNED

In *The Craftsman* (2008), Richard Sennett attributes the club-foot of the deified craftsman of Olympus, Hephaestus, to civilization's ambivalence about craft in light of its potential to create both good and evil.[26] Constantly thrown between the Olympic heavens and underworld, Hephaestus's "dis"placement and his "dis"ability mark not inadequacy of production, however, but rather the elemental ambiguity upon which human production rests. Paradoxically, to be "sure-footed" might require losing track amid shifting terrain. Beneath and within the fires of the furnace and volcano, Hephaestus suffers no burns. Etymologically, "dis" means lack of, opposite, or apart or away and is related to "twice." To see the paradox as something to which to attend, to give voice, and to make explicit, we need

only remember that Hephaestus's betrothed is none other than Aphrodite—beauty.

That double-edged sword of learning to blow glass, which Schmid pointed out, is readily understood as the difference between expression and technique. But far from defining that polarity between "art versus craft" as modes of production, walking the double-edged sword points to the complicity of human journeys and elemental anomaly. The first gather may commence with that "voyage of information and practical experience, which will make [the novice] a more diverse and interesting person," but the double-edged sword along which one walks in the journey of becoming cleaves a world. The sword is never not cutting, even if that through which it cuts is as fine as air. The biologist, feminist, and cultural theorist Donna Haraway notes: "It matters what stories we tell to tell other stories with; it matters what concepts we think to think other concepts with." To avoid anachronism—or perhaps better, *to embrace the duplicity of anachronism*—theories of embodied knowledge must situate skill acquisition—that quintessential journey of development and achievement—must understand their elemental organization.

The German poet Rainer Maria Rilke (1825–1926) lamented his corporeal entwining—"the static my senses make"—in his struggle to know God.[27] Yet is it not precisely thereby that, as the American poet E. E. Cummings (1894–1962) writes, "now the ears of my ears awake and now the eyes of my eyes are opened"?[28] To the first gather, is there not an "Ah!" of the "Aha!" of "Glassblowing!"—the gasp of the grasp—the "wound" with which Stoics like Scotus, Diogenes Laertius, and Sextus Empiricus and contemporary Stoic philosophies of education like that of Deleuze and Weil claim learning—if it's to be a way of "apprenticing" life rather than authority—begins?[29] With such plenitude comes the cry.

162 QUINTESSENTIAL CRAFT

All glassblowers get burned. In my case, it was less so as I developed skill, moving beyond the days of giant blisters upon my fingertips from grabbing the pipe too close to the gather and the seared lines across my soft inner arm from hot jack blades gone astray. There were plenty of days I left the hotshop with some area of my body slathered in Silvadine—burn ointment—and then plastered with bandages. Even with developing proficiency, it can still happen. Along with this, I felt a deeper burning. I followed it, ascendant, a spark toward the heavens. On this journey I variously practiced and suffered reversals. In those moments of losing footing on unsure ground, I sometimes got back on track to finish the globlet and globletta. Other times, I recoiled from the heavens in elemental anomaly, roaring like Tiamat.[30] When I got burned, I neither did nor noticed either.

6

MATERIA EROTICA

Love and Strife in the Hotshop

As a sweet apple turns red on a branch,
High on the highest branch and the applepickers
forgot—
well, no they didn't forget—were not able to reach.
 —Sappho, *Poetarum Lesbiorum Fragmenta*, fr. 105a

If seems the faster I chase you is just the faster I run away
It's just you look so tasty in that fur clad body
C'mon make it last my dear
Run, run away
The faster we run and I forget
Who is the prey
The faster we run
 —Predator Prey, "Fur Clad Body"

I slept late, until about 9:30. It was so blissfully deep—I had been so tired. I dreamed about glass in the night, something about a punty. I was with Diana and Eloise in a dark, low-lit bar in the West Village, gathered around a small barrel table. Diana said she wasn't sure she could open her heart to me

because if she did, I might just walk away, and she didn't want to get hurt. I started crying and crying—I didn't want her to feel like that! Eloise comforted us both. We drank beer. The rest of the dream vanished upon waking. In the hotshop, we had recently formed the "Sisters of Glass," for which we took the names of tools as our own. Diana was "Diamond Shears" (of course she was! A masterful weaver of sparkle, brilliance, and gleam), Eloise was Jack (again, perfect. Precise, technical, achievement oriented, and a studio tech), and I was Parchoffi (a jacks-like tool with rounded wooden tongs for gentle rounding and opening without leaving marks that felt akin to my imagination and writing). Two other girls completed the group: Sofietta (the puffer tool used to blow out shoulders in goblet making) and Pastorale (the two-tined fork used to hold the kiln shelf when picking up cane or murrine). As with life among students in the hotshop, some stay involved—Diana, Eloise, and I remain friends—while others move on. Maureen once good-heartedly teased me, "Yeah, Erin, you can use that for your book. You can write about the Sisters of Glass." I laughed, "Actually, that might be kind of interesting."

The Sisters of Glass was a make-believe club—we had no official board, agenda, or meetings. This did not keep us from imagining a design to emblazon upon T-shirts and other merch. I drew a "Sisters of Glass" logo with a girl holding a blowpipe with a goblet atop busting through a pane of glass in the old-school lettering used by the rock bands Twisted Sister and KISS. Get it? Guys blow goblets, guys teach. And we "sisters" were breaking the glass ceiling of goblet making. It was a bad visual pun. Even so, it points to the solidarity we felt learning to blow glass together—and, for Diana, Eloise, and I, variously working on teams and as studio labor. We formed bonds— lifelong ones.

Friendships in the hotshop run deep, as does the love of glass. Maureen, whose primary job was as the education director of a contemporary art museum, explained that she worked as Paul's assistant because she "loves glass and loves being in the studio." So too with Paul. Together, they scoffed at pay and explained: "We don't do it for the money. We do it for the sake of the material. For teaching others to love the material, to love glass." It was easy to fall in love in the hotshop in all manners of ways. There was an older marver that the hot glass seemed to have eaten over time, leaving a pocked beauty that, while perhaps not suitable for marvering, was sublimely gorgeous, Jackson Pollack–like. The floors in front of the furnaces were similarly marked. No longer flat and smooth, the concrete was smattered with flecks, pocks, and even divots about five inches wide. They were constellations of glass-having-fallen, of trails and landings of so many shooting stars. Sarkis often interwove his glass practice with other media, notably drawing. He once laid long sheets of paper over the floor's constellations and "rubbed" them with charcoal, documenting the rich texture. With loving these everyday beauties came loving the stories of glass, the lives lived within and with the hotshop. For Empedocles, Love and Strife were the two forces that wove and unwove earth, water, air, and fire into the Cosmos. In a cycle of constant renewal—life and death—elemental mixtures bore all beings, their worlds, and their dynamics. The experience of the socio-material life of the hotshop did not feel much different, interwoven, as everyday life was in elemental saturation.

In this way, all varieties of friendship, love, and animosity were intertwined and calibrated among varying polarities. The Sisters of Glass talked about each one: hot guys, hot girls, hot bodies, rock stars, hookups, fantasies, as well as breakups and

rumors, though conversations tended to stay on the dreamier side of love. One night after class, we headed to a downtown dive bar called Milady's. It's enough of an institution in New York City today to offer separate "Day" and "Evening" cocktail menus that cost upward of twenty dollars a drink. One cocktail (about seven or eight dollars) into that evening, Sofietta reported her hots for Sarkis and expressed her disappointment that he had not yet listened to a CD of songs that she had burned for him: "Yeah, I walked by Sarkis working, and he looked at me, so I waved. When I was coming back from the lockers, I asked him if he had listened to the CD that I had given him. He was just like 'No,' and I was like 'Ok . . .'"

We rapped about Sarkis's past and present loves in and around the hotshop. On topic, Eloise said that the guys at the tavern had heard that I had recently broken up with my boyfriend (I had) and were debating it. News travels fast through the hotshop. Circling back to Sarkis, Diana suggested he had a crush on me. I was not always the best at reading such vibes, like the night that Sofietta thought I was asking her to make out when, in actuality, I just wanted to know if she also needed to use the bathroom on our way out. My lack of interest wasn't an issue of sexuality but rather chemistry, that alchemical affinity. Diana and Eloise had their own stories to tell. We all had stories to tell. They developed day to day and week to week. On another night out at the local watering hole near the hotshop, Sofietta confessed a crush on Paul and insisted I had one too. "Come on, admit it," she demanded. "You have a crush on him too." "No, honestly, I don't," I replied, laughing. "I'm sorry to disappoint you, but the thought hasn't even crossed my mind!" That said, the conversation about Sarkis struck a chord. I had noticed him in the hotshop, or should I say, his presence demanded my notice.

SARKIS

I consider my first meeting with Sarkis, a former track athlete, to have been at the furnace the second night he substitute taught Intermediate Glassblowing for Paul, in which we Sisters of Glass were enrolled. Until that week, we had no formal interaction, but I had watched him blow glass. He was one of the best in the hotshop—a rock star—and admired for how his practice embodied the challenge of the material with tact, grace, precision, and vision. A practical pied piper, the molten glass seemed to flow into the form Sarkis intended of its own accord. It was around Thanksgiving, and some students asked him to demonstrate how to make a gourd. "Ugh," I thought, "we have Sarkis for a teacher, and you want him to blow a gourd?!" I wanted to participate in the beauty that I had watched flow from his limbs, to be caught up in the dance that his movements mapped, to model myself, my practice, and this all seemed at odds with a kitschy cornucopia object. "So, you want to see it blown with the optics?" he asked the group, following up on a student request. "Yeah," the majority responded in chorus. "OK," he said, "well then, you'll have to give me two tries," and then grabbed the top of his T-shirt with crossed arms, to pull it off.

A wave of shyness washed over me as his shirt hem rose to expose a trim and strong torso. He pulled down the undershirt, gray and threadbare, removed a pipe from the warming rack, and walked to the glory hole to heat its tip. His rounding chest and prominent, broad collarbone filled out the undershirt, which remained draped over his shoulders, and his movements were fluid, one somehow always underway before the last one was completed.

He walked toward the furnace on the other side of the platform, though his teaching assistant, who would typically open

the furnace door, had not yet arrived. I slipped away from the other students, who were caught up in conversation, and hustled to catch up to Sarkis, laying my hand on the furnace door's handle just as he reached for it himself. "Ah, you're here, thank you," he said. "No problem," I replied, sliding the door open and facing his profile. The heat and glow of the furnace's ton of molten glass bathed his upper body, and he started talking: "It was weird today," he began as he lowered the blowpipe into the furnace, twirling to gather, watching the end of the pipe. "I went to visit my Grandma." Anticipation and confusion simultaneously came over me. Grandma? "And she is like ninety-three," he continued, twirling the pipe, gathering glass.

I liked being alone with him, having this private conversation, which quieted the furnace's roar while the rest of the class waited on the other side of the platform, chatting and out of sight. "She almost died like ten years ago. She had a stroke, but now, now she and her friends decided that they were going to have a class reunion, so now she is walking around her living room twice. She started with her walker, but now she does it without." "That's amazing," I said, sensing how his movements and manners somehow embraced the proximity required to blow glass, feeling myself partnered in the practice. I looked at his face and could see faint freckles behind the frames of his large, black, rectangular eyeglasses, swirled with the gray and white that curled around his temples. "And her hair is like growing in the reverse direction—it's growing in black now." Each turn of his tale gathered my attention. I noticed his black hair, its ruler-straight short strands radiating out like tender quills.

"OK, open," he said. The roar of the furnace returned. With a light heave, Sarkis withdrew the gather, undulating, luminous, thick with heat at the end of the pipe, primed to become

a gourd. Closing the door, I raised the metal trough of water from the pipe cooler and dragged it over his pipe, back and forth, the cool water showering the hot steel, sizzling, sputtering steamy spittle. We didn't talk. He lifted the pipe from the cooler and headed toward the group. The glass waved from the pipe's rotating end: "I only hope that I can be like that when I'm ninety-three," he called over his shoulder. "There is no doubt that you will be," I called back, eyes brimming. A comment he made to the class the night he first substitute taught for Paul, who was out sick, floated to mind: "Yup, I can't talk and blow glass at the same time," he paused . . ."but I can flirt." I released the trough into the water, heard it thunk on the cooler's metal bottom, and walked back to the group in his wake.

Back at the bench, students had gathered around the workbench where Sarkis sat, cupping the gather with a wooden block; his Dickies polyester work pants were cuffed just above his ankles, exposing worn and creased, laced black leather boots. He popped up and slid the glass into the glory hole, his body silhouetted before its coiling fires. Twirling the pipe, taking in the heat, he raised his right shoulder to his turned chin to wipe sweat from his mouth and peered down the pipe into the glory hole to reheat it, mounting the glass's sauntering wag with steady cadenced rotations.

Drawing his right foot behind the left with the severe grace of a flamenco dancer, he nimbly quit the heat and wheeled the hot glass over his shoulder like a flag girl, parting the sea of students. I did not see a gourd, or any form, in the choreography of heat, the practical charisma of which was dizzying. Though Sarkis had landed the wheel of glass onto an arm of the workbench and was already seating himself in it, my attention, lingering in the glory hole, wasn't quite there yet. My senses were chasing him. His movements, concise and eloquent, gestured

like corporeal calligraphy—a script that my own body stammered and stuttered to comprehend. "Can someone blow?" he asked. The student nearest to the blowpipe's opening squatted as Sarkis picked up the folded wet newspaper and, rotating the pipe back and forth across the arms of the workbench, rounded the hot glass in his newspaper-lined hand. "Blow," he instructed, his left palm kneading the pipe while spry and tawny fingers ran over silver steel, propelling it back and forth over the workbench's arms. The student puffed up his cheeks and blew, while Sarkis, with cocked wrist and flexed forearm, puckered his lips as if in expectation of a kiss and shaped the glass into a cone. The meeting of fire and water, paper and glass, centrifugal force and centripetal pressure etched a topography of ash into that day's story of the presidential campaign. It was 2004.

I inhaled the newspaper's smoke as he tossed it onto the workbench and stood, stepping onto a footstool. Catholic smells, the ritual smells of my childhood. He shoved the glass into the optic mold and blew. With the same effortless and engrossing choreography, he returned to the bench and shaped the gourd. Was he performing? Were his movements the flirtation? His twirling? I didn't remember seeing him making these gestures before.

I was working with Sofietta that night. I had mentioned to her that it made me nervous to have Sarkis as an instructor. She didn't seem to like that. "Why, do you have it for him?" she asked, her taut, milky white features appearing even more chiseled against her shock of red hair and British accent. She was an art and design student at a local college. "No, there is something about him that I find intriguing. He's just so good. I've seen him in here blowing. I just feel a little intimidated, feel like I have to somehow reveal my underlying potential to be a master glassblower . . . this still nascent brilliance. Plus, there is

something about him." The past Wednesday, Sofietta and Pastorale had debated whether he was straight or gay. I thought straight. He had recently explained that he couldn't blow glass for just a short period—once every three months at the time of the new moon—as his ex-girlfriend had told him that men lose their balance on every third new full moon. His sense of humor was like that. "It's funny to see you so quiet and shy," Sofietta taunted me. "I get that way sometimes," I admitted. "I don't know why. A part of me is really shy."

Toward the end of class, Sofietta suddenly remembered that she had to leave in the middle of blowing a gourd. Sarkis stepped in: "Erin and I can finish it, don't worry." She left lightheartedly, though my heart stilled listening to my name being brought into his project. How could my amateur body answer his call? Sarkis took the gaffer seat and looked at me, "Do we really want to finish this? What are we going to do with it?" The words "it" and "finish" felt forced. With Sofietta, I could follow the "how-to" of blowing the gourd, but Sarkis's presence introduced a challenge of imbuing my hands and body with that lived character of glass that animated his practice. "I don't know," I responded, daunted, and continued, "I don't really understand the gourd. The mold makes it hard to see the form. I can't really follow what I'm doing." Though we discussed form and execution, he looked neither at the glass nor at the tools but directly into my eyes the entire time that I spoke. "I know, that's why I said that we should do it without the optic mold," he replied, breaking his gaze and tapping the pipe, flipping the piece and reattaching it from the other direction. Not that I saw each step. I only had heard the thwack and subsequent invitation: "Why don't you heat it from the shoulder up and open up the neck?" He took the piece to the glory hole and, rotating the pipe with one hand, faced me. "Uh, sure," I managed, baffled

by his trick, and, stepping into the clearing he had made between his body and the pipe, took over its rotation.

As I stood at the glory hole, taking the heat, Sarkis left to help other students, asking a woman from another group to help me. I finished the heat, returned to the bench, picked up the jacks, and began to rotate the pipe back and forth, tooling its opening. Like all my pieces that night, it fell to the ground and shattered. I placed the pipe in the barrel and started to clean up, noticing that I did not care about the lost object. There was no loss. On the contrary, I swelled with coursing thoughts, feelings, and sensations not readily grasped by any moment of the choreographed production.

CAUGHT UP IN LOVE'S GLORY

During my fieldwork, love and talk about it abounded—flirtation, sex, flings, relationships, marriage, and breakups. The question of "love in the field" is typically answered with a code of research ethics addressing power and differences among researchers and subjects. This is valid. Yet some have addressed it theoretically: sociological giants like Max Weber, Georg Simmel, and Talcott Parsons.[1] More empirically, the sociologist of culture Anne Swidler inquired into "talk about love."[2] Even so, I eschewed the question of love in the hotshop. I recoiled at the thought of subjecting the love I felt—both for the material and practice as well as my eventual lover and friends—to sociological function or otherwise. Moreover, I had tacitly learned all too well about the risk of talking about love without theoretical armature, having witnessed the condescension for those who tried to do so; no one asked with June Jordan, "Where is the love?" or evoked the "power of the erotic" with Audre

Lorde.[3] The intersection of gender, sexuality, race, and ethnicity in this prejudice is glaring; self-described as a "Black, lesbian, mother, warrior, poet," Lorde poignantly signaled this.[4]

In Plato's canonical love inquiry in *The Symposium*, Eros/eros, both demigod and disposition, arcs as an intermediary between lack and plenty in accord with his birth from Penia (Poverty/Need) and her lover, Poros (Resource/Path). In this sense, Eros is commonly depicted with a drawn arrow—the Roman Cupid—charting both aim and arc toward its fulfillment. This dynamic finds voice in the work of the famed psychoanalyst Sigmund Freud, for whom desire, or libido, is the origin of the drives and strivings "oriented toward sexuality, development, and increased life activity."[5] Desire longs, desire strives, desire attains. In sociology, such libidinal drives are not "natural" or "psychological" but socialized.

In Bourdieu's "logic of practice," for example, *habitus* and *field* form a "relationship of mutual attraction," such that a person becomes invested in "the game."[6] This "socialized libido" or "socialized desire" is not directed toward strictly personal, private, or individual fulfillment but, as the sociologist Nick Crossley explains, recognition.[7] This is, in part, an inheritance of Durkheim's social ontology and, in part, of Hegel's theory of recognition.[8] The former explains that people are both individuals and society, while the latter explains that people experience self-consciousness only with the recognition of others. A theory of socialized desire thus connects people's investment in what they do (and who they are) to their search for recognition; in the conditions sketched by society, they pursue that through which to experience themselves and their lives as meaningful.[9] This pursuit does not arc unidirectionally from lack to plenty (*habitus* and *field* are mutually constitutive), but the search nonetheless maintains directionality insofar as the "mutual

174 ❧ MATERIA EROTICA

attraction" produces "becoming toward" that which offers itself "socially for investment," quintessence-like.[10]

In this vein, Wacquant unpacks the pugilistic libido of Chicago's South Side boxer, that "socially constituted interest" that "impels those it inhabits to accord value and surrender themselves body and soul" to their practice.[11] By attending to passion "in the double sense of *love and suffering*," Wacquant connects the commitment and struggle to become a boxer to a desire to construct a "publicly recognized, heroic self." The socio-erotics of recognition is "a project of ontological transcendence" wherein self-consciousness arises with an abnegation of instinctual desire for connection to an objective world of social relations.[12] When Sarkis said that "Erin and I can finish it," he drew an arrow along and toward the gourd, orientating us toward recognition achieved in production and its sociomaterial dynamics. He was a teacher, I was a student, and the glass was our shared medium. We produced so that learning might happen through doing. From such complicity—between becoming (*habitus*) and social rules (*field*)—we took or pursued what the queer phenomenologist Sara Ahmed describes as a "straight line," namely, a normative path.

Putting askew the logic of lack and plenty (and the soteriology of Cupid's arrow), Lorde evokes Eros's more archaic parent—Chaos—from whom Eros is the "measure between the beginnings of our sense of self and the chaos of our strongest feeling." Lorde uses the language of aim, bridging, and fulfillment with regard to eros but recalibrates, or even eliminates, the aim. Instead of achieving completion or attainment of the socially prescribed, Lorde understands eros to be a creative power associated with intuited knowledge and the practice of opening, stretching, and sharing as connection and joy.[13]

Herein, love grows in "deep participation." With neither denouement nor resolution, the power of the erotic is the ability to follow, hear, listen, connect, mix, and surrender. Employing a distinction widespread among French social theorists and philosophers, including Foucault and Deleuze, Lorde's power of the erotic exercises *puissance* (immanent power to act) rather than *pouvoir* (power over).[14] This is not simply a distinction between making with and making upon—emergent form versus imposed form—but of the orientation of the trajectory. Through the creative power of eros, folks and the world become, but not via a direction "toward." Instead, that "deep participation" may lead this way or that, forward or backward, straight or askew. For Ahmed, this wandering through connection—proximities that were previously hidden—characterizes a queer orientation.[15] Orientations are not given but arise in a "field" of things and objects.[16] In this sense, sexual orientation is a clearing of some objects so that others may appear; the clearing of homosexual objects, notably, makes way for the appearance, and hence direction and orientation, of heterosexuality. A heterosexual orientation is "straight" because it proceeds toward those objects (things and actions) that appear proximate. In the hotshop, the furnace, tools, equipment, and, notably, the *medium*—that substance of the artist's expression—are made proximate, and I, like so many glassblowers, longed for them. Lorde and Ahmed invite investigation into the orientation of love in the hotshop, and like Cupid's arrow, that toward which it points. For Empedocles, the Force of Love causes elements to be attracted to each other, while the Force of Strife causes the decomposition of things. Indeed, love, making, and making-love are bound together in a ceaseless doing and undoing of one another.

A MAT(T)ER OF ELEMENTAL LOVE

I want to return to the vitreous metabolism of intracorporeality that I experienced the day I worked for Oren—that inhabitation within and immanent becoming of heat. Recall that the work was dehydrating, the heat relentlessly extracting sweat from my body such that, by day's end, my clothes adhered to my body by the dried salt of my sweat. As I felt those crystals fall away in the warm water of the shower, I could not help but notice that I had "become glass," that inexact analogy of salt's crystalline and glass's random molecular structure. In chemistry and everyday masonry, the flowering of salt from a material is known as "efflorescence"; salt migrates from within a porous material—cement, bricks, stone, etc.—to the surface because of water therein. Water's saturation of brick, for example, carries the salt to the brick's surface and evaporates, leaving behind the salt "deposit." Salt heightens. The sagacious Brazilian poet and novelist Clarice Lispector writes, "For we are moist and salty beings, we are beings of seawater and tears . . . we are salty since sweating is our exhalation . . . I swear that's how love is."[17] I be-came in salty efflorescence—a very different be-cumming that led me to a very different out-cum than the gourd. I did not produce (bring forth my leading) but flowered (thrived and bloomed). With Lorde, I opened, stretched, and shared in "deep participation," in intracorporeality.

I was not the first human of glass or to feel glass-like.[18] *Homo vitreous* dates from the fourteenth through the late eighteenth centuries. Sick with the "glass delusion," Charles VI perceived his entire body as "glass, fused and brittle, fired into a whole that could shatter everywhere."[19] Perhaps in writing about becoming glass, I, like Charles VI and other "Glass Men," employed (akin to Haraway's material semiotics) "matterphor"—

"a tropic-material coil, word and substance together . . . agentic and thick."[20] My vitreous intracorporeality did not direct me toward the "pristine realization of self as object, flesh and bone fused into excruciating crystal clarity" of Charles VI—a project of self and world formation vis-à-vis said world and others (of mutuality and recognition)—but blurred the boundaries of human and nonhuman bodies in "deep participation" and disoriented my experience and account of production.[21] To be "salt caked" was deeply satisfying, but far from rendering me blissed out or at one with the world, this vitreous intracorporeality erupted, interrupting the line of production. At this juncture, I had two options: I could ignore and subsume this salty efflorescence within production, that is, straighten, align, or a-line—follow it off course. The latter is that queer rather than straight orientation discussed by Ahmed. I was attracted to the queer option, which not only was deeply satisfying but also allowed me to see and think about the straight eros of socialized desire. Becoming salt also "put me in touch" with the "natural resources" occluded by socialized desire and in the phenomenal appearance of the objects. Of salt and crystal, how could I not notice the depths to which the glass was rooted and the extractive industries that afforded "becoming glass"? Becoming a glassblower depends upon mining, be it for silica or the endless other minerals used to compose glass and affect its material properties, as well as fracking and drilling for gas to "feed the furnaces." But in the straight logic of production, the *mater*—that vital fertility of the living earth—is transformed into matter.[22]

In the straight logic of production, elemental love is stabilized like the glass itself, namely, "set straight"—be it by lime, curriculum, art markets, or otherwise. Production orientates mat(t)er. For Deleuze, metal is coextensive to all of matter—all is populated by "salts or mineral elements," but this "material

vitalism" is hidden in form.[23] Oren's vessels would be sold and erected in a collection atop pedestals or well-lit shelves, resource extraction hidden in gleaming hylomorphic transparency. Similarly, my *field*notes about blowing the gourd with Sarkis, attended the said, done, and visible, caught up as I was in the *field* (action and objects) of the socio-erotics of recognition in the hotshop. In the queerer love of vitreous intracorporeality, I exited the normative field of writing, of making, and of straight love. I left behind the straight logic of "becoming toward" and the socio-erotics of recognition "in relation to" an-other(s). Instead, I reveled in anomalous, elemental intracorporeality, porous wanderings, copious copulation, and promiscuity. Therein, desire and love always already are without yearning. I like a good orgy: that "orgy of being" described by Lispector. "It's not dangerous," she assuredly writes, "I swear it's not dangerous."[24]

I found the courage to answer glassblowing's challenge to think about that intracorporeality so visceral and emotionally experienced. I found the courage to love, to write love, and to open to the double entendre of "making love" as production and becoming. This meant digging and delving into those conversations that wove the Sisters of Glass, lessons about how-to, and constellations left by so many shooting stars of furnace glass on the floor. Yes, some glassblowers have straight sex. But the magnetic push and pull of opposites—desire's arc from lack to plenty—happens as a matter of production, too. In addition to making love, so too do glassblowers "make-love." Within the straight logic of production, this means making objects in the socio-erotics of recognition, wherein self and world are formed via an-other.[25] Thinking about salty copulations, salty becomings—and following them—queers this orientation. Elemental love and its opening onto the *mater*

of matter allowed me to leave the normative "field," that clearing of elemental intracorporeality and matterly promiscuity.

It's not either/or, however. As noted in my fieldnotes, "sexual feelings well up in me and I wonder if there is something to blowing glass and screwing. Yeah, sure folks are sometimes too tired. A day's work can be exhausting. But sex seems to follow glassblowing even when you're sweaty and disgusting. Or maybe it is *because* you're so sweaty and disgusting. The sweat tastes good and I wonder whether there is something about the sweat, salt, and whole pheromone thing." Yet the push and pull of the social world—that Bourdieusian magnetism—urges such salty salaciousness (siliciousness?)—on course. I did fall in love with Sarkis.

SARKIS'S B(L)OOM

On the night of the 2004 election, I interviewed Sarkis at Bo's Bar, tucked into the neighborhood behind New York Glass amid a budding art scene and its politics of urban gentrification. Like the neighborhood, its clientele was a mix of African Americans born and raised nearby and newcomers—white, Latinx, West Indian, and Asian—who occupied the garden- and attic-level apartments of the beautiful, four-story limestones for the going rate of $600/bedroom. Bo's, like most evenings, was full, with year-round Christmas lights dimly illuminating the three rooms. Sarkis was surprised to know I had "only ordered a ginger ale," ordered a beer, and joined me at the table. Rather formally, I reviewed the topic that I had proposed to discuss—learning to blow glass, the body, embodied knowledge—and, recording, dutifully began taking notes, should my recorder fail to distinguish his voice from the low din of hip-hop,

house, and an occasional Euro-American pop tune from the 1980s.

Sarkis spoke of growing up in Texas as a first-generation Chinese American, driving his pickup truck from San Francisco to New York City with his dog to start his art career following the completion of his MFA (master of fine arts) at a large Midwestern state school and finding community among artists in an early downtown Brooklyn live-work loft—a modest seven-story mercantile building around which skyscrapers now rise. Sarkis, a sculptor specializing in glass, earned his bread and butter like many emerging professionals teaching how-to courses at New York Glass: "I won't even say anything. I'll just gather a bunch of glass, sit at the bench, pull it into a rose . . . you know, the students are all gathering around at that point and they're like, 'Wow, a rose!' Then I'll take it over to the marver, tap it off, and just stand there watching it. And they're like, 'What?' But I don't look at them. So, I'm sitting [*sic*] there watching it and, you know, 'Boom!' It starts to crack and shatter and then they're all like, 'What?? Wait! Oh no!!' And I just laugh and look at them." I smiled with a knitted brow, jotting down a few notes, and continued my interview as he drank, wiping the beer foam from atop his sardonic smile onto the knee of his steel-gray polyester Dickies.

Sarkis's b(l)oom is a *pyromenon*—that fiery "puzzle of natural philosophy"—that presents the paradox of glass's rigid and molten states: The hot interior wants to expand, while the cool exterior wants to contract, the tension of which causes the explosion.[26] Uncannily, Luce Irigaray considers the kinship of flower and furnace in her inquiry into "elemental passions." Therein, the male gaze consummates the flower "in bloom" for the sake of that formation of male subjectivity. Severed and arrested from both its cyclical movement—opening with day

and closing with night—and its subterranean stems, roots, and earthen matter, the arrested flower, Irigaray muses is "no longer embracing. No longer embracing itself. No longer a brazier?" Of this, she quixotically asks, "Is it the splitting of that efflorescence? Mildew and crystal. For instance."[27]

Consider the brazier of Irigaray's flower and the furnace of Sarkis's rose, a contrast arguably between the Hestian hearth and Hephaestian forge. Sarkis's b(l)oom indeed severs "mildew" from "crystal," the subterranean from that produced in the power dynamics of natural resource extraction toward the formation of self and world vis-à-vis an-other/an object. Was not all of this said, done, and visible the object of my fieldnotes, caught up as I was in the field of human action, in the socioerotics of recognition? Sarkis's b(l)oom is swept into the dust pan and dumped into the knockoff bin at night's end. Because of contamination with floor dust and debris, the b(l)ooms are not remelted but disposed of in the dumpster to be collected by a private waste management company to go some "other" place. Yet, in the moment of Sarkis's b(l)oom—that cracking and shattering—it is only to the lesson in tensility to which Sarkis, his students, and, indeed, my notes attend. Unattended are the b(l)oom's origins, which are not selfsame as its causes. Hereby, Sarkis's *pyromenon* teaches that the glass is a *medium*, namely, that which mediates and exists only between or in reference to an-other. It is without coincidence that he explains learning to blow glass in terms of a "relationship":

> I was talking to my students about getting intimate with the glass like a relationship. You have to think about blowing a bubble out too far and it exploding like going to Shakespeare in the Park and that is one of the memories that you share together that becomes the whole that you call your relationship. You go into

situations with this person and you deal with the situation and you learn more and more and more. A lot of it is not something that you can write down, it's just something intuitive. It's nothing you even think about until it happens. You have to go through these things. As you do this, you become more intimate with the glass. Once you start figuring it out and experiencing the medium itself, and knowing what it can do, you can do more things. . . . The reason why some people are really, really good at it and some people aren't, is because some people really, really understand the medium and some people don't. . . . Intimacy is direct experience with the medium. It's not steps, it's not making a cup. It's like dribbling on the floor, getting things too hot, getting things not hot enough, it's understanding the medium, it's never going to go right, you just have to deal.

It is obvious to every glassblower that glass is defined as a *medium* by its working properties and, herein, that learning to blow glass is about understanding how to manipulate those properties toward an end.[28] As Ira, a studio technician and glassblower whom I once interviewed explained, "Once you understand that the point is to manipulate the glass, and not to 'blow a bowl,' there is a shift in the manner of thinking about the glass, the tools, the designs. It actually changes how you see the glass, how you feel it through the tools." The glass appears as a medium of manipulation, as a matter of course, because the glassblower is oriented as such. Sarkis's b(l)oom— that cracking and shattering—delivered a lesson in a working property of glass as a medium—tensility. But in doing so, it also left out the b(l)oom's matterly origins. Marxist sociologists call the implicit lessons embedded in explicit lessons the "hidden curriculum." In the relational logic of media, namely, as intermediaries toward an other, we lose the mat(t)er of its becoming.

MATERIA EROTICA ❧ 183

Direct experience with a medium (by which glassblowers nearly unanimously refer to the glass), that is, obscures its mineral origins. Flower and brazier open and close, ignite and extinguish, akin to the "double-ness" of women, themselves the furnace of man's birth, placenta and womb, without the unattached glory promised by Hephaestus's forge and crucible, wherein life is twice born.[29]

The splitting of the Irigarayan flower's efflorescence into mildew and crystal is an elemental imaginary with which to think the politics of sexual difference.[30] "Straight love" is caught up in phenomenal appearance and aims toward. This circumscribes eros to an arena of recognition, namely, a field from which queer loves that are and express anomalous intracorporeality are cleared. Embedded in such an arena—the hotshop—and so aimed, how could I not become caught up "where the action [was]" and desire to become a glassblower amid the fires, smoke, heat, steam, furnace roar? How could I not be swept away by Sarkis's practical charisma, wondering how my amateur body could respond to his prowess and be filled thereby?

After our interview at Bo's Bar, Sarkis walked me to a friend's apartment, where fellow graduate students watched an election in which the Republican incumbent George W. Bush would emerge victorious over the Democrat John Kerry by morning. "Hey," he called from down the sidewalk. I turned around. "Can I call you sometime?" he asked. I said, "Yes." We were engaged to be married two years later. The tensility of the relationship was apparent to the many who said it was a bad idea from the start. I heard many a glassblower say, "It's always a bad idea to date other glassblowers; it never works out." The end of the relationship followed quickly.

Sarkis harbored a handful of close friends and was notoriously complicated—a "bridge burner" with a personal history

littered with misunderstandings, breaks, and grudges. Amid this, however, no one disputes his magnetic charisma, and many were wooed, to bed or otherwise, by the transformative power of his practical pied-piping. Known for his prowess, Sarkis was a rock star—a hotshop hero—that very public masculinity of self, world, and feats in the socio-erotics of recognition. The b(l)oom promises clarity in crystalline performance, yet this clairvoyance comes only with marginalizing the anomalous elementality therein. I cannot help but see parallel lines between "becoming a glassblower" and "making straight love" in the hotshop as a Romantic tale of *Prometheus Unbound*.[31]

I, like the Greek *pornê*—the woman/wife turned prostitute, having left the patriarch's house—have wandered. Portable fire, brazier, mobile, unstable, and ambiguous, I, a woman "out of control" by being "out of place," turned *pornê*, recoiling from a logic of masculine domination, cunted and cunting.[32] Born not of hollow but of the devastatingly textured anomalous entwining that is living, the *pornê* wanders between households. She stays a while at any one. She then sets out again. To understand the wandering *pornê* in terms of modern sexual prostitution or sexual promiscuity would be to miss the point entirely. Instead, I invite you, dear Reader, to feel the philosophical resonance of this tale from and with that chaotic and wandering participation of and with the anomalous elemental world. Intracorporeality unbound. Making ever-emergent will never be contained; the cup will always overflow. The *pornê* lets it do so. If empty, she puts it back on the shelf and perhaps sets the table with it that evening for company. It'll be a lovely dinner party. Cups will break; cups will overflow. The ways of love and strife are many, contained and uncontained.

Far too young, Sarkis was diagnosed with cancer and passed away in the 2010s. He was forty-five years old. With gratitude and respect, I offer these thoughts about love, making love,

making-love, and the erotic orientations therein in memorandum, askew of those intimate relations of Sarkis's b(l)oom.

EXITING THE FIELD

Writing about love in the field bears questioning that field and its various trajectories, directions, and orientations. Love "in the field" proceeds topographically through signs—those objects proximate, legible, and visible. Falling in love, making-love, making love, and loving and losing love in the topography of the straight hotshop revealed the dynamics of *socialized desire*, wherein persons abnegate instinctual desire for connection with an objective world and thereby achieve both self and world. Arguably, when an ethnographic account of craft focuses on production, it follows this straight logic and documents "where the action is" toward the formation of self and world for recognition.[33] The "field" of the "fieldsite" and "fieldwork" is not neutral. In the United States, those "fields" long ago surveyed and staked, hoed and sown, by settler-colonialists perpetuate themselves in the topography of the field of social inquiry, the *mater* of *mat(t)er* overcome.[34] Through delving into the eros of intracorporeality—that elemental love, comingling, and copulation—I lost sight/site, but be-cam, off course, thereby.

RED

Fifteen years later, I was en route to Venice, to Murano, and sat at a Mexican-style bar at John F. Kennedy Airport, chatting with Roger, a middle-aged Midwesterner, and Vincent, a young Dutchman. They drank beer. I, a mezcal neat. Red soon appeared, taking the corner barstool adjacent to me and next to

Roger and ordered a Heineken. En route to Milan to participate in Fashion Week, Red was a strikingly handsome older, tall, and lanky man with sun-creased skin, slicked-back salt and pepper hair, strong jaw line, and a light Dutch accent that Vincent immediately recognized. Inspired by the Dutch connection, Red fished a black-and-white silk "Vincent Van Gogh" handkerchief from the pocket of his white linen shirt, the shoulder of which was beautifully hand-darned with a yellow squiggle of embroidery. A faux rose gold heart pendant with a dangling moonstone tumbled from the handkerchief into Red's hand. Bemused, he turned it around, its smooth and round to his rough and slender, laughed, pocketed it, and proclaimed in the husky voice of an at least occasional smoker who has enjoyed a lot of life and adventure, "I have no idea where that came from!"

Through a second round, the four of us talked about cars, agricultural technology, psychedelics, health care, nihilism, careers, fruit flies, more cars, glass, modeling, and more cars: Dodge Chargers and Challengers, Porsches, efficient European types, and classic Buicks—Red's Riviera, Roger's Regal, and my LeSabre. Red was a magician of sorts. Things appeared not only from his pocket and vintage leather duffel bag but also from his poetic way of weaving conversation. I stood to take my leave for my flight to Venice when Red laid his long, salt-worn, tawny-fingered hand on the bar and pushed it toward me. "Here," he said, "take this." As he lifted his hand, I saw the faux rose gold heart pendant with a dangling moonstone. I was surprised and touched. "Ah, thanks," I smiled, scooping it up. I zipped it into a purse pocket, shouldering the purse with my tote bag that carried a nearly finished version of this book. And like that, book and pendant flush against my side, as I turned toward my gate, I suddenly felt the significance of the fact that I was on the

legendary trip undertaken by so many American studio glass-blowers to Murano. Amid the day-to-day demands of dead-lines, family, work, holidays, and illness, I had not had the opportunity to think about the trip beyond pragmatics. "Gen-tlemen," I said, with a tip of my hat and gratitude for their insightful company, "it's been a pleasure."

CONCLUSION

Heart of Glass

Time is a great storyteller.
—Irish proverb

I led the maestro. He, warm hearted and giant-smiled for the ten minutes I had known him, was willing to play the game. It had taken him a moment to warm up. When he half-jokingly asked in a heavy accent, "Anyone want to try?" I eagerly raised my hand, stepping forward. He nodded and waved me toward him. I threw my heavy shearling coat, which was hardly protection against the damp January cold of the stones of Venice, onto a workbench. Taking the blowpipe from his extended hand, I gave no thought to the shared saliva that warranted the already-popped bubble at its end. Enthralled, I was on the precipice of blowing glass in a glasshouse on Murano, one of the oldest in the world.

Pat, a friend, neighbor, painter, and professor of art, had invited me to join her trip to Venice with her friends. Knowing about my research on glass and a self-proclaimed Venice-o-phile, she could not believe I had not been. One of her friends, a glass aficionado, had arranged that day's tour. Upon arrival,

the showroom director, a well-dressed and welcoming woman, explained that tours rarely happen but that they had made an exception, given the slow season. When the maestro had posed the question to our touring group, I had seen interest flit across some faces of my companions and had briefly thought, "I should let one of them go! They've never experienced it!" But it was as if the maestro's suggestion had opened a gate against which I was pressing body and soul. I was more than ready. Knowing of my experience and enthusiasm, my companions let me step into the opportunity.

Without knowing my glass history, the maestro gently held the pipe and guided me toward the marver. I let him lead me, bucking slightly. Despite my deference to his expertise, I didn't want to be babied. Reluctant to release the pipe, he cupped it midpoint at the edge of the marver in a yoke-like fashion. The idea seemed to be that he would hold it so that I could blow. With some jostling, I loosed the pipe just enough to raise and draw the mouthpiece to my mouth as I had been taught. My hands shook with nerves before the maestro, whose conviction that I needed nonstop guidance slowly waned as he realized that I knew something, a little something, the smallness of which in no way diminished the vastness with which it set me apart from those who knew nothing. I blew, knocking off an unexpectedly removable mouthpiece in the process, which he turned to pick up.

Pure and total delight flooded my newfound independence and steadied my determination as the maestro picked up and handed me the mouthpiece. I replaced it and began to marver, half-seeing the maestro's bottom lip fall open in disbelief. As I fell into the rhythms of cup making, a smile spread across his face. Pointing at me, he beckoned his colleagues from the flanking stations to come. I nudged the pipe toward him, indicating, as he well knew, that I needed a heat. In good fun, he

took the pipe from me and headed to the furnace to reheat in its *bocce*, or mouth, unlike the individual fire of the American glory hole. The maestro was a maestro, and I was an amateur. Though he was willing to play the game, we both knew, and I respected, that it was on his terms. As he heated the bubble, I promptly went to the bench and sat. Or, should I say, my body did all of this. Oblivious to anything save the call of the hot glass, tools, bench, and maestro, my body responded and carried me despite having not blown glass in several years. I needed only to be given the opportunity and allow it.

Seated on the cushioned bench, I watched the maestro heat my bubble in the furnace's mouth. He looked over his shoulder at me, and understanding his intentions, I nodded, jacks already in hand. Momentarily, he'd bring me the warmed bubble to tool. I looked for that mound of beeswax that one finds atop the tool bench in an American hotshop. None. He set the pipe onto the workbench arms and, taking leave, squatted at the mouthpiece to blow. I came onto the bubble with the jacks to "ride it like a wave," as Allen had taught me, rolling the pipe back and forth over the arms of the workbench as he blew. The glass was stiffer than I expected—an entirely different feel—and the bubble blew up just a bit. Perhaps he had also not blown much, not knowing if I could handle an expanding bubble. I proceeded nonetheless and necked it, rocking the jacks back and forth between the *moile* and the bubble, remembering to create the valley. I felt the lessons I had learned in every move. I flattened the bubble's bottom with the jack's handle, and the maestro looked down upon the bubble, nodding vigorously with a glowing smile and hands on hips.

As I set the jacks down—handle forward, tips back as they ought to be—he was already serving me a punty to transfer the bubble. Taking his cue, I grabbed the tweezers and, pulling the

pipe toward me, tacked the punty to the bubble's bottom even as he shoved it on himself. The work flowed just as it ought to in cup making—without pause or hesitation, humming. Quickly, I dipped the tweezer's tips into the bucket of water behind the bench. It was exactly where my body reached for it to be. I squeezed and then positioned the captured droplet just above the jackline and released—the thermal shock of the cool water on the hot glass spread in white veins. For good measure, I did it one more time—an uncouth maneuver that could have easily backfired by overcooling and cracking the glass. Fate spared me.

Looking up at the maestro as he looked at me, I flipped the tweezers upside down, lifted the pipe, and tapped it with the tweezer's back end. The bubble broke along the cooled jackline, releasing it from the blowpipe. So transferred, the first stage of cup making was complete. I rolled the blowpipe to the front of the bench, and an assistant whisked it away. Picking up the jacks and looking at him, I cocked my head toward the furnace. I needed a heat to open up the bubble and complete the cup. Instead, he stayed in place. My entire body felt the sudden stalemate of the otherwise flowing choreography of production. I knew that something had changed.

"Basta!" "Basta!" "Basta!" I heard, accompanied by an enough-already handclap each time. The well-dressed woman giving us the tour was intent on moving our group forward. "Basta!" she repeated, clapping. I knew that playtime was over. No matter. I was over the moon. The maestro put the punty with my bubble in the knockoff barrel—the destiny of so many of mine—as I shook the jacks at him in a gesture, saying, "Hey, what's the idea?! I was going to open that bubble up!" He clapped me on the shoulder, laughing good-naturedly as if to say, "Next time!" With eyes now off the glass, I noticed that

CONCLUSION ❧ 193

men from around the shop had gathered to watch, looking amused. Overjoyed would be an understatement of how I felt. With a difference of a thousand miles, a thousand years, and thousands of hours of experience, my body swelled with the others, tools, glass, heat, and heady scent. Together, we filled the cavernous old stone factory despite the draft through the single-pane iron-mullioned clerestory. The connection was real. I speak no Italian and the maestro, little English. Yet, though having just met, we knew each other.

I rejoined my group, who congratulated me, "Nice work!" The group included a close friend of mine for over twenty years, Ian, a professor of architectural history and theory in Paris. He knew of my research and writing but, living abroad, had not been with me during my years of fieldwork. His chiseled profile and sculpted acetate eyeglasses heighten his snarky and cutting humor. With a characteristic straight-toothed and dimple-inflected smile, he concluded with self-satisfaction, "Well, now I know what you've been up to all these years!" The woman giving the tour pleasantly welcomed me back but continued her commentary on the blowslot. Hands upturned and head shaking, she repeated: "We don't usually give tours. Sometimes, for some people. It's slow, the holidays," she repeated, "I can't understand why he permitted this! They never do that! It's not allowed. It's just not allowed." Her surprise surprised me! She continued in disbelief, "They can't do that!" and gesturing toward the furnace, concluded, "What if you got burned!" This point, concerning my ability rather than the anomaly of the situation, pierced my attention. Had she not just seen me blow glass with the maestro? Had she not realized that I "knew" what to do with the pipe and marver, how to sit in the bench, how to maneuver the tools and glass, and how to practically communicate with him? "Have you ever blown glass?" I asked

her, suspecting that I already knew the answer. "No, I haven't," she replied. I launched into the million and one reasons why she should—"At least gather once!"—while hearing about the obstacles that gender, the organization of work, and centuries of tradition presented to the possibility of her doing so.

I could not focus on the continued tour and, quitting the group, bid haste to find the maestro to snap a twenty-first-century selfie. He wasn't far and smilingly obliged. In the photo, the maestro and I are nearly cheek to cheek with arms around each other's shoulders, broad smiles nearly filling the entire frame. I returned to the tour group again, maestro-novice camaraderie archived as a digital snapshot. My descent from practice to observation jarringly halted the flood of dopamine I had felt upon joining the maestro in practice. No longer in and of the heat among glassblowers but instead looking at some finished objects lying atop insulating fiberglass pads, also called "fraks," I sensed longing carving into plenitude. It had not been but a minute when I felt an unexpected tap upon my shoulder. Turning around, it was him, arm outstretched. There, in the palm of his upturned hand, was a piece of murrine—those circles sliced like salami from a glass rod through which a design runs. The round was opaque white with an unfolding and winding whorl of translucent red swirls at its center. A hole had been coldworked through it like a bead, ready for a string, jump ring, or other interlocking or hooking mechanism. The undulating center was suspended in a cloud. I saw and felt myself in it: alive with red-hot blood amid a quintessential moment. Heart of Glass. A full moon rose over Venice that evening, spilling a white light that did nothing to warm the chilled cobblestone pathways impervious to automobiles. Despite winter's reach through the soles of my shoes, I felt nothing but radiant warmth.

CONCLUSION ❧ 195

OF HOOKS AND ANGLERS,
TRAILS AND TALES

I went to Murano in the footsteps of visitors before me: Sir James Howell, Queen Anne, and even the protagonists, Stelio and Foscarina, of D'Annunzio's *The Flame,* who expressed their love while strolling along Murano's central canal. The canonical tale of Harvey Littleton picking up the maestro's tools in a glasshouse on Murano while the glassworkers were lunching in the *menza* was at the forefront of my mind. So too were the visits of Dale Chihuly in 1968 and Richard Marquis in 1969 that legendarily amalgamated Venetian technique to Littleton's early studio tradition. I think back to the May 1979 inscription written in green ink by M.M. to Chris on the inside cover of Ada Polak's *Glass: Its Tradition and Its Makers* (1975), where she points Chris to Polak's chapters on the glasshouses of "Venice, Murano, and Torcello" and the migration patterns of glassworkers. This history, she writes, reinforced her impression that her practice had European ancestry. My journey was through and with the intertwined matters of embodiment, practical knowledge, and learning the art of glassblowing in the settler-colonial studio context. The journey thereto had been woven, and so too did each footstep knot anew—the furnaces, canals, cobblestone paths, and generous glasshouse owners, managers, and blowers rising to meet me (or not) with each step. This vitreous world never exists to reinforce, but true to its nature, it points to, is emblematic of, and embraces constant change.

Throughout this book, I have drawn upon Hannah Arendt's classic *The Human Condition* (1952). For Arendt, the work of *homo faber,* the craftsman, is characterized by the endurance of his objects of production. He erects a world that is ideally

suitable and fit for action and speech, namely, those modes by which man distinguishes himself from mere bodily existence as human.[1] Herein, man forges a "new beginning" or "second birth" that transcends his originary beginning in physicality; it's "with the creation of man," she argues, "[that] the principle of beginning came into the world."[2] In the case of glassblowing, setting the pot creates a manmade ground that not only converts living materialities into resources but also, as embedded in early imperialism, plantation, and settler colonialism, vitrifies a New World. Arendt did not arrive at a theory of vibrant matter, but she did see a connection between modern man's alienation from Earth—that forged by the Age of Discovery, in which all became land known and mapped—and violence.[3] Man's creations assert a "beginning" proper to human time, yet what *Fire Craft* has shown is that intracorporeality, that elemental complicity, pulls man down, immersed in unending becoming.

For Arendt, human-earth metabolism characterized labor belonging to *animal laborens*. Labor is never done and cannot, unlike the work of *homo faber*, erect an enduring world in which men can act and tell their stories. Labor, namely, meeting life's necessities, was "slavish," as it meant being "enslaved by necessity".[4] *Fire Craft* has shown the depth, viscosity, and viscerality of human-world co-becoming in matters of skill acquisition, learning, language, teamwork, and love. Richard Sennett, Arendt's student and a figurative advisor and teacher to me, also took issue with Arendt's subordination of labor and work to action and speech. In *The Craftsman* (2007), Sennett suggests that "thinking and feeling are contained in the process of making."[5] I carry this finding beyond the sphere of humanism to include the nonhuman world. Not only is making thinking, but "making-thinking" is also matter of the elemental.

CONCLUSION ☞ 197

At the start of this book, I set out my goal: to find the hook or hooks by which folks get caught up in the art of glassblowing and, like any good angler, understand how the catch gets reeled in. I grew up on the shore of Lake Huron: There is no fishing without the sea. "Getting hooked" is a matter of sensible communion between the hooked and the hook, that elemental complicity with the logic of practice. The glassblower swells not dwells—only to then dwell and swell again. Sometimes, this is well aimed, but other times it is not. The double meaning of aspiration—to both aim toward something higher and breathe in—is apropos. Indeed, grounded dwelling, watery flows, fiery swelling, and the aspiration of both breath and aim are mixed. My query into embodied knowledge, the meaning of making, and the development of proficiency turned upon itself, inhabited and inhabiting as I was by an elemental complicity.

Discovering the warp and weft of embodied knowledge and intracorporeality permitted me to move beyond an account or theory of skill rooted in the acquisition to elemental immanence. Humans rise and fall. The ABCs of the Book of Glassblowing coordinate, but learning to see and read counterintuitively demands losing track in elemental complicity. The story of *Fire Craft* bears these trajectories, reversals, and emergent co-becomings.

I belong to the world and am of it. I feel that. I am that. And I know through and with that. At the same time, I am compelled, like Sarah, Lot's wife fleeing Sodom and Gomorrah in the Book of Genesis, to look behind, hardening that co-belonging and co-becoming—a pillar of salt standing apart and erect from the sea. I am this unending problematic and embrace it as my more-than-human condition. The double-edged sword is alive and well amid love and strife in the hotshop. This has

allowed me to understand that embodied knowledge is both a matter of intracorporeality—of elemental complicity—and progress along the arc of intentionality.

Storytelling has two options for Donna Haraway. On the one hand, there is the tale of the hero—a combative tale of action in which the actor overcomes all others—with tools, words, and weapons—to capture his bounty. In contrast to this "prick tale," a "carrier theory of storytelling" tells stories in human/nonhuman reciprocity. Herein, the story conveys not a possibility realized by a human but a human becoming with and from the humus of its making.[6] The hotshop hero—one marked by the movements of aspiration, failure, and cunning—cannot be isolated as a tale of overcoming, however. By striving toward, suffering with, and thinking about glassblowing, I have learned that gravity and grace are one and the same. The hero tale is not of prick overcoming but striving and failing, grasping and gasping, and staying on point—regardless of goal—while remaining open. Attention requires inattention; pursuit, porosity. *Here lies lessons learned.* It's not just rock stars like Allen and Sarkis, who are hotshop heroes; instead, like Schmid's novice waving, greeting, and meeting the furnace, the hero is any novice undertaking the journey of becoming a glassblower. Sagacious ones knowingly carry a bag.

In celebration of the consanguinity of glassblower, glass, and the elements, *Fire Craft* has told both a story of skill and about the shared, ongoing, and unfolding intracorporeality of bodies, both human and non-. As an elemental ethnographer rather than an ethnographer of the elements, I write to you, Reader, from here—that swelling and dwelling, erotic in its intracorporeal entwinements and aspirational in its aim; you can find it at the center of the glassblower's blown vessel.

TOWARD A SYMGEOLOGY OF STUDIO GLASS

I got caught up in the arc of becoming a studio glassblower as a matter of skill acquisition and practical knowledge only to discover the intracorporeality from which the thresholds of achievement are charted. In *Fire Craft*, I have explored this in elemental complicity, unpacking fire and air in particular and the mixture of quintessential cup making. This exploration has only opened up more questions. What is the "stuff" of glassblowing? That batch reliably counted upon as the art's medium? Looking into the elements of the art has drawn my attention to mines and minerals. By attending them, I bridge the ecological lacunae across studio glass literature, practices, and the environment. Notably, this includes an account of resource extraction and an inquiry into the *symgeologic* dynamics of studio glass. Like the term "symbiotic" refers to how humans co-become with the biological (the example of the inter-relationship of gut flora, emotions, and brain function is a popular case in point), the "symgeologic" poses a little-explored inquiry into the co-becoming, or *symcoming*, of the human and the geological.

The material life of glassmaking—mines and minerals—does exist in the records of color, cullet, and batch-making facilities as well as in the undocumented memories and contemporary experiences of mining and studio glassmaking professionals. As I was completing *Fire Craft*, I became drawn into the depths of abandoned quartz mines by their whispers and seductive glints. I have felt the soft flows and cool paste of mixing the raw minerals of glass batch in my bare hands. I have felt the dust of silica, feldspar, and other powdered minerals in my hair and seen its clouds through streaming sunlight. This new

research combines concerns regarding the human experience of self-determination and creativity with those of the living (and dying) ecological world. With these tides, I, too, will swell and dwell. Admittedly, I am still hot and bothered. Long ago, infected with the glass bug, I'm not sure I will ever recover. Gladly so.

CODA

In *On the Heavens*, Aristotle buried a cutting gibe against Empedocles in a passing comment about the uselessness of a shoe when not worn.[7] Empedocles's life ended when he leaped into a volcano on Mount Etna. Legend has it that the volcano spit up one of his shoes. Knowledge does come with a purpose, but so too with the cognizance of and openness to elemental autochthony.

ACKNOWLEDGMENTS

My life has borne this book—the people, places, and stuff with which its grown, unfolded, and journeyed in so many directions. I am eager to thank each one with deep gratitude. Of first order, I would like to thank the world of wonder in which I was first raised. At any moment, I see the sparkle of the freshwater Great Lake bay on which my family lived. I see its harvest moons, its ice, and its winds and cherish the limitless embrace I felt in its waters during the short summer season of northern Michigan. I can feel the jutting carrot tops of our vegetable garden, the beds of bleeding hearts, and the willow, which provided a petite niche at the branching of her trunk into towering limbs and lanky, ample fronds from which to swing down. That beauty, part and parcel of my flesh and blood, continues to propel me to wonder, "World, who are you?"

There were no better accomplices in this endeavor than my family. Rare is the conversation with my father, Timothy J., in which something is not noticed, questions are not asked, and problems are not posed and pursued. His sense of curiosity is unparalleled. In keeping, no color, texture, line, shape, space, tone, or proportion goes unnoticed by my mother, Margaret

Ann. Apprenticing her keen aesthetic eye taught me how to see and to know that I was immersed in a world of possibility, all of which could be arranged, rearranged, and arranged again, endlessly anew in the act of creation. In all of this, my greatest accomplice is my brother, Shawn. His steadfast camaraderie, humor, and honed practical aesthetics draw us together in creative, adventurous, and often hilarious ways. Thank you for weaving this early life cradle from which I still live. There are many more in my hometown community to thank. While I cannot list them all, I'd like to give special thanks to my stepmom, LuAnn; my stepsisters, Aimee and Kelly; my stepbrother, Tony; my Aunt Connie and Uncle John; my O'Connor and Champion grandparents; Mr. Bailey and Mrs. Reasner; and our dear family friend, Mr. Rieth.

My home community set me on this path, but I could not have written this book without the support of my husband, Taylor. It's with deep gratitude that I reflect on your calm disposition, patience, and unwavering belief in and love for me. Thank you for your joy, fun, love, and the beautiful gift of music that you brought into my life. Our sons have woken in the dark of many early mornings to find me bent over a manuscript at my desk or kitchen table, vigorously editing with my characteristic Pilot G-Tec-C 0.25 pens, nursed by a very strong cup of coffee or tea. Their warm presence, which calls for breakfast and the doings of the day, reminds me that life does the writing and not vice-versa. Thank you, boys, for keeping me in the present, for your curiosity, and for the endless opportunity to learn to better follow the flow rather than hammer it into a track.

I would also like to thank my mother-in-law, Ann Bergren. Both a classicist and architectural theorist, her work brought *mêtis*, the Greek concept of cunning intelligence, into my life in myriad ways. To Uncle Neil and Aunt Kathy, thank you for

taking me in like a daughter. Neil's constant "life meetings" with me kept me writing, applying, and simply trying to become better. It's from the gentle mountainous cradle of their home that I've written much of this work. Their generosity is only matched by that of the land, which grounded me in a body-world relation very unlike the Great Lake horizon on which I had been raised. Thank you for the deep roots you've lent to my feet, mind, and family.

I am a first-generation college student. Getting a PhD was something that no one knew much about. I moved to New York City after having lived in Europe and India and found elements of both. Attending the New School for Social Research, I participated in the local inter-consortium classes, meeting Craig Calhoun and Richard Sennett at New York University. It was a seminar in the Sociology of Culture, the second year of my master's degree, and the fall of 9/11. The community that emerged from this seminar was my intellectual family, which was only to be matched by the support of my NSSR advisor, Terry Williams. My introduction to ethnography with Terry was life changing; he encouraged my creative writing style, assuring me that poetics could live with theory and method. Craig and Richard served as mentors extraordinaire, allowing me to find my voice in countless workshop-seminars. These seminars, called NYLON (NYU and London School of Economics), ran year-round, with an annual conference alternating between London and New York City. All of my early publications were written in that incubator. I owe great thanks to my NYLON family, without whom I would not be the academic person I am today. Special thanks go to my friend and fellow sociologist Andrew Deener; our conversations always get me thinking. The final version of this book would not be what it is without such insights and anecdotes. Many thanks.

No book could be written with an ounce of joy without the love and friendship of many. To my beloved coming-of-age girl-friends: Amanda, Atsuko, Carole, Grace, Jasmine, Patricia, Rubina, Susie, and Tsuya. And to the many others who have brought so much love into my life: Kostas, Fotini, Savvas, Ellis Jr., Ellis Sr., Alice, Greg, Rodrigo, Manolo, Ipek, Deniz, Horacio, Figen, Micah, Andre, Chanel, Oisin, Ken, Mani, Jon, Morgan, Gina, Brent, Martie, Lizbeth, Pauline, and so many more neighbors, friends, and colleagues whom I hold dear.

Most of all, I would like to thank the glassblowers at New York Glass, who welcomed me into the community to write about embodied knowledge in glassblowing. The time with you changed my life in more ways than one. The names used in this book are pseudonyms. Having the opportunity to think with and through glass has become my lifelong pursuit and passion. I am indebted to you and your art. Looking ahead, I would like to thank Tom, Greg, and the folks in Appalachia whose warm welcome and support carried this research into its next phase.

GLOSSARY

Selection taken from the online Corning Museum of Glass *Glass Dictionary* (https://allaboutglass.cmog.org/glass-dictionary/) and the website of the toolmaker Carlo Dona (https://www.carlodona.com/en/glossary/).

annealing: The process of slowly cooling a completed object in an auxiliary part of the glass furnace or in a separate furnace. This is an integral part of glassmaking because if a hot glass object is allowed to cool too quickly, it will be highly strained by the time it reaches room temperature; indeed, it may break, either as it cools or at some later date. Highly strained glasses break easily if subjected to mechanical or thermal shock.

avolio: (Italian) A spool-shaped piece of glass, which, as a rule, is used to unite a bowl with its base. In a drinking glass, it connects the upper portion (known in Muranese as *bevante*) with the stem (in Muranese, *gambo*).

batch: The mixture of raw materials (often silica, soda or potash, and lime) that is melted in a pot or tank to make glass.

bench: The chair used by the gaffer while forming a glass object. Traditionally, this is a wide bench with arms, on which the gaffer rests the blowpipe with its parison of molten glass and rolls it backward and forward so that the parison retains its symmetrical shape during the forming process.

bit: A mass of small and freshly gathered molten glass from the furnace. Also known as a gob.

block: A tool made of hollowed-out wood that forms a hemispherical recess. After being dipped in water to reduce charring and create a

206 ❧ GLOSSARY

cushion of steam, the block is used to form the gather into a sphere before it is inflated.

blow hose: A neoprene tube attached to a swivel with a mouthpiece at one end. It enables the glassblower to blow into the bubble while working it in the flame.

blowing: The technique of forming an object by inflating a gather or gob of molten glass on the end of a blowpipe. Traditionally and in modern furnace working, the gaffer blows through the tube, slightly inflating the gob, which is then manipulated into the required form by swinging it, rolling it on a marver, or shaping it with tools or in a mold. It is then inflated to the desired size. In flameworking, one end of the glass tube is heated and closed immediately, after which the worker blows into the other end and manipulates the hot glass.

blowpipe: An iron or steel tube, usually four to five feet long, for blowing glass. Blowpipes have a mouthpiece at one end and are usually fitted at the other end with a metal ring that helps to retain the gather.

blower: The glassworker that blows the air through the blowpipe.

blowing: The technique of forming an object by inflating a gather or gob of molten glass on the end of a blowpipe. A gaffer blows through the tube to slightly inflate the gob, which is then manipulated by swinging it, rolling it on a marver, or shaping it with tools or in a mold. The form is then inflated to the desired size.

borsèlle: A traditional, basic glassmaking tool. A kind of pair of flexible tongs, resembling chimney tongs and used for squeezing, modeling, and shaping objects.

bubble: (1) Called a parison, from the French *paraison*. A gather, on the end of a blowpipe, that is already partly inflated. (2) A pocket of gas trapped in glass during manufacture. The term is used both for bubbles introduced intentionally (known as air traps or beads) and for unwanted bubbles created during the melting process. Very small bubbles are known as seeds.

cane: A thin, monochrome rod or a composite rod consisting of groups of rods of different colors, which are bundled together and fused to form a polychrome design that is visible when seen in cross section.

cord: A part of the glass that differs in composition from the surrounding matrix. This difference produces a change in the refractive index, which

GLOSSARY ❧ 207

enables the cord to be seen as a streak and so spoils the appearance of the glass.

cracking off: The process of detaching the unwanted portion of the parison from the blowpipe and the intended rim.

crown glass: Sheet glass made by blowing a parison, cutting it open, and rotating it rapidly with repeated reheating until the centrifugal force has produced a flat disk. After annealing, the disk is cut into panes. Bull's-eye panes come from the centers of the disks and display the thickened area where the parison was attached to the pontil.

cullet: (1) Raw glass or pieces of broken glass from a cooled melt, intended for use as an ingredient of batch; (2) scrap glass intended for recycling.

filigrana: (Italian, "filigree glass.") The generic name for blown glass made with colorless, white, and sometimes colored canes. The *filigrana* style originated on the island of Murano in the sixteenth century and spread rapidly to other parts of Europe, where façon de Venise glass was produced. Manufacture on Murano continued until the eighteenth century and was revived in the twentieth century.

forcella: (Italian) An iron rod approximately three meters long with a two-pronged fork at one end. It is used to maneuver the still-hot glass pieces to the annealer and position them according to the annealing requirements.

flux: A substance that lowers the melting temperature of another substance. For example, a flux is added to the batch in order to facilitate the fusing of the silica. Fluxes are also added to enamels in order to lower their fusion point to below that of the glass body to which they are to be applied. Potash and soda are fluxes.

free blown glass: Glassware shaped solely by inflation with a blowpipe and manipulation with tools.

frit: Batch ingredients such as sand and alkali, which have been partly reacted by heating but not completely melted. After cooling, frit is ground to a powder and melted. Fritting (or sintering) is the process of making frit.

furnace: An enclosed structure for the production and application of heat. In glassmaking, furnaces are used for melting the batch, maintaining pots of glass in a molten state, and reheating partly formed objects at the glory hole.

208 ◈ GLOSSARY

gaffer: (corruption of "grandfather") The master craftsman in charge of a chair, or team, of hot-glass workers.

gambo: (Italian) The stem, which may take various forms, supporting the bowl of a glass and uniting it with the foot.

garage: A heating chamber used to hold parts of objects that are intended to be assembled on the blowpipe while other parts are being made.

gathering iron: A long, thin rod used to gather molten glass.

glass: A homogeneous material with a random, liquidlike (noncrystalline) molecular structure. The manufacturing process requires that the raw materials be heated to a temperature sufficient to produce a completely fused melt, which, when cooled rapidly, becomes rigid without crystallizing.

glory hole: (1) A hole in the side of a glass furnace, used to reheat glass that is being fashioned or decorated; (2) a separate appliance for reheating glass.

gob: See **bit**.

incalmo: (Italian) The technique of constructing an object, usually a vessel, by fusing two or more blown-glass elements. The process, first practiced in the Islamic world in the Middle Ages, demands great precision because the edges of the adjoining elements must have precisely the same diameter.

jacks: A tool with two metal arms joined at one end by a spring. The distance between the arms is controlled by the glassworker, who uses jacks for a variety of purposes while shaping the parison (for example, to form the mouths of open vessels). This tool is also known as a *borsella* or *pucellas*.

lime: Calcined limestone, which, added to batch in small quantities, gives stability. Before the seventeenth century, when its beneficial effects became known, lime was introduced fortuitously as an impurity in the raw materials. The addition of insufficient lime can cause crizzling.

lip wrap: A trail, usually of a contrasting color, wrapped around the edge of the rim. It is also known as an edge wrap.

marver: (from French *marbre*, "marble") (Noun) A smooth, flat surface on which softened glass is rolled, when attached to a blowpipe or pontil, in order to smooth it or to consolidate applied decoration. (Verb) To roll softened glass on a marver.

GLOSSARY ❧ 209

melt: The fluid glass produced by melting batch.

melting point: The temperature below which glass acts as a solid and above which it can be shaped.

metal: A term frequently used as a synonym for glass. It is misleading because glass is not a metallic substance. The use of this term is discouraged.

moil: The unwanted top of a blown object. When the last stage in the forming process is the removal of the object from the blowpipe, the result is a narrow opening that almost certainly is not what the glassblower desires. After annealing, therefore, the top of the object is removed, usually by cracking off. The moil from a mold blown object is often known as an overblow.

mold: A form used for shaping and/or decorating molten glass. Some molds (e.g., dip molds) impart a pattern to the parison, which is then withdrawn and blown and tooled to the desired shape and size; other molds (sometimes known as full-size molds) are used to give the object its final form, with or without decoration. Dip molds consist of a single part and are usually shaped like beakers. Full-size molds usually have two or more parts and can be opened to extract the object. Nowadays, most molds are made of metal, but stone, wood, plaster, and earthenware molds were used in the past and are still occasionally employed today.

mold blowing: Inflating a parison of hot glass in a mold. The glass is forced against the inner surfaces of the mold and assumes its shape, together with any decoration that it bears.

murrine: Murrine are slices of cane. Murrina is the singular form of the word, but you will also see murrine spelled "murrini" in publications and online.

morise: (Italian) A traditional Murano decoration consisting of an undulating design made by applying a thread of hot glass to a surface and pinching it with borsèlla. In practical terms, it actually comprises a twist of glass that is placed on the object being made and fashioned into the characteristic undulating pattern.

natron: Sodium sesquicarbonate, originally obtained mainly from the Wadi el-Natrun, northwest of Cairo. It was commonly used by Roman glassmakers as the alkali constituent of batch.

necking: Reducing an end of a blown glass object to form a bottle neck.

210 ❧ GLOSSARY

obsidian: A volcanic mineral that was the first form of natural glass used by humans. It is usually black, but it can also be very dark red or green; its splinters are often transparent or translucent.

paddle: A wooden tool used for forming hot glass, usually flattening the bottom of bubbles in order to form a vessel.

paciòfi: (Italian; American: parchoffi) Glassmaker's tools similar to borselle but terminating in two wooden sticks. They are used for "opening" vases and whenever the use of metallic implements might result in the glass being "scratched."

parison: See **bubble.**

punty: The punty, or pontil, is a solid metal rod that is usually tipped with a wad of hot glass, then applied to the base of a vessel to hold it during manufacture. It often leaves an irregular or ring-shaped scar on the base when removed. This is called the "pontil mark."

pot: A fire-clay container in which batch is fused and kept molten. The glassworker gathers glass directly from the pot.

reticello: (Italian, "glass with a small network") A type of blown glass made with canes organized in a crisscross pattern to form a fine net, which may contain tiny air traps.

rondelle: Flat blown glass that was spun hot.

sand: The most common form of silica used in making glass. It is collected from the seashore or, preferably, from deposits that have fewer impurities. For most present-day glassmaking, sand must have a low iron content. Before being used in a batch, it is thoroughly washed, heated to remove carbonaceous matter, and screened to obtain uniformly small grains.

seeds: Minute bubbles of gas, usually occurring in groups.

shears: A tool used to trim excess hot glass from an object during production. Many modern shears are embedded with chips of industrial diamonds.

silica: Silicon dioxide, a mineral that is the main ingredient of glass. The most common form of silica used in glassmaking has always been sand.

soda: Sodium carbonate. Soda (or alternatively potash) is commonly used as the alkali ingredient of glass. It serves as a flux to reduce the fusion point of the silica when the batch is melted.

soda-lime glass: Historically, the most common form of glass. It contains three major compounds in varying proportions, but usually silica (about

60–75 percent), soda (12–18 percent), and lime (5–12 percent). Soda-lime glasses are relatively light, and upon heating, they remain plastic and workable over a wide range of temperatures. They lend themselves, therefore, to elaborate manipulative techniques.

soffietta: (Italian) A tool consisting of a curved metal tube attached to a conical nozzle, used to further inflate a vessel after it has been removed from the blowpipe and is attached to the pontil. The glassblower reheats the vessel, inserts the nozzle into their mouth so that the aperture is blocked, and then inflates the vessel by blowing through the tube.

stem: The narrow part of a goblet or tazza that separates the bowl from the foot.

stemware: The collective name for drinking vessels and serving dishes with a stem supporting the bowl.

taglia: (Italian) A square-ended knife used to shape or sculpt molten glass on the blowpipe.

tank: The large receptacle in a furnace for melting batch. First used in antiquity, it replaced pots in larger glass factories in the nineteenth century.

tooling: The result of using a tool or tools.

tweezers: A tool used for decorating glass objects by pinching them while still molten.

NOTES

PREFACE

1. Lola Kovener and Geoffrey T. Hellman, "Easy Does It," *New Yorker*, September 21, 1945, 17, https://www.newyorker.com/magazine/1945/09/29/easy-does-it-2.

INTRODUCTION: ARRIVING AT NEW YORK GLASS

1. See, for example, Eugene Cooper, *The Wood-Carvers of Hong Kong*; Dudley, *Guitar Makers*; Marchand, *The Pursuit of Pleasurable Work*; Terrio, *Crafting and the Culture and History of French Chocolate*; Kondo, *Crafting Selves*; Singleton, "Japanese Folkcraft Pottery Apprenticeship"; Herzfeld, *The Body Impolitic*; Hendrickson, *Weaving Identities*; Wilkinson-Weber, *Embroidering Lives*; Makovicky, "'Something to Talk About'"; Venkatesan, "Learning to Weave; Weaving to Learn . . . What?"; Paxson, *The Life of Cheese*; Surak, *Making Tea, Making Japan*; Tsing, *The Mushroom at the End of the World*; Ocejo, *Masters of Craft*; Sudnow, *Ways of the Hand*; Rotella, *Good with Their Hands*; Downey, *Learning Capoeira*; Wacquant, *Body and Soul*; Hancock, *American Allegory*; Lindsay, "Hand Drumming"; Clawson, *I Belong to This Band, Hallelujah!*; Stoller, *A Taste of Ethnographic Things*; Ingold, *Making*; Ingold, *The Perception of the Environment*; Geurts, *Culture and the Senses*; Howes, *Empire of the Senses*; M. Harris, *Ways of Knowing*; Grasseni, "Good Looking"; Ingold, *Being Alive*; Bishir,

214 &) INTRODUCTION

Crafting Lives; Farr, *Artisans in Europe*; Rock, Gilje, and Asher, *American Artisans*; Bridenbaugh, *The Colonial Craftsman*.

2. Lave and Wenger, *Situated Learning*.

3. Calhoun and Sennett, *Practicing Culture*; Bourdieu, *The Logic of Practice*.

4. Miller, *Materiality*.

5. Nash, *Crafts in the World Market*; Tice, *Kuna Crafts*; Grimes and Milgram, *Artisans and Cooperatives*; Coy, "Being What We Pretend to Be"; Buechler and Buechler, *The World of Sofía Velasquez*; Lave, *Apprenticeship in Critical Ethnographic Practice*; Downey, Dalidowicz, and Mason, "Apprenticeship as Method."

6. Marchand, *Making Knowledge*; Ingold, *Making*; Smith, Meyers, and Cook, eds., *Ways of Making and Knowing*; Haraway, *Staying with the Trouble*; Alaimo, *Bodily Natures*; Coole and Frost, eds., *New Materialisms*; Barad, *Meeting the Universe Halfway*; Bennett, *Vibrant Matter*.

7. Bennett, *Vibrant Matter*.

8. Geertz, *The Interpretation of Cultures*; Alaimo, *Bodily Natures*, 2010; Engert and Schürkmann, "Posthuman?"

9. On becoming with animals, see, among others Haraway, *The Companion Species Manifesto*; and Boisseron, *Afro-Dog*.

10. New Daggett, *The Birth of Energy*; Neimanis, *Bodies of Water*; Cohen and Duckert, eds., *Elemental Ecocriticism*; Sharpe, *In the Wake*; Coole and Frost, *New Materialisms*; Gumbs, *M Archive*; McDermott Hughes, *Energy Without Conscience*.

11. On sensory ethnography, see, for example, Pink, *Doing Sensory Ethnography*, 2nd ed. On touch, see, for example, Classen, ed., *The Book of Touch*; and Sedgwick, *Touching Feeling*.

12. On the neologism *intra-action*, see Barad, "Posthumanist Performativity."

13. Arendt, *The Human Condition*, 254; Marx, "Economic and Philosophic Manuscripts of 1844," 70–81.

14. Arendt, *The Human Condition*, 137–41.

15. Haraway, *Staying with the Trouble*, 40.

16. Barad, *Meeting the Universe Halfway*, 378.

17. C. Anderson, *Makers*.

18. Currid, *The Warhol Economy*; Ocejo, *Masters of Craft*.

INTRODUCTION ↔ 215

19. Adamson, "The Revenge of the Pastoral." Adamson builds on his earlier analysis of nostalgia in craft revival in *The Invention of Craft* to critically challenge craftwork's self-conception as "oppositional."

20. McCray, *Glassmaking in Renaissance Venice*, 86.

21. McCray, *Glassmaking in Renaissance Venice*, 86.

22. McCray, *Glassmaking in Renaissance Venice*, 86.

23. Howell, *Epistolae Ho-Elianae*, 1:71.

24. Howell, *Epistolae Ho-Elianae*, 1:74.

25. "*Fatta di uetro io son, e son di soffio.*" "Fornace Da Vetri," British Museum, Online Collection, 1852, 1009.1036.

26. "Fornace Da Vetri." The "Holy League" included Venice, Austria, Russia, and Poland.

27. D'Annunzio, *The Flame*, 235.

28. Biringuccio, *Pirotechnia*, 132.

29. Schwind, "The Glassmakers of Early America," 189.

30. Harris, "Pyromena."

31. Clifford and Marcus, *Writing Culture*; Clifford, *The Predicament of Culture*; Rabinow, *Reflections on Fieldwork in Morocco*.

32. Heidegger, *What Is Called Thinking*, 14.

33. Heidegger, *What Is Called Thinking*, 14.

34. Heidegger, *What Is Called Thinking*, 16.

35. Only with the late, posthumously published work of Maurice Merleau-Ponty does phenomenology, which earnestly sought to voice lived experience, turn toward "antihumanistic humanism"; there are no subjects or objects but rather consanguineous styles of being only later analytically defined as "animal," "vegetable," "mineral," or "human." "Course Notes," in *Husserl at the Limits of Phenomenology*, 67–75; see also Leder, "Embodying Otherness."

36. Drexler-Lynn, *American Studio Glass 1960–1990*; Koplos and Metcalf, *Makers*; Lucie-Smith, *The Story of Craft*.

37. A version of this chapter has been previously published: O'Connor, "Embodied Knowledge."

38. Weiss, *Body Images*, 5. A version of this chapter has been previously published: O'Connor, "Inter- to Intracorporeality."

39. Weiss, *Body Images*, 5–6.

40. Latour, *Reassembling the Social*, 46. Please also see Ingold's critique of "network" (connecting dots or intersecting routes) from the perspective,

216 ∼ INTRODUCTION

borrowing from Henri Lefebvre (1991), of "meshwork" (interwoven co-lived trajectories). Ingold, *Lines*, 80–81.

41. Irigaray, *The Forgetting of Air in Martin Heidegger*; Leder, *The Absent Body*.
42. Macauley, *Elemental Philosophy*, 354.
43. A version of this chapter has been previously published: O'Connor, "Materia Erotica."
44. Crutzen and Stoermer, "The Anthropocene."
45. Margetts, "The Post-Craft Turn."
46. Risatti, *A Theory of Craft*, 2007.
47. Adamson, *The Invention of Craft*.
48. Heraclitus, *Fragments* 37.

1. THE GLASSY STATE: SETTING THE POT OF MAN AND WORLD

1. Pellatt, *Curiosities of Glassmaking*, 39.
2. Jarves, *Reminiscences of Glass-making*, 43.
3. Scoville, *Revolution in Glassmaking*, 31; Polak, *Glass*, 24-27; Jarves, *Reminiscences of Glass-making*, 43.
4. Engle, "The Glassmaker's Salamander."
5. Scholes, *Modern Glass Practice*, 4.
6. Palmer-Schwind, "Glassmakers of Early America," 181.
7. Martineau, "Birmingham Glass Works," 33, 34, 36.
8. Martineau, "Birmingham Glass Works," 34, 36.
9. Neri, *The World's Most Famous Book on Glassmaking*, 213.
10. Ashton, *Social Life in the Reign of Queen Anne*, 218-19.
11. Jarves, *Reminiscences of Glass-making*, 37.
12. Jarves, *Reminiscences of Glass-making*, 57.
13. Beretta, *The Alchemy of Glass*, 8-22.
14. Neri, *The World's Most Famous Book on Glassmaking*, 213-16.
15. Newman, *Promethean Ambitions*, 25–27.
16. Neri, *The World's Most Famous Book on Glassmaking*, 272.
17. Biringuccio, *Pirotechnia*, 126; Neri, *The World's Most Famous Book on Glassmaking*, 45.
18. Sennett, *The Craftsman*, 211.

I. THE GLASSY STATE ❧ 217

19. Aristotle, *Metaphysics*, 982b10–25.

20. Descartes, *The Passions of the Soul*, 373.5–373.15.

21. Eliade, *The Forge and the Crucible*, 56–57, 61, 65.

22. Jarves, *Reminiscences of Glass-making*, 45, 46.

23. Pliny was an advisor to the Flavian dynasty (69 CE–96 CE). Vespasian is remembered for restoring the Roman court, Senate, and public welfare following the excesses of Nero (37–68 CE).

24. Pliny the Elder, *The Natural History*; Hess and Husband, *European Glass in the J. Paul Getty Museum*, 8, 22n26.

25. Kelly, *The Roman Empire*; Pliny the Elder, *The Natural History*.

26. Neri, *The World's Most Famous Book on Glassmaking*, 48.

27. Haraway, *When Species Meet*, 4; Haraway, "Situated Knowledges"; see also Armstrong, *Victorian Glassworlds*, 95–166.

28. Exodus 35:30–39:43; Barney, *The Etymologies of Isidore of Seville*, 328; Hrabanus, *De Universo*, 179–80.

29. MS 24189, "Illustrations for Sir John Mandeville, Voyage d'outer mer," British Library, http://www.bl.uk/manuscripts/Viewer.aspx?ref =add_ms_24189_f016r; http://www.bl.uk/manuscripts/Viewer.aspx ?ref=harley_ms_3954_f076r; see Krása, *The Travels of Sir John Mandeville*.

30. Rodrigo, "The Dynamic of Hexis in Aristotle's Philosophy."

31. See, for example, Cixous, "Sorties: Out and Out: Attacks/Ways Out/ Forays," on the persistence of mastery; and Singh, *Unthinking Mastery*.

32. Built in 1574 amid the Florentine renaissance for Francesco I de Medici (1541–1587), Grand Duke of Tuscany (1574–1587), the Medici Glass Workshop was located among distilleries; workshops for silver-smithing and pottery as well as those dedicated to the study of apothecary, alchemy, and more; and galleries displaying the work. Berreta, *Laboratories of Art*, 137–39; Berreta, *The Alchemy of Glass*, 152; Berreta, "Glassmaking Goes Public," 1053.

33. It is no coincidence that Neri, the author of that first public text about glassmaking, *The Art of Glassmaking* (1622), not only wrote the book from firsthand experience in the Medici Glass Workshop but was foremost an alchemist. His *Di Alchimia* (1599) is replete with illustrations of alchemic processes. Engel, "Depicting Alchemy."

218 ✌ I. THE GLASSY STATE

34. Turner, "A Notable British Seventeenth-Century Contribution to the Literature of Glassmaking," 3.
35. Smith, *The Adventures of Captain John Smith*, 117.
36. Working, *The Making of an Imperial Polity*, 50; Bacon, "Of Plantations," 92.
37. Harrington, *A Tryal of Glasse*, 23–29.
38. According to Harrington, *A Tryal of Glasse*, 3, "glass was first made in the Western hemisphere by Spanish craftsmen, probably at Puebla de los Angeles in Mexico, beginning about 1535." His book, alternatively titled *Glassmaking at Jamestown: America's First Industry* (1952) and *A Trial of Glasse: The Story of Glassmaking at Jamestown* (1980 [1972]), uses "America" to indicate North America.
39. Harrington, *Glassmaking at Jamestown*, 15.
40. Illustration by Sydney E. King (1906–2002), *Glassmaking at Jamestown: One of the First Industries in America*, n.d.
41. On the discourse of civilization, see, for example, Bederman, *Manliness and Civilization*.
42. See, for example, McDermott, *Energy Without Conscience*, on the discursive and ideological conversion of people into fuel in the Bermudas in relation to sugar.
43. Grizzard and Smith, *Jamestown Colony*, 226.
44. Hudson, "Glassmaking at Jamestown," 6–8.
45. Farr, *Artisans in Europe*; Wallach Scott, *Glassworkers of Carmaux*; Judde de Larivière, *The Revolt of the Snowballs*.
46. Tyler, *The Cradle of the Republic*, 31–33, 103; Working, *The Making of an Imperial Polity*, 67.
47. Jamestown is the site of the 1619 July church gathering commemorated as the "first free legislative body . . . on the American continent" as well as the Virginia Company's first purchase of enslaved Angolans from those stewarding the *São João Bautista* that August.
48. The glassblower, whom Nathan watches, could be a German glassblower—Wilhem Wentzel, Caspar Halter, Simeon Griessmeyer, or Johan Martin Halter—whom Wistar had contracted to teach him and his son glassmaking. Unusually, each glassblower owned a furnace and tools and operated it as a subsidiary company within the parent company, Wistarburgh glassworks, and, together, received

I. THE GLASSY STATE ❧ 219

one-third of company profits. Palmer, *The Wistarburgh Glassworks*, 3, 33; Palmer-Schwind, "Glassmakers of Early America," 161; Palmer, *The Wistars and Their Glass*, 10; Scoville, *Revolution in Glassmaking*, 4–6.

49. Beiler, *Immigrant and Entrepreneur*.

50. Bourgeois, *Nathan's Dark House*, 56.

51. Martineau, "Birmingham Glass Works," 32.

52. Bourgeois, *Nathan's Dark House*, 35, 26, 48.

53. Benjamin Franklin to Darling, February 10, 1746/7, as cited in Palmer, *The Wistars and Their Glass*.

54. On the relation of fire and European colonization, see Pyne, *Fire: A Brief History*, 137–158.

55. The Lords Commissions for Trade and Plantations reported the Wistarburgh glassworks to the crown, and it fell into bankruptcy under the consequent taxation and fees. Protoindustrial American glassworks of Henry William Stiegel (1729–1785) and John (Johannes) Amelung also fell into bankruptcy, albeit under different circumstances. Palmer, *The Wistarburgh Glassworks*, 3, 33; Palmer, *The Wistars and Their Glass*, 4, 7–9; Palmer-Schwind, "Glassmakers of Early America," 161.

56. On the relation of heat work, thermodynamics, and the Industrial Revolution, see Daggett, *The Birth of Energy*.

57. Marx, "Economic and Philosophic Manuscripts of 1844," 319–21.

58. Arendt, *On Revolution*.

59. Knight, *Knight's American Mechanical Dictionary*, 988; McCray, *Glassmaking in Renaissance Venice*, 127.

60. Scoville, *Revolution in Glassmaking*, 4–7, 23–29, 49, 176–77, 266–67; Lanmon et al., *John Frederick Amelung*, 15–21, 31–33; Quattlebaum, *Early American Glass*, 10; Oland, *Maryland Historical Magazine*, 268–69. On America's protoindustrial glass manufactories, including Wistarburgh but also William Stiegel's American Flint Glass Manufactory and John Amelung's glassworks, see Scoville, *Revolution in Glassmaking*.

61. Zembala, "Machines in the Glassmaking," 214, 222; Scoville, *Revolution in Glassmaking*, 22, 154; Pellatt, *Curiosities of Glassmaking*, 65; McKearin, *American Glass*, xv.

220 ❧ I. THE GLASSY STATE

62. McCray, *Glassmaking in Renaissance Venice*, 19–21, 45; *Report of the Industrial Commission on the Relations and Conditions*, 921.
63. In the early to mid-twentieth century, the shop system gave way to a fully automated glassmaking industry: "The [mechanical] revolution," as the American glass historian Warren Scoville wrote in 1948, "has been extensive and is now well-nigh complete." Labino, *Visual Art in Glass*, 17; Scoville, *Revolution in Glassmaking*, 173.
64. Dunbar-Ortiz, *An Indigenous Peoples' History of the United States*, 1–3.
65. Harvey Littleton (1922–2013). Byrd, *Harvey K. Littleton*. Dale Chihuly (b. 1941) is an American glass artist who was a student of Littleton and went on to found both the Pilchuck Glass School in Seattle, Washington, and assist in the development of the Rhode Island School of Design, founded by Norman Schulman in 1965. Drexler-Lynn, *American Studio Glass, 1960–1990*, 60. Lino Tagliapietra (b. 1934) is a Muranese master who has been traveling to the United States since the late 1970s to teach Venetian techniques to Americans. Oldknow, *Pilchuck*, 163–64.
66. Natiba, "On Native Land."

2. EMBODIED KNOWLEDGE: THE EBBS AND FLOWS OF SKILL ACQUISITION

1. David Sudnow discusses the shift away from an awareness of the particularities toward the whole in regard to his jazz piano playing as an "express aiming" or "melodic intentionality": "The emergence of a melodic intentionality, an express aiming for sounds, was dependent in my experience upon the acquisition of facilities that made it possible, and it wasn't as though in my prior work I had been trying and failing to make coherent note-to-note melodies." Sudnow, *Ways of the Hand*, 44.
2. Polanyi, *Personal Knowledge*, 59.
3. "The blind man's stick has ceased to be an object for him, and is no longer perceived for itself; its point has become an area of sensitivity, extending the scope and active radius of touch, and providing a parallel to sight. In the exploration of things, the length of the stick does not enter expressly as a middle term: the blind man is rather aware of

2. EMBODIED KNOWLEDGE ❦ 221

it through the position of objects than of the position of objects through it. . . . To get used to a hat, a car or a stick is to be transplanted into them, or conversely, to incorporate them into the bulk of our own body. Habit expresses our power of dilating our being-in-the-world, or changing our existence by appropriating fresh instruments." Merleau-Ponty, *The Phenomenology of Perception*, 143.

4. Polanyi, *Personal Knowledge*, 55.

5. Polanyi, *The Tacit Dimension*, 11.

6. Polanyi, *Personal Knowledge*, 55.

7. Bourdieu, *The Logic of Practice*, 52.

8. Bourdieu, *Pascalian Meditations*, 143–44.

9. Merleau-Ponty, *The Phenomenology of Perception*, 144, 146–47.

10. Brentano, *Psychology from an Empirical Standpoint*.

11. Husserl, *Cartesian Meditations*.

12. Dilthey, *Introduction to the Human Sciences*.

13. Heidegger, *Being and Time*; Heidegger, *What Is Called Thinking*.

14. Merleau-Ponty, *The Phenomenology of Perception*, 144.

15. Mauss, "Techniques of the Body," 458. Mauss was also the nephew of the sociologist Emile Durkheim (1858–1917), whose "social ontology"—that the fact of man is both individual and society, namely, the cause of the experience of dualism as "body and soul"—remains a bedrock of sociology. Durkheim, "The Dualism of Human Nature and Its Social Condition."

16. Merleau-Ponty, *The Primacy of Perception*, 159–190.

17. Bourdieu, *Pascalian Meditations*, 143.

18. Generally speaking, education from a rationalist approach entails the transmission, acquisition, and retention of eternal, unchanging, necessary, and demonstrable truths, whereas education from an empiricist perspective entails abstracting from sense experience to achieve those general and universal truths; the former proceeds from a priori propositional knowledge whereas the later achieves a posteriori propositional knowledge — knowledge "that" something is true. Both proceed from a theory of man as a rational mind. Nineteenth-century forerunners of social theory importantly asserted a social ontology and thereby made claims to the social construction of knowledge.

19. Polanyi, *Personal Knowledge*, 58, 57.

222 ∽ 2. EMBODIED KNOWLEDGE

20. Bourdieu, *The Logic of Practice*, 66.
21. Merleau-Ponty, *The Phenomenology of Perception*, 143.
22. Bachelard, *Air and Dreams*, 8.
23. Bachelard, *The Poetics of Reverie*, 11.
24. I had understood reverie as "relaxed consciousness": "Since reverie is always considered in terms of a relaxed consciousness, one usually ignores dreams of definite action, which I will designate as reveries of will." Bachelard, *On Poetic Imagination and Reverie*, 13.
25. Bachelard, *The Psychoanalysis of Fire*, 30.
26. See O'Connor and Peck, "The Prototype."
27. Merleau-Ponty, *The Phenomenology of Perception*, 144.
28. Bourdieu, *The Logic of Practice*, 66.
29. Bourdieu, *Pascalian Meditations*, 135.

3. FIRE AND SWEAT:
CALORIFIC BODIES AND TEAMWORK

1. Drexler-Lynn, *American Studio Glass*, 14.
2. Hot glass was the last form of glasswork to enter artists' studios, following warm- and cold-glass methodologies, such as stained glass, enameling, and etching. Midcentury artists using warm- and cold-glass methodologies are regarded as "proto-studio" glass artists because they did not melt or blow glass. Drexler-Lynn, *American Studio Glass*, 14.
3. Armstrong, *Victorian Glassworlds*; Drexler-Lynn, *American Studio Glass*, 14.
4. Labino, *Visual Art in Glass*, 117; Littleton, *Glassblowing*.
5. Oldknow, *Pilchuck*.
6. Sennett, *The Craftsman*, 54. See, for example, Farr, *Artisans in Europe*; Darton, "Workers Revolt"; and Adamson, *Craft*.
7. Drexler-Lynn, *American Studio Glass*, 14.
8. Scoville, *Revolution in Glassmaking*, 22.
9. Jarves, *Reminiscences of Glass-making*, 27.
10. Polak, *Glass*, 21.
11. Schmid, *Advanced Glassworking Techniques*, 60.
12. See also O'Connor, "Touching Tacit Knowledge."
13. Palmer Schwind, "Glassmakers of Early America," 181.
14. Merleau-Ponty, *Signs*, 168.

4. BLOW ❧ 223

15. Schmid, *Advanced Glassworking Techniques*, 60.
16. Csordas, *Embodiment and Experience*.
17. Latour, *Reassembling the Social*, 46.
18. Craftwork, as described by Parolin and Mattozzi, is an "interaction [by craftsmen] with other bodies," that is, material bodies. Parolin and Mattozzi, "Sensitive translations," 10. On intercorporeality, see also Weiss, *Body Images*.
19. See O'Connor, "Hot Glass"; see also O'Connor, "Glassblowing Tools."
20. Bachelard, *The Psychoanalysis of Fire*, 40.
21. Classen, *The Book of Touch*, 81.
22. Bachelard, *The Psychoanalysis of Fire*, 40.
23. The science of this analogy is not exact: "Substances in the glassy state or vitreous condition, as distinguished from substances that are crystalline, do not have the internal structure characteristic of crystals; this is, the atoms have only a random arrangement and not the regular lattices which become manifest in crystals." Scholes, *Modern Glass Practice*, 2.
24. See O'Connor, "Inter- to Intracorporeality."
25. Barad, "Posthumanist Performativity," 822.
26. Barad, *Meeting the Universe Halfway*, 378.
27. Alaimo, *Bodily Natures*, 2.
28. Maxwell, *Theory of Heat*; Mach, *The Principles of the Theory of Heat*.
29. In Drew Leder's critique of Merleau-Ponty's concept of embodiment and his later concept of the flesh, he points to the absence of viscerality, the blood of the flesh. Leder, "Flesh and Blood."
30. On "intraontology" as a matter of depth and transcendence without intentionality, see Merleau-Ponty, *The Visible and the Invisible*, 219, 227; Deleuze, *One Thousand Plateaus*, 9.
31. See O'Connor, "Becoming with Glass."

4. BLOW: TIME, SPACE, AND THE VESSEL

1. See Lande, "Breathing Like a Soldier"; Pagis, *Inward*.
2. *The Compact Edition of the Oxford English Dictionary*, 1:963.
3. See Kurasawa, *The Ethnological Imagination*.
4. "Body techniques can be classified according to their efficiency, that is, according to the results of training. Training, like the assembly of

a machine, is the search for, acquisition of efficiency." Mauss, "Techniques of the Body," 10.

5. By arguing that the people with the most efficacious body craft, which included management of practical tasks and "emotions and unconscious," were the most achieved, he unwontedly elevated a value from capitalist rationality, which Max Weber's *The Protestant Ethic and the Spirit of Capitalism* (1904) revealed to be anything but universal. Mauss, "Techniques of the Body," 10.

6. Shilling, *Embodying Sociology*; Shilling, *The Body and Social Theory*; Price and Shildrick, *Feminist Theory and the Body*; Lock and Farquhar, *Beyond the Body Proper*; Young, *Throwing Like a Girl*; Bordo, *Unbearable Weight*; Sheets-Johnstone, *The Primacy of Movement*; Sheets-Johnstone, *The Corporeal Turn*; Sheets-Johnstone, *The Roots of Power*; Sheets-Johnstone, *The Roots of Thinking*; Grosz, *Volatile Bodies*, 1994.

7. Mauss, "Techniques of the Body," 10.

8. Sheets-Johnstone, *The Primacy of Movement*, 486–87.

9. *The Compact Edition of the Oxford English Dictionary*, 1:963.

10. This does not refer to the incorporeal as "sense" or "event" as opposed to materiality but to the everyday sense of it as material that is too fine to be material: air. On the incorporeal as sense and event, see Grosz, *The Incorporeal*, 2017.

11. See Wacquant, *Body and Soul*; Crawford, *Shop Class as Soulcraft*; Downey, *Learning Capoeira*.

12. See Pagis, *Inward*; Lande, "Breathing Like a Soldier."

13. Granet, *Chinese Civilization*.

14. Chambliss, "The Mundanity of Excellence."

15. See Leder, "Flesh and Blood."

16. Casey, *The Fate of Place*, 147–50.

17. Irigaray, *The Forgetting of Air in Martin Heidegger*, 16.

18. Scoville speculates that the technique was likely known by ancient glassmakers but forgotten over time and concedes that it was the United States that perfected its use. Scoville, *Revolution in Glassmaking*, 18, 38.

19. Scoville, *Revolution in Glassmaking*, 19.

20. Scoville, *Revolution in Glassmaking*, 175.

21. "The Owens bottle machine, which in 1903 both gathered and formed glass, was the first to produce small-mouth ware. Ashley and Arnold, two Englishmen who had never worked around glass factories, in 1886

5. QUINTESSENTIAL CRAFT ⋘ 225

had made an earlier attempt in this direction. The orifice of bottles was too small for the worker to form the mouth and lip by using a plunger to press the glass up and around the mold's neck. He could do this with jars but not with bottles." Scoville, *Revolution in Glassmaking*, 179.

22. Scoville, *Revolution in Glassmaking*, 179.
23. M. J. Owens estimated that "each fifteen-arm machine [of the Owens bottle machine] displaced from thirteen to fifty-four skilled blowers, depending upon the kind of bottles made." Owens "also stated that his latest model could produce 43,000 fruit jars every twenty-four hours, whereas one blower ordinarily made 200 in eight hours. The vice-president of the Glass Bottle Blowers' Union corroborated Owens' statement by testifying before the Tariff Commission that an Owens machine could make 350 gross of pint beers in 24 hours and displaced about 54 skilled workmen." Scoville, *Revolution in Glassmaking*, 161, n44.
24. Scoville, *Revolution in Glassmaking*, 161.
25. On handwork, see O'Connor, "Touching Tacit Knowledge."
26. Sheets-Johnstone, *The Primacy of Movement*. See also Epstein, *Thoughts Without a Thinker*, 145–46.
27. Sennett argues that handwork teaches important lessons including how to negotiate autonomy and authority; how to work with resistant forces, rather than against them; how to accomplish a task using minimum force; how to engage the world with sympathetic imagination; and how to dialogue with the world, that is, play. Sennett, *The Craftsman*.
28. Arendt, *The Human Condition*, 123.
29. See Appadurai, *The Social Life of Things*.
30. Heidegger, "The Thing."
31. Sloterdijk, *Neither Death nor Sun*, 153.
32. See Deleuze, *Difference and Repetition*.

5. QUINTESSENTIAL CRAFT: CUP MAKING AND THE TURNS OF *MÊTIS*

1. Macauley, *Elemental Philosophy*.
2. In the Bible's Book of Matthew, John the Baptist foretells of a baptism "with the Holy Spirit ([pnuema]) and fire." See Dunn, *Spirit-and-Fire Baptism*, 81–92.

226 ∾ 5. QUINTESSENTIAL CRAFT

3. Empedocles's tetrad theory of the origin of the universe breaks from the monist theories proposed by his predecessors and contemporaries. Macauley, *Elemental Philosophy*, 107, 115–16.

4. Macauley, *Elemental Philosophy*, 143.

5. Noting the ambiguity of the common English word "spell," Abram charts its passage from referring to the recitation of a story or tale to either assembling letters into the name of something *or* casting a magical formula. Abram explores the relation between the "new" phonetic literacy of the Greeks and the emergence of a reflexive sense of self, a shift in the perceptual field away from a sensuous, mimetic, embodied consciousness of orality emergent from an animate, living world toward a consciousness of transcendence in relation to abstract words independent of and separate from the corporeal world. Abram, *The Spell of the Sensuous*.

6. Aristotle, *On the Heavens*. Quintessence has a far-reaching intellectual legacy, including in the work of the Stoic- and Christian-influenced alchemists Zosimos of Panopolis (300 CE), Paracelsus (1493–1541), Rene Descartes (1596–1650), and Mary Daly (1928–2010).

7. As matter to form, so too is it with body (potentiality) and soul (actuality). See Bos, *The Soul and its Instrumental Body*; Bos, *Aristotle on God's Life-Generating Power and on Pneuma as Its Vehicle*, 200; Bos, *The Soul and Its Instrumental Body*, 93, 157–58. See also Bos, "*Pneuma* as Quintessence of Aristotle's Philosophy."

8. So too was it with other *hexeis*—the statesman legislating toward a good society developed *phronesis* (practical knowledge), while the philosopher contemplating the good or truth cultivated *episteme* (theoretical knowledge). Aristotle, *Nicomachean Ethics*, 1139b15–1143b15.

9. Schmid, *Ed's Big Handbook of Glassblowing*.

10. Quintessence is determinative of pnuema and becoming whereas *habitus* and field are mutually constitutive. At the same time, they share in a soteriological arc, wherein capacity unfolds and aligns with a goal.

11. Indeed, the "fire" of John the Baptist is more akin to quintessence than fire; see Bos, "*Pneuma* as Quintessence of Aristotle's Philosophy."

12. Shakespeare, *Hamlet*, 2.2.

5. QUINTESSENTIAL CRAFT ❧ 227

13. Gladwell, *Outliers*; Sennett, *The Craftsman*.

14. Grasseni, *Learning to See*, 47; see also Goodwin, "Vision and Inscription in Practice," 170; Ingold, *The Perception of the Environment*.

15. Grasseni, *Learning to See*, 44, 47.

16. Detienne and Vernant, *Cunning Intelligence*, 20.

17. Detienne and Vernant, *Cunning Intelligence*, 310; see Kofman, "Beyond Aporia?," 8–9.

18. Detienne and Vernant, *Cunning Intelligence*, 35–39, 310–14.

19. Detienne and Vernant, *Cunning Intelligence*, 46–47.

20. Understood as shapeshifting, conjecture, and reversal, *métis* is "typically the object of a verb 'to sew' or 'to weave,' namely, as classicist, feminist, architectural theorist, Ann Bergren notes, "of the woman's sign-making art." Bergren, *Weaving Truth*, 17; Detienne and Vernant, *Cunning Intelligence*, 224–25.

21. Ingold, *Being Alive*, 10.

22. Ingold, *Being Alive*, 71, understands this as a difference of through rather than across.

23. Bergren, *Weaving Truth*, 247–48.

24. A notable exception is Herzfeld, *The Body Impolitic*.

25. Aristotle, *Metaphysics*, 1009b33–1010a7, 79(106).

26. Sennett, *The Craftsman*, 293.

27. "If only for once it were still / If the not quite right and the why this / could be muted, and the neighbor's laughter, / and the static my senses make— / if all of it didn't keep me from coming awake— / Then in one vast thousandfold thought / I could think you up to where thinking ends. / I could possess you, / even for the brevity of a smile, / to offer you / to all that lives/in gladness. Rilke, "Wenn es nur einmal so ganz stille wäre," in *Rilke's Book of Hours*.

28. "I thank You God for most this amazing": "how should tasting touching hearing seeing / breathing any—lifted from the no / of all nothing—human merely being / doubt unimaginable You? / (now the ears of my ears awake and / now the eyes of my eyes are opened)." Cummings, *Selected Poems*, 114.

29. Kotva, "Gilles Deleuze, Simone Weil, and the Stoic Apprenticeship," 151.

30. Casey, *The Fate of Place*, 23–32.

6. MATERIA EROTICA: LOVE AND
STRIFE IN THE HOTSHOP

1. Rusu, "Theorising Love in Sociological Thought"; Featherstone, "Love and Eroticism."
2. Swidler, *Talk of Love*.
3. Jordan, "Where Is the Love?"; Lorde, "The Uses of the Erotic."
4. Crenshaw, "Mapping the Margins."
5. American Psychological Association, *Dictionary of Psychology*, s.v. "eros," https://dictionary.apa.org/eros.
6. Aarseth, "Eros in the Field?," 94; Bourdieu and Wacquant, *An Invitation to Reflexive Sociology*, 128; Bourdieu, "The Contradictions of Inheritance," 512.
7. Aarseth, "Eros in the Field?," 94; Crossley, *The Social Body*, 102.
8. See Durkheim, "The Dualism of Human Nature and Its Social Condition"; Hegel, *The Phenomenology of Spirit*; Kojeve, *Introduction to the Reading of Hegel*.
9. For an exemplary ethnography, see Bourgois, *In Search of Respect*.
10. Bourdieu, "The Contradictions of Inheritance," 512.
11. Wacquant, "The Pugilistic Point of View," 520; Bourdieu, "L'intérêt du sociologue."
12. Wacquant, "The Pugilistic Point of View," 491, 501. This has Hegelian roots. See Kojeve, *Introduction to the Reading of Hegel*.
13. Lorde, "The Uses of the Erotic," 89–91.
14. Ahmed, *Queer Phenomenology*, 68–72; Deleuze, *Difference and Repetition*; Foucault, *Discipline and Punish*.
15. Ahmed, *Queer Phenomenology*, 71.
16. Bodies gather objects as they turn toward them—an iterative dynamic that makes certain objects proximate and others beyond reach, invisible. The clearing of some things (including both object-things and doing-things) so that others may appear, she argues, drawing upon the feminist and phenomenologist Judith Butler, constitutes a "field." Ahmed, *Queer Phenomenology*, 87, 90–91. See Butler, *The Psychic Life of Power*, 21.
17. Lispector, *The Passion According to G.H.*, 38.

6. MATERIA EROTICA ❧ 229

18. See also the contemporary artwork of the interdisciplinary artist Grace Whiteside, *Homosilica*, https://gracewhiteside.com/home.html.

19. Harris, "Pyromena," 39.

20. Cohen and Duckert, *Elemental Ecocriticism*, 11.

21. Harris, "Pyromena," 39.

22. This is not an ecofeminist essentializing of the earth as woman but an exploration of the masculine domination as discourse to the exclusion of living vitalities.

23. Deleuze and Guattari, *One Thousand Plateaus*, 411.

24. Lispector, *The Passion According to G.H.*, 48.

25. Nonheterosexual relationships are not immune to heteronormativity. See Hollibaugh and Moraga, "What We're Rolling Around in Bed With," 58–62. I was in a "heterosexual" relationship with Sarkis as a bisexual cisgender woman. On the bed and the logic of masculine domination, see Bergren, *Weaving Truth*.

26. Harris, "Pyromena."

27. Irigaray, *Elemental Passions*, 32–33. On the Irigarayan flower as an image of fluidity, see Canters and Jantzen, *Forever Fluid*, 79–81.

28. For further reading on medium and materiality in glassblowing, see O'Connor, "Becoming with Glass."

29. Regarding the uterine furnace, see Eliade, *The Forge and the Crucible*.

30. Irigaray, *Elemental Passions*.

31. Having been bound in chains by Hephaestus after stealing fire from the gods to give to humankind, Prometheus was unbound by Hercules after thirty thousand years. The Romantic interpretation of Prometheus shifted away from Aeschylus's tragedy *Prometheus Bound* (479–424 BCE) to Percy Bysshe Shelley's heroic account *Prometheus Unbound*.

32. Bergren, *Weaving Truth*.

33. Goffman, *Interaction Ritual*.

34. I am indebted to the work of the critical Indigenous theorist Dina Gilio-Whitaker. Her discussion of settler-colonial conceptions of "environment" and "nature" continues to shift my paradigm for thinking through matter, materiality, and elemental imaginaries. See Gilio-Whitaker, *As Long as Grass Grows*.

CONCLUSION: HEART OF GLASS

1. Arendt, *The Human Condition*, 173–76.
2. Arendt, *The Human Condition*, 177. For Karl Marx, man is a matter of double transcendence; first, he transcends the physical world through his labor, and then, through unalienated labor, he transcends alienation caused by conflict and inequality.
3. Arendt, *The Human Condition*, 251.
4. Arendt, *The Human Condition*, 83.
5. Sennett, *The Craftsman*, 7.
6. Haraway, *Staying with the Trouble*, 39–40.
7. Aristotle, *De Caelo*, 271a30.

BIBLIOGRAPHY

Aarseth, H. "Eros in the Field? Bourdieu's Double Account of Socialized Desire." *Sociological Review* 64 (2016): 93–109.

Abram, David. *Becoming Animal: An Earthly Cosmology.* Pantheon, 2010.

——. *The Spell of the Sensuous: Perception and Language in a More-Than-Human World.* Vintage, 1996.

Acampora, Ralph. 2006. *Corporeal Compassion: Animal Ethics and Philosophy of Body.* University of Pittsburgh Press, 2006.

Adamson, Glenn. *Craft: An American History.* Bloomsbury, 2021.

——, ed. *The Craft Reader.* Berg, 2010.

——. "Gatherings: Creating the Studio Craft Movement." In *Crafting Modernism: Midcentury American Art and Design*, ed. Jeannine Falino, 32–55. Abrams, 2012.

——. *The Invention of Craft.* Berg, 2012.

——. "The Revenge of the Pastoral." In *Post-Craft*, ed. Alex Coles and Catharine Rossi, 3:107–18. Sternberg, 2022.

——. *Thinking Through Craft.* Berg, 2007.

Agricola, Georgius. *De Re Metallica* [1556]. Trans. Herbert Clark Hoover and Lou Henry Hoover. Dover, 1950.

Ahmed, Sara. *Queer Phenomenology: Orientations, Objects, Others.* Duke University Press, 2006.

Aeschylus. *Prometheus Bound.* Trans. Deborah H. Roberts. Hackett, 2012.

Alaimo, Stacey. *Bodily Natures: Science, Environment, and the Material Self.* Indiana University Press, 2010.

232 \\ BIBLIOGRAPHY

——. "Elemental Love in the Anthropocene." In *Elemental Ecocritism: Thinking with Earth, Air, Water, and Fire*, ed. Jeffrey Jerome Cohen and Lowell Duckert, 298–309. University of Minnesota Press, 2015.

——. "States of Suspension: Trans-corporeality at Sea." In *Interdisciplinary Studies in Literature and Environment* 19, no. 3 (2012): 476–93.

Alpers, Svetlana. "The View from the Studio." In *The Studio Reader: On the Space of Artists*, ed. Mary Jane Jacob and Michelle Grabner, 126–49. University of Chicago Press, 2010.

Althusser, Louis. *Lenin and Philosophy and Other Essays*. Monthly Review Press, 1971.

Anderson, Benedict. *Imagined Communities: Reflections on the Origin and Spread of Nationalism*. Verso, 2006.

Anderson, Chris. *Makers: The New Industrial Revolution*. Crown Business, 2012.

Appadurai, Arjun. *The Social Life of Things: Commodities in Cultural Perspective*. Cambridge University Press, 1986.

Arendt, Hannah. *The Human Condition*. University of Chicago Press, 1998.

——. *On Revolution*. Penguin, 1965.

Aristotle. *Metaphysics*. Trans. Hippocrates G. Apostle. Peripatetic, 1979.

——. *Nichomachean Ethics*. Trans. Martin Ostwald. Prentice Hall. 1999.

——. *On the Heavens*. Trans. W. K. C. Guthrie. Harvard University Press, 1986.

——. *Physics*. Trans. Hippocrates G. Apostle. Peripatetic, 1980.

Armstrong, Victoria. *Victorian Glassworlds: Glass Culture and the Imagination, 1830–1880*. Oxford University Press, 2008.

Ashton, John. *Social Life in the Reign of Queen Anne, Taken from Original Sources*. 1919; Chatto & Windus, 2017.

Atkinson, Paul. "Blowing Hot: The Ethnography of Craft and the Craft of Ethnography." *Qualitative Inquiry* 19, no. 5 (2013): 397–404.

——. "Ethnography and Craft Knowledge." *Qualitative Sociology Review* 9, no. 2 (2013): 56–63. http://qualitativesociologyreview.org/ENG/archive _eng.php.

——. *For Ethnography*. Sage, 2014.

——. *Handbook of Ethnography*. Sage, 2007.

Atkinson, Paul, Richard Watermeyer, and Sara Delamont. "Expertise, Authority, and Embodied Pedagogy: Operatic Masterclasses." *British Journal of Sociology of Education* 34, no. 4 (2013): 487–503.

BIBLIOGRAPHY ∞ 233

Atkinson, Paul, Sara Delamont, and William Housley. *Contours of Culture: Complex Ethnography and the Ethnography of Complexity*. AltaMira, 2007.

Auerbach, Jeffrey. *The Great Exhibition of 1851: A Nation on Display*. Yale University Press, 1999.

Augustine. *Confessions*. Trans. Henry Chadwick. Oxford University Press, 1991.

Babich, Babette. "Nietzsche and Eros Between the Devil and God's Deep Blue Sea: The Problem of the Artist as Actor–Jew–Woman." In *Continental Philosophy Review* 33, no. 2 (2000): 159–88.

Bachelard, Gaston. *Air and Dreams: An Essay on the Imagination of Matter*. Dallas Institute Publications, 1988.

——. *Fragments of a Poetics of Fire*. Dallas Institute Publications, 1990.

——. *On Poetic Imagination and Reverie*. Spring Publications, 1998.

——. *The Poetics of Reverie*. Beacon, 1971.

——. *The Psychoanalysis of Fire*. Beacon, 1964.

——. *Water and Dreams: An Essay on the Imagination of Matter*. Pegasus Foundation, 1999.

Bacon, Francis. "Of Plantations." In *Works of Francis Bacon*. https://www.gutenberg.org/files/59163/59163-h/59163-h.htm.

Baigell, Matthew. "The Emersonian Presence in Abstract Expressionism." *Prospects* 15 (1990): 91–108.

Barad, Karen. *Meeting the Universe Halfway: Quantum Physics and the Entanglement of Matter and Meaning*. Duke University Press, 2007.

——. "Posthumanist Performativity: Toward an Understanding of How Matter Comes to Matter." *Signs: Journal of Women in Culture and Society* 28, no. 3 (2003): 801–31.

Barney, Stephen A., W. J. Lewis, J.A. Beach, and Oliver Berghof. *The Etymologies of Isidore of Seville*, 2006. https://sfponline.org/Uploads/2002/st%20isidore%20in%20english.pdf.

Barrett, Chris. "The Quintessence of Wit." In *Elemental Ecocriticism: Thinking with Earth, Air, Water, and Fire*, ed. Jeffrey Cohen and Lowell Duckert, 158–82. University of Minnesota Press, 2015.

Barringer, Tim. *Men at Work: Art and Labour in Victorian Britain*. Yale University Press, 2005.

Bauman, Zygmunt. *Liquid Modernity*. Polity, 2000.

Becker, Howard. *Art Worlds*. University of California Press, 1982.

234 ✍ BIBLIOGRAPHY

Bederman, Gail. *Manliness and Civilization: A Cultural History of Gender and Race in the United States, 1880–1917*. University of Chicago Press, 1995.

Beiler, Rosalind. *Immigrant and Entrepreneur: The Atlantic World of Caspar Wistar, 1650–1750*. Pennsylvania State University Press, 2008.

Bellah, Robert N., Richard Madsen, William M. Sullivan, Ann Swidler, and Steven M. Tipton. *Habits of the Heart: Individualism and Commitment in American Life*. University of California Press, 2008.

Bennett, Jane. *Vibrant Matter: A Political Ecology of Things*. Duke University Press, 2010.

Bentham, Jeremy. "The Introduction to the Principles of Morals and Legislation." In *The Works of Jeremy Bentham*, 11 vols., ed. John Bowring, 1–154. Edinburgh: William Tait, 1838–1843.

Benzecry, Claudio. *The Opera Fanatic: An Ethnography of an Obsession*. University of Chicago Press, 2011.

Beretta, Marco. *The Alchemy of Glass: Counterfeit, Imitation, and Transmutation in Ancient Glassmaking*. Science History Publication, 2009.

——. "Glassmaking Goes Public: The Cultural Background to Antonio Neri's *L'Arte Vetraria* (1612)." *Technology and Culture* 58, no. 4 (2017): 1046–70.

——. "Material and Temporal Powers at the Casino di San Marco (1574–1621)." In *Laboratories of Art: Alchemy and Art Technology from Antiquity to the Eighteenth Century*, ed. Sven Dupré, 129–56. Springer, 2014.

Bergren, Ann. *Weaving Truth: Essays on Language and the Female in Greek Thought*. Harvard University Press, 2008.

Biringuccio, Vannoccio. *Pirotechnia* [1540]. Trans. Cyril Stanley-Smith and Martha Teach Gnudi. MIT Press, 1966.

Bishir, Catherine W. *Crafting Lives: African American Artisans in New Bern, North Carolina, 1770–1900*. North Carolina University Press, 2015.

Boisseron, Bénédicte. *Afro-Dog: Blackness and the Animal Question*. Columbia University Press, 2018.

Bourgeois, Florence. *Nathan's Dark House*. Doubleday, Doran & Co., 1942.

Bordo, Susan. *Unbearable Weight: Feminism, Western Culture, and the Body*. University of California Press, 1993.

Boris, Eileen. *Art and Labor: Ruskin, Morris, and the Craftsman Ideal in America*. Temple University Press, 1986.

BIBLIOGRAPHY ❧ 235

Bos, Abraham P. *Aristotle on God's Life-Generating Power and on Pneuma as Its Vehicle.* SUNY Press, 2018.

——. "*Pneuma* as Quintessence of Aristotle's Philosophy." *Hermes* 141 (2013): 417–34.

——. *The Soul and Its Instrumental Body: A Reinterpretation of Aristotle's Philosophy of Living Nature.* Brill, 2003.

Bourdieu, Pierre. "The Contradictions of Inheritance." In *The Weight of the World: Social Suffering in Contemporary Society,* ed. Pierre Bourdieu et al., 507–13. Polity, 1999.

——. "L'intérêt du sociologue." *Economies et Sociêtes* 18 (October 1984): 12–29.

——. *The Logic of Practice.* Trans. Richard Nice. Polity, 1990.

——. *Outline of a Theory of Practice.* Trans. Richard Nice. Cambridge University Press, 1977.

——. *Pascalian Meditations.* Trans. Richard Nice. Polity, 2000.

Bourdieu, Pierre, and Loïc Wacquant. *An Invitation to Reflexive Sociology.* University of Chicago Press, 1992.

Bourgois, Phillipe. *In Search of Respect: Selling Crack in El Barrio.* Cambridge University Press, 2003.

Bowles, Samuel, and Herbert Gintis. *Schooling in Capitalist America: Educational Reform and the Contradictions of Economic Life.* Basic Books, 1977.

Braidotti, Rosi. *Metamorphoses: Towards a Materialist Theory of Becoming.* Polity, 2002.

Brenner, Neil. "Urban Governance and the Production of New State Spaces in Western Europe, 1960–2000." *Review of International Political Economy* 11, no. 3 (August 2004): 447–88.

Brentano, Franz Clemens. *Psychology from an Empirical Standpoint.* Trans. A. C. Rancurello, D. B. Terrell, and L. McAlister. Routledge, 1973.

Bridenbaugh, Carl. *The Colonial Craftsman.* University of Chicago Press, 1950.

Brodribb, Somer. *Nothing Mat(t)ers: A Feminist Critique of Postmodernism.* Spiniflex, 1992.

Brodsley, L., F. F. Charles, and S. J. Wickham. "Prince Rupert's Drops." *Notes and Records: The Royal Society Journal of the History of Science* 41, no. 1 (1986): 1–26.

236 ℠ BIBLIOGRAPHY

Buechler, Hans, and Judith-Maria Buechler. *The World of Sofía Velasquez: The Autobiography of a Bolivian Market Vendor.* Columbia University Press, 1996.

Buechner, Thomas S. *New Glass: A Worldwide Survey.* Corning Museum of Glass, 1979.

Burgard, Timothy Anglin. *The Art of Dale Chihuly.* Chronicle Books and the Fine Arts Museums of San Francisco, 2008.

Burke, Doreen Bolger, ed. *In Pursuit of Beauty: Americans and the Aesthetic Movement.* Metropolitan Museum of Art, 1986.

Butler, Judith. *The Psychic Life of Power.* Stanford University Press, 1997.

——. "Performative Acts and Gender Constitution: An Essay in Phenomenology and Feminist Theory." *Theatre Journal* 40, no. 4 (December 1988): 519–31.

——. *Subjects of Desire: Hegelian Reflections in Twentieth-Century France.* Columbia University Press, 1987.

Byrd, Joan Falconer. *Harvey K. Littleton: A Life in Glass: Founder of America's Studio Glass Movement.* Skira Rizzoli, 2012.

——. "Oral History Interview with Harvey K. Littleton, 2001 March 15." Archives of American Art, Smithsonian Institution.

Cabot, Richard. "Work Cure." *Psychotherapy* 3, no. 1 (1909): 24–29.

Calhoun, Craig, and Richard Sennett. *Practicing Culture (Taking Culture Seriously).* Routledge, 2007.

Canters, Hanneke, and Grace M. Jantzen. *Forever Fluid: A Reading of Luce Irigaray's Elemental Passions.* Manchester University Press, 2014.

Carbone, Mauro. *The Thinking of the Sensible.* Northwestern University Press, 2004.

Carlet, Yves. "Emerson and the West: The Metamorphoses of the 'Great and Crescive Self.'" *Études Anglaises* 55, no. 4 (2002): 444–55.

Carman, Taylor. "The Body in Husserl and Merleau-Ponty." *Philosophical Topics* 27, no. 2 (1999): 205–26.

Casey, Edward. *The Fate of Place: A Philosophical History.* University of California Press, 1998.

——. *Getting Back Into Place: Toward a Renewed Understanding of the Place-World.* Indiana University Press, 1993.

Chambliss, Daniel F. "The Mundanity of Excellence: An Ethnographic Report on Stratification and Olympic Swimmers." *Sociological Theory* 7, no. 1 (1989): 70–86.

BIBLIOGRAPHY ○⃝ 237

Chen, Cecilia, Jane MacLeod, and Astrida Neimanis, eds. *Thinking with Water.* McGill-Queen's University Press, 2013.

Chihuly, Dale. *Baskets.* Portland, 1994.

Cixous, Hélène. "Sorties: Out and Out: Attacks/Ways Out/Forays." Trans. Betsy Wing. In *The Newly Born Woman,* by Hélène Cixous and Catherin Clément, 63–132. University of Minnesota Press, 1986.

Clark, Garth, and Margie Hughto. *A Century of Ceramics in the United States: 1878–1978.* E. P. Dutton, 1979.

Clark, Robert Judson. *The Arts and Crafts Movement in America, 1876–1916.* Princeton University Press, 1992.

Clarke, Isaac Edwards. *Education in the Industrial and Fine Arts in the United States.* Part 3: *Industrial and Technical Training in Voluntary Associations and Endowed Institutions.* Washington, DC: Government Printing Office, 1897.

Classen, Constance, ed. *The Book of Touch.* Routledge, 2005.

——. *Worlds of Sense: Exploring the Senses in History and Across Cultures.* Routledge, 1993.

Clawson, Laura. *I Belong to This Band, Hallelujah! Community, Spirituality, and Tradition Among Sacred Harp Singers.* University of Chicago Press, 2011.

Clifford, James. *The Predicament of Culture: Twentieth-Century, Ethnography, Literature, and Art.* Harvard University Press, 1988.

Clifford, James, and George E. Marcus. *Writing Culture: The Poetics and Politics of Ethnography.* University of California Press, 1986.

Coates, Robert. "The Art Galleries: Abroad and at Home." *New Yorker,* March 30, 1946.

Cohen, Jeffrey Jerome, and Lowell Duckert, eds. *Elemental Ecocriticism: Thinking with Earth, Air, Water, and Fire.* University of Minnesota Press, 2015.

——. "Introduction." In *Elemental Ecocriticism: Thinking with Earth, Air, Water, and Fire,* ed Jeffrey Cohen and Lowell Duckert, 1–26. University of Minnesota Press, 2015.

Collins, Harry. *Tacit and Explicit Knowledge.* University of Chicago Press, 2010.

Coole, Diana, and Samantha Frost, eds. *New Materialisms: Ontology, Agency, and Politics.* Duke University Press, 2010.

Cooper, Emmanuel. *Bernard Leach: Life and Work.* Paul Mellon Centre BA, 2003.

238 BIBLIOGRAPHY

——. *Ten Thousand Years of Pottery.* 4th ed. British Museum Press, 2000.

Cooper, Eugene. *The Wood-Carvers of Hong Kong: Craft Production in the World Capitalist Periphery.* Cambridge University Press, 1980.

Copernicus, Nicolaus. *On the Revolutions of Heavenly Spheres* [1543]. Prometheus, 1995.

Coy, Michael W. "Being What We Pretend to Be: The Usefulness of Apprenticeship as Field Method." In *Apprenticeship: From Theory to Method,* ed. M. W. Coy. State University of New York Press, 1989.

Crane, Diana. *The Sociology of Culture: Emerging Theoretical Perspectives.* Basil Blackwell, 1994.

——. *The Transformation of the Avant-Garde.* University of Chicago Press, 1987.

Crawford, Matthew B. *Shop Class as Soulcraft: An Inquiry into the Value of Work.* Penguin, 2009.

Crenshaw, Kimberle. "Mapping the Margins: Intersectionality, Identity Politics, and Violence Against Women of Color." *Stanford Law Review* 43, no. 6 (1991): 1241–99.

Crossley, Nick. *Key Concepts in Critical Social Theory.* Sage, 2004.

——. "Researching Embodiment by Way of 'Body Techniques.'" In *Embodying Sociology: Retrospect, Progress, and Prospects.* Blackwell, 2007.

——. *The Social Body: Habit, Identity, and Desire.* Sage, 2001.

Crutzen, Paul J., and Eugene F. Stoermer. "The 'Anthropocene'" (2000). In *The Future of Nature: Documents of Global Change,* ed. Libby Robin, Sverker Sörlin, Paul Warde. Yale University Press, 2013.

Csordas, Thomas, ed. *Embodiment and Experience: The Existential Ground of Culture and Self.* Cambridge University Press, 1994.

Cummings, E. E. *Selected Poems.* Ed. Horace Liveright. Grove Press, 1959.

Currid, Elizabeth. *The Warhol Economy: How Fashion, Art, and Music Drive New York City.* Princeton University Press, 2008.

Daly, Mary. *Pure Lust: Elemental Feminist Philosophy.* Beacon, 1984.

——. *Quintessence . . . Realizing the Archaic Future: A Radical Elemental Feminist Manifesto.* Beacon, 1998.

D'Annunzio, Gabriele. *The Flame* [1900]. Trans. Susan Bassnett. Marsilio, 1991.

Darton, Robert. *The Great Cat Massacre: And Other Episodes in French Cultural History.* Vintage, 1985.

BIBLIOGRAPHY ❧ 239

Davies, Brian. *Thomas Aquinas's Summa Theologiae: A Guide and Commentary*. Oxford University Press, 2014.

Davis, Pearce. *The Development of the Glass Industry*. Harvard University Press, 1949.

de Larivière, Claire Judde. *The Revolt of the Snowballs: Murano Confronts Venice, 1511*. Routledge, 2018.

Deleuze, Gilles. *Bergsonism*. Trans. Hugh Tomlinson and Barbara Habberjam. Zone, 2002.

———. *Difference and Repetition*. Trans. Paul Patton. Columbia University Press, 1994.

———. *The Logic of Sense*. Trans. Mark Lester and Charles Stivale. Continuum, 2004.

———. *Proust and Signs: The Complete Text*. Trans. Richard Howard. Continuum, 2008.

Deleuze, Gilles, and Felix Guattari. *A Thousand Plateaus: Capitalism and Schizophrenia*. University of Minnesota Press, 2000.

Deloria, Phillip. *Playing Indian*. Yale University Press, 1999.

Demos, T. J. *Decolonizing Nature: Contemporary Art and the Politics of Ecology*. Sternberg, 2016.

Descartes, Rene. "Meditations on the First Philosophy." Trans. John Veitch. In *The Rationalists*. Anchor, 1974.

———. *The Passions of the Soul*. Trans. Stephen Voss. Hackett, 1989.

Desjarlais, Robert R. *Body and Emotion: The Aesthetics of Illness and Healing in the Nepal Himalayas*. University of Pennsylvania Press, 1992.

———. *Counterplay: An Anthropologist at the Chessboard*. University of California Press, 2011.

Desmond, Matthew. *On the Fireline: Living and Dying with Wildland Firefighters*. University of Chicago Press, 2007.

Detienne, Marcel, and Jean-Pierre Vernant. *Cunning Intelligence in Greek Culture and Society*. Harvester Press, 1978.

de Tocqueville, Alexis. *Democracy in America*. Penguin, 2003.

Dewey, John. *Art as Experience*. Penguin, 2005.

Dillon, Edward. *Glass*. Putnams, 1907.

Dilthey, Wilhelm. *Introduction to the Human Sciences*. Ed. Rudolph A. Makkreel and Frithjof Rodi. Princeton University Press, 1991.

DiMaggio, Paul, and Michael Useem. "Cultural Entrepreneurship in Nineteenth-Century Boston: The Creation of an Organizational Base

for High Culture in America." *Media, Culture, and Society* 4 (1982): 33–50.

Donne, John. "Loves Growth." In *The Poems of John Donne*, ed. Herbert J. C. Grierson. Clarendon, 1912.

Dormer, Peter, ed. *The Culture of Craft*. Manchester University Press, 1997.

Downey, Greg. *Learning Capoeira: Lessons in Cunning from an Afro-Brazilian Art*. Oxford University Press, 2005.

Downey, Greg, Monica Dalidowicz, and Paul H. Mason. "Apprenticeship as Method: Embodied Learning in Ethnographic Practice." *Qualitative Research* 15, no. 2 (2014): 183–200.

Dreisbach, Fritz. "The Glassblowing Studio." Paper presented at the annual meeting for the National Council on Education for the Ceramic Arts, California School of Arts & Crafts, Oakland, April 1970. http://www.glassnotes.com/resources/The-Studio.pdf.

Drexler-Lynn, Martha. *American Studio Glass, 1960–1990*. Hudson Hills, 2004.

——. "Challenging Boundaries: The History and Reception of American Studio Glass, 1960–1990." PhD diss., University of Southern California, 2000.

Dreyfus, Stuart E. "The Five-Stage Model of Adult Skill Acquisition." *Bulletin of Science, Technology & Society* 24, no. 3 (June 2004): 177–81.

Droste, Magdalena. *Bauhaus, 1919–1933*. Benedikt Taschen, 1998.

Dudley, Kathryn Marie. *Guitar Makers: The Endurance of Artisanal Values in North America*. University of Chicago Press, 2014.

Dunbar-Ortiz, Roxanne. *An Indigenous People's History of the United States*. Beacon, 2014.

Dunn, James D. G. *Spirit-and-Fire Baptism*. *Novum Testamentum* 14, fasc. 2 (1972): 81–92.

Durkheim, Emile. "The Dualism of Human Nature and Its Social Condition." *Durkheimian Studies* 11 (2005): 35–45.

——. *Elementary Forms of Religious Life* [1912]. Trans. Carol Cosman. Oxford University Press, 2001.

——. *Moral Education: A Study in the Theory and Application of a Sociology of Education* [1925]. Trans. Everett K. Wilson. The Free Press, 1973.

——. *Rules of Sociological Method* [1895]. Ed. Steven Lukes, trans. W. D. Halls. Simon and Schuster, 1982.

Durkheim, Emile, and Marcel Mauss. *Primitive Classification* [1903]. Trans. Rodney Neeham. University of Chicago Press, 1963.

Efland, Arthur D. *A History of Art Education: Intellectual and Social Currents in Teaching and the Visual Arts.* Teachers College Press, 1990.

Eliade, Mircea. *The Forge and the Crucible: The Origins and Structures of Alchemy.* Trans. Stephen Corrin. Harper Torchbooks, 1962.

——. *Yoga: Immortality and Freedom.* 1954; Princeton University Press, 1973.

Emerson, Ralph Waldo. "Art" [1841]. In *Emerson: Essays and Lectures: Nature: Addresses and Lectures / Essays: First and Second Series / Representative Men / English Traits / The Conduct of Life.* Library of America, 1983.

. "New England Reformers" [1844]. In *Emerson: Essays and Lectures: Nature: Addresses and Lectures / Essays: First and Second Series / Representative Men / English Traits / The Conduct of Life.* Library of America, 1983.

Emmenegg, Patrick. *The Power to Dismiss: Trade Unions and the Regulation of Job Security in Western Europe.* Oxford University Press, 2014.

Empedocles. *Fragments.* Ed. M. R. Wright. Yale University Press, 1981.

Engert, Kornelia, and Christiane Schürkmann. "Posthuman? Nature and Culture in Renegotiation." *Nature and Culture* 16, no. 1 (2021): 1–10.

Engle, Paul. *Conciatore: The Life and Times of Seventeenth-Century Glass-maker Antonio Neri.* Heiden & Engle, 2014.

——. "Depicting Alchemy: Illustrations from Antonio Neri's 1599 Manuscript." In *Glass of the Alchemists: Lead Crystal-Gold Ruby, 1650–1750,* ed. Dedo Von Kerssenbrock-Krosigk, 48–61. Corning Museum of Glass, 2008.

Epictetus. *Enchiridion.* Trans. George Long. Prometheus, 1991.

Epstein, Mark. *Thoughts Without a Thinker.* Basic Books, 1995.

Failing, Patricia. "Studio Glass, 1945–1969." In *Crafting Modernism: Midcentury American Art and Design,* ed. Jeannine Falino, 246–56. Abrams, 2012.

Fair, Susan W. "Story, Storage, and Symbol: Functional Cache Architecture, Cache Narratives, and Roadside Attractions." *Perspectives in Vernacular Architecture* 7 (1997): 167–82.

Falino, Jeannine, ed. *Crafting Modernism: Midcentury American Art and Design.* Abrams, 2012.

Farr, James R. *Artisans in Europe, 1300–1914.* Cambridge University Press, 2000.

242 BIBLIOGRAPHY

Featherstone, Michael. "Love and Eroticism: An Introduction." *Theory, Culture & Society* 15, no. 3–4 (1998): 1–18.

Feld, Stephen. *Sound and Sentiment: Birds, Weeping, Poetics, and Song in Kaluli Expression.* 2nd ed. University of Philadelphia Press, 1990.

Foucault, Michael. *The Care of the Self.* Random House, 1986.

——. *Discipline and Punish: The Birth of the Prison.* Random House, 1995.

Fritsch, Kelly. "Desiring Disability Differently: Neoliberalism, Heterotopic Imagination, and Intracorporeal Reconfigurations." *Foucault Studies* 19 (June 2015): 43–66.

Furman, Robert. "Brooklyn Heights History: The Glass Works." *Brooklyn Heights: Dispatches from America's First Suburb* (blog). May 22, 2011. http://brooklynheightsblog.com/archives/29288.

Furman, Robert, and Brian Merlis. *Brooklyn Heights: The Rise, Fall, and Rebirth of America's First Suburb.* History Press, 2015.

Gadamer, Hans-Georg. *Truth and Method.* Continuum, 1995.

Gallagher, Shaun, and Katsunori Miyahara. "Neo-Pragmatism and Enactive Intentionality." In *Action, Perception, and the Brain,* ed. Jay Schulkin, 117–46. Palgrave-Macmillan, 2012.

Gandorfer, Daniela, and Zulaikha Ayub. "Introduction: Matterphorical." *Theory & Event* 24, no. 1 (2021): 2–13.

Gaskell, Peter. "Artisans and Machinery: The Moral and Physical Condition of the Manufacturing Population Considered with Reference to Mechanical Substitutes for Human Labour" [1836]. In *The Craft Reader,* ed. Glenn Adamson, 55–60. J. W. Parker, 2010.

Geertz, Clifford. *The Interpretation of Cultures.* Basic Books, 1973.

Geurts, Kathryn Linn. *Culture and the Senses: Bodily Ways of Knowing in an African Community.* University of California Press, 2003.

Ghadessi, Touba. "Lords and Monsters: Visible Emblems of Rule." *I Tatti Studies in the Italian Renaissance* 16, no. 1/2 (September 2013): 491–523.

Gibson, James J. *The Ecological Approach to Visual Perception.* Houghton Mifflin, 1979.

——. *The Senses Considered as Perceptual Systems.* Houghton Mifflin, 1964.

Gilio-Whitaker, Dina. *As Long as Grass Grows: The Indigenous Fight for Environmental Justice, from Colonization to Standing Rock.* Beacon, 2019.

Gladwell, Malcolm. *Outliers: The Story of Success.* Back Bay, 2011.

BIBLIOGRAPHY ❧ 243

Glass Art Society. "Glass Educational Institutions: Degree Programs." October 2012. http://www.glassart.org/_Library/Schools_and_studios /GlassEdInstitutions_DEGREE_Oct2012.pdf.

——. "Glass Educational Institutions: Non-Degree Programs." October 2012. http://www.glassart.org/_Library/Schools_and_studios/Glass EdInstitutions_NONDEGREE_Oct2012.pdf.

Glassmaking at Jamestown: One of the First Industries in America. Jamestown Foundation, n.d.

Glassworker: Official Organ of the Amalgamated Glassworkers International Association of America 10, no. 114 (March 1913): 1–2.

Goodenough, Ward H. *Culture, Language, and Society,* 2nd ed. Addison-Wesley, 1981.

Goodwin, Charles. "Vision and Inscription in Practice." *Mind, Culture, and Activity* 7, no. 1–2 (2000): 1–3.

Goody, Esther N. "Daboya Weavers: Relations of Production, Dependency, and Reciprocity." In *From Craft to Industry: The Ethnography of Protoindustrial Cloth Production*, ed. E. N. Goody. Cambridge University Press, 1982.

Goffman, Erving. *Interaction Ritual: Essays on Face-to-Face Behavior.* 1967; Pantheon, 1982.

Granet, Marcel. *Chinese Civilization.* 1930; London: Routledge, 1997.

Grasseni, Cristina. "Good Looking: Learning to Be a Cattle Breeder." In *Skilled Visions: Between Apprenticeship and Standards*, ed. Cristina Grasseni, 47–66. Berghahn, 2007.

——. "Skilled Vision. An Apprenticeship in Breeding Aesthetics." *Social Anthropology* 12, no. 1 (2004): 41–55.

German Heritage Society of Greater Washington, 1997. https://german-society- md.com/wp-content/uploads/2020/11/The-First-Germans.pdf.

——. "Who Were the First Glassmakers in English America?" *The Report: A Journal of German-American History* 43 (1996): 37–42.

Greenberg, Clement. "Toward a Laocoön" [1940]. In *Art in Theory, 1900– 1990: An Anthology of Changing Ideas*, ed. Charles Harrison and Paul Wood, 754–760. Blackwell, 1992.

Grieve, Victoria. *The Federal Art Project and the Creation of Middlebrow Culture.* University of Illinois Press, 2009.

Grimes, Kimberly M., and B. Lynne Milgram. *Artisans and Cooperatives: Developing Alternative Trade for the Global Economy.* University of Arizona Press, 2000.

Grizzard, Frank, and D. Boyd Smith. *Jamestown Colony: A Political, Social, and Cultural History.* ABC-CLIO, 2007.

Groarke, Louis. *An Aristotelian Account of Induction: Creating Something from Nothing.* McGill-Queens University Press, 2009.

Gropius, Walter. *The New Architecture and the Bauhaus.* Trans. P. Morton Shand. MIT Press, 1965.

Grosz, Elizabeth. *The Incorporeal: Ontology, Ethics, and the Limits of Materialism.* Columbia University Press, 2017.

——. *Volatile Bodies: Towards a Corporeal Feminism.* Indiana Univerisity Press, 1994.

Guilbaut, Serge. *How New York Stole the Idea of Modern Art: Abstract Expressionism, Freedom, and the Cold War.* Trans. Arthur Goldhammer. University of Chicago Press, 1983.

Gumbs, Alexis Pauline. *M Archive: After the End of the World.* Duke University Press, 2018.

Goux, Jean-Joseph. "Vesta, or the Place of Being." *Representations* 1 (1983): 91–107.

Halem, Henry. *Glass Notes: A Reference for the Glass Artist.* Franklin Mills, 1993.

——. "Henry, Fritz, Dudley." *Glass Notes* 4.0. http:// www.glassnotes.com /author.html.

Hammond, John Lawrence, and Barbara Hammond. *The Town Labourer: 1760–1832, the New Civilisation.* British Publishers Guild, 1949.

Hancock, Black Hawk. *American Allegory: Lindy Hop and the Racial Imagination.* University of Chicago Press, 2013.

Hantman, Jeffery L. "Long-Term History, Positionality, Contingency, Hybridity: Does Rethinking Indigenous History Reframe the Jamestown Colony?" In *Across a Great Divide: Continuity and Change in Native North American Societies, 1400–1900,* ed. Laura L. Scheiber and Mark D. Mitchell, 42–60. University of Arizona Press, 2010.

Haraway, Donna. *The Companion Species Manifesto: Dogs, People, and Significant Otherness.* Prickly Paradigm, 2003.

——. *Manifestly Haraway.* University of Minnesota Press, 2016.

BIBLIOGRAPHY ❧ 245

———. "Situated Knowledges: The Science Question in Feminism and the Privilege of Partial Perspective." *Feminist Studies* 14, no. 3 (Autumn 1988): 575–99.

———. *Staying with the Trouble: Making Kin in the Chthulucene*. Duke University Press, 2016.

———. *When Species Meet*. University of Minnesota Press, 2007.

Hardt, Michael. *The Procedures of Love*. documenta und Museum Fridericianum, 2012. http://bettinafuncke.com/100Notes/068_Hardt.pdf.

Harper, Douglas. *Working Knowledge: Skill and Community in a Small Shop*. University of Chicago Press, 1987.

Harper, Vicki, and Diane Douglas. *Choosing Craft: The Artist's Viewpoint*. University of North Carolina Press, 2009.

Harrington, J. C. *Glassmaking at Jamestown: America's First Industry*. Dietz, 1952.

———. *A Tryal of Glasse: The Story of Glassmaking at Jamestown*. Dietz, 1980.

Harris, Anne. "Pyromena: Fire's Doing." In *Elemental Ecocriticism: Thinking with Earth, Air, Water, and Fire*, ed. Jeffrey Jerome Cohen and Lowell Duckert, 27–54. University of Minnesota Press, 2015.

Harris, Mark, ed. *Ways of Knowing: New Approaches in the Anthropology of Experience and Learning*. Berghahn, 2007.

Harvey, Charles. *William Morris: Design and Enterprise in Victorian Britain*. Manchester University Press, 1991.

Hatch, Charles E. "Glassmaking in Virginia, 1607–1625." *William and Mary Quarterly* 21, no. 3, (1941): 227–38.

Hegel, G. W. F. *The Phenomenology of Spirit*. Trans. A. V. Miller. Oxford University Press, 1977.

Heidegger, Martin. *Being and Time*. Trans. Joan Stambaugh. State University of New York Press, 1996.

———. "The Thing." In *Poetry, Language, Thought*. Trans. Albert Hofstadter. Harper Perennial, 1971.

———. *What Is Called Thinking*. Trans. Glenn Gray. Harper Collins, 2004.

Heikamp, Detlef. *Studien zur mediceischen Glaskunst: Archivalien, Entwurfszeichnungen, Glaser und Scherben*. Kunsthistorisches Institut, 1986.

Hendrickson, Carol. *Weaving Identities: Construction of Dress and Self in a Highland Guatemala Town*. University of Texas Press, 1995.

Hennion, Antoine. "Pragmatics of Taste." In *The Blackwell Companion to the Sociology of Culture*, ed. Jacobs M. Hanrahan, 131–44. Blackwell, 2005.

Hennion, Antoine, and Emilie Gomart. "A Sociology of Attachment: Music Amateurs, Drug Users." *Sociological Review* 47, no. S1 (1999): 220–47.

Heraclitus. *Fragments*. Trans. T. M. Robinson. University of Toronto Press, 1991.

Herzfeld, Michael. *The Body Impolitic: Artisans and Artifice in the Global Hierarchy of Value*. University of Chicago Press, 2004.

Hess, Catherine, and Timothy Husband. *European Glass in the J. Paul Getty Museum*. J. Paul Getty Museum, 1997.

Hollibaugh, Amber, and Cherríe Moraga. "What We're Rollin' Around in Bed With. Sexual Silences in Feminism: A Conversation Toward Ending Them." https://www.freedomarchives.org/Documents/Finder/DOC46_scans/46.WhatwereRollinAroundinBedWith.pdf.

Howell, James. *Epistolae Ho-Elianae, or, The familiar letters of James Howell* [1645]. Vol. 1. Houghton, 1907.

Howes, David, ed. *Empire of the Senses: The Sensual Culture Reader*. Berg, 2005.

Hudson, J. Paul. "Glassmaking at Jamestown: 1608–09 and 1621–24: One of the First English Industries in the New World." In *Glassmaking at Jamestown: One of the First Industries in America*. Jamestown Foundation, n.d.

Hume, David. "An Inquiry Concerning Human Understanding (1748)." In *The Empiricists*, 307–430. Anchor, 1961.

Husserl, Edmund. *Cartesian Meditations: An Introduction to Phenomenology* [1931]. Trans. Dorion Cairns. Martinus Nijhoff, 1995.

——. *The Crisis of European Sciences and Transcendental Phenomenology*. Trans. David Carr. Northwestern University Press, 1970.

——. *Ideas for a Pure Phenomenology and Phenomenological Philosophy: First Book: General Introduction to Pure Phenomenology*. Trans. Daniel O. Dahlstorm. Hackett, 2014.

Ihde, Donald, and Lambros Malafouris. "Homo Faber Revisited: Postphenomenology and Material Engagement Theory." *Philosophy and Technology* 32 (2019): 195–214.

Illich, Ivan. *Deschooling Society*. Marion Boyers, 1995.

——. *Tools for Conviviality*. Harper & Row, 1973.

BIBLIOGRAPHY ❧ 247

"Illustrations for Sir John Mandeville, Voyage d'outer mer." MS 24189. British Library. http://www.bl.uk/manuscripts/Viewer.aspx?ref=add _ms_24189_f016r; http://www.bl.uk/manuscripts/Viewer.aspx?ref=harley _ms_3954_f076r.

Ingold, Tim. *Being Alive: Essays on Movement, Knowledge, and Description*. Routledge, 2011.

——. *Lines: A Brief History*. London: Routledge, 2007.

——. *Making: Anthropology, Archaeology, Art, and Architecture*. Routledge, 2013.

——. *The Perception of the Environment: Essays on Livelihood, Dwelling, and Skill*. Routledge, 2011.

Irigaray, Luce. *Elemental Passions*. Routledge, 1992.

——. *An Ethics of Sexual Difference*. Trans. Carolyn Burke and Gillian C. Gill. Cornell University Press, 1993.

——. *The Forgetting of Air in Martin Heidegger*. Trans. Mary Beth Mader. University of Texas Press, 1999.

Irigaray, Luce, and Eleanor H. Kuykendall. "Sorcerer Love: A Reading of Plato's *Symposium*, Diotima's Speech." *Hypatia* 3, no. 3 (1989): 32–44.

Jarves, Deming. *Reminiscences of Glass-making*. Beatrice C. Weinstock, 1968.

Jay, Martin. *Downcast Eyes: The Denigration of Vision in Twentieth-Century French Thought*. University of California Press, 1994.

Johnson, Mark. *The Body in the Mind: The Bodily Basis of Meaning, Imagination, and Reason*. University of Chicago Press, 1987.

——. *The Meaning of the Body: Aesthetics of Human Understanding*. University of Chicago Press, 2007.

Jordan, June. "Where Is the Love?" In *Some of Us Did Not Die*, 268–74. Basic Books, 2002

Jorgensen, C. Gregg. *John Dewey and the Dawn of the Social Sciences: Unraveling Conflicting Interpretations of the 1916 Report*. Information Age Publishing, 2012.

Jung, Carl. *Psychology and Alchemy*. Princeton University Press, 1980.

Kaiser, Fritz. *Degenerate Art: The Exhibition Guide in German and English* [1937]. Ostara, 2012.

Kant, Immanuel. *Critique of Judgement*. Trans. Werner S. Pluhar. Hackett, 1987.

248 ℠ BIBLIOGRAPHY

Kaufman, Edgar, Paul N. Perrot, and Rudolf M. Riefstahl. "Statement." In *Toledo Glass National*, 1. Toledo Museum of Art, 1966.

Kelly, Christopher. *The Roman Empire: A Very Short Introduction*. Oxford University Press, 2006.

Kikuchi, Yuko. *Japanese Modernisation and Mingei Theory: Cultural Nationalism and Oriental Orientalism*. Taylor & Francis Group, 2004.

Kirk, G. S., J. E., Raven, and M. Schofield. *The Presocratic Philosophers*. Cambridge University Press, 1983.

Klein, Dan, and Ward Lloyd, eds. *The History of Glass*. Orbis, 1984.

Knight, Edward Henry. *Knight's American Mechanical Dictionary*. Boston: Houghton, Mifflin & Co., 1884.

Knott, Stephen. *Amateur Craft: History and Theory*. Bloomsbury, 2015.

Koeninger, Kay. "The Studio Pottery Tradition, 1940–1970." In *Revolution in Clay: The Marer Collection of Contemporary Ceramics*, 17–45. University of Washington Press, 1994.

Kofman, Sara. "Beyond Aporia?" In *Post-Structuralist Classics*, ed. Andrew Benjamin, 7–20. Routledge, 1988.

Kojeve, Alexandre. *Introduction to the Reading of Hegel*. Basic Books, 1969.

Kondo, Dorinne K. *Crafting Selves: Power, Gender, and Discourses of Identity in a Japanese Workplace*. University of Chicago Press, 1990.

Koplos, Janet, and Bruce Metcalf. *Makers: A History of American Studio Craft*. University of North Carolina Press, 2010.

Kotva, Simone. "Gilles Deleuze, Simone Weil, and the Stoic Apprenticeship: Education as a Violent Training." *Theory, Culture & Society* 32, nos. 7–8 (2015): 101–21.

Kovener, Lola, and Geoffrey T. Hellman. "Easy Does It." *New Yorker*, September 21, 1945, 17.

Krása, Josef. *The Travels of Sir John Mandeville: A Manuscript in the British Library*. Trans. Peter Kussi. George Braziller, 1983.

Kuhn, Thomas. *The Structure of Scientific Revolutions*. 2nd ed. University of Chicago Press, 1970.

Kulasiewicz, Frank. *Glassblowing: The Technique of Free-Blown Glass*. Watson- Guptill, 1974.

——. "Offhand Blown Glass as a Contemporary Craft." PhD diss., Teachers College, Columbia University, 1970.

Kurasawa, Fuyuki. *The Ethnological Imagination: A Cross-Cultural Critique of Modernity*. University of Minnesota Press, 2004.

Labino, Dominick. *Visual Art in Glass*. Wm. C. Brown, 1968.

Lampert, Nicholas. *A People's Art History of the United States: 250 Years of Activist Art and Artists Working in Social Justice Movements*. New Press, 2013.

Lande, Brian. "Breathing Like a Soldier: Culture Incarnate." In *Embodying Sociology: Retrospect, Progress, and Prospects*, ed. Chris Shilling, 95–108. Wiley- Blackwell, 2007.

Landes, Donald A. *Merleau-Ponty and the Paradoxes of Expression*. Bloomsbury, 2013.

Langlands, Alexander. *Cræft: An Inquiry Into the Origins and True Meaning of Traditional Crafts*. Norton, 2017.

Lanmon, Dwight, Arlene P. Schwind, Ivor N. Hume, Robert H. Brill, and V. F. Hanson. *John Frederick Amelung: Early American Glassmaker*. Corning Museum of Glass Press, 1990.

Lapham, Heather A. "More Than 'a Few Blew Beads': The Glass and Stone Beads from Jamestown Rediscovery's 1994–1997 Excavations." *Journal of the Jamestown Rediscovery Center* 1 (January 2001).

Latour, Bruno. *Laboratory Life: The Construction of Scientific Facts*. Princeton University Press, 1986.

——. *Reassembling the Social: An Introduction to Actor-Network-Theory*. Oxford University Press, 2007.

——. *We Have Never Been Modern*. Harvard University Press, 1993.

Lave, Jean. *Apprenticeship in Critical Ethnographic Practice*. University of Chicago Press, 2011.

——. "Cognitive Consequences of Traditional Apprenticeship Training in West Africa." *Anthropology and Education Quarterly* 8, no. 3 (August 1977): 177–80.

——. "A Comparative Approach to Educational Forms and Learning Processes." *Anthropology and Education Quarterly* 13, no. 2 (Summer 1982): 181–87.

Lave, Jean, and Etienne Wenger. *Situated Learning: Legitimate Peripheral Participation*. Cambridge University Press, 1991.

Leach, Bernard. *A Potter's Book*. Faber and Faber, 1940.

Leder, Drew. *The Absent Body*. University of Chicago Press, 1990.

———. "Embodying Otherness: Shape-Shifting and the Natural World." *Environmental Philosophy* 9, no. 2 (Fall 2012): 123–42.

———. "Flesh and Blood: A Proposed Supplement to Merleau-Ponty." *Human Studies* 13, no. 3 (1990): 209–19.

Lefebvre, Henri. *The Production of Space*. Trans. Donald Nicholson-Smith. Blackwell, 1991.

———. *Rhythanalysis: Space, Time, and Everyday Life*. Trans. Stuart Elden and Gerald Moore. Continuum, 2004.

LeGuin, Ursula K. "The Carrier Bag Theory of Fiction." In *Dancing at the Edge of the World: Thoughts on Words, Women, Places*, 165–70. Grove, 1989.

Leen, Nina. "The Old Crafts Find New Hands." *Life*, July 29, 1966.

Levi-Strauss, Claude. *The Elementary Structures of Kinship*. Beacon, 1969.

Lindsay, Shawn. "Hand Drumming: An Essay in Practical Knowledge." In *Things as They Are: New Directions in Phenomenological Anthropology*, ed. Michael Jackson, 196–212. Indiana University Press, 1996.

Lispector, Clarice. *The Passion According to G.H.* Trans. Idra Novey, ed. Benajmin Moser. New Directions, 2012.

Littleton, Harvey. "Artist Produced Glass: A Modern Revolution." Paper presented at the Eighth International Glass Congress, London, July 1968.

———. *Glassblowing: A Search for Form*. Van Nostrand Reinhold, 1971.

———. "Oral History Interview with Harvey K. Littleton." Interview by Joan Falconer Byrd. Archives of American Art, Smithsonian Institution, March 15, 2001. http://www.aaa.si.edu/collections/interviews/oral-history -interview-harvey-k-littleton-11795.

Llewelyn, John. "On the Saying That Philosophy Begins in Thaumazein." *Afterall: A Journal of Art, Context, and Enquiry* 4 (2001): 48–57.

Lock, Margaret, and Judith Farquhar, eds. *Beyond the Body Proper: Reading the Anthropology of Material Life*. Duke University Press, 2007.

Lorde, Audre. "An Open Letter to Mary Daly." In *Sister Outsider: Essays and Speeches*. Crossing, 1984.

———. "The Uses of the Erotic: The Erotic as Power." In *Sister Outsider: Essays and Speeches*. Crossing, 1984.

Lucie-Smith, Edward. *The Story of Craft*. Cornell University Press, 1981.

Lukacs, George. *The Ontology of Social Being*. Vol. 2: *Marx's Basic Ontological Principles*. Merlin, 1978.

BIBLIOGRAPHY ∽ 251

Macauley, David. *Elemental Philosophy: Earth, Air, Fire, and Water as Environmental Ideas.* State University of New York Press, 2010.

Mach, Ernst. *The Principles of the Theory of Heat* [1896]. Ed. Brian McGuinness. Kluwer, 2012.

MacNaughton, Mary Davis. "Innovation in Clay: The Otis Era, 1954–1960." In *Revolution in Clay: The Marer Collection of Contemporary Ceramics*, ed. Mary Davis McNaughton, 47–97. University of Washington Press, 1994.

——. *Revolution in Clay: The Marer Collection of Contemporary Ceramics.* University of Washington Press, 1994.

Makovicky, Nicolette. "'Something to Talk About': Notation and Knowledge-Making Among Central Slovak Lace-Makers." In *Making Knowledge: Explorations of the Indissoluble Relation Between Mind, Body, and Environment*, ed. Trevor Marchand. Wiley-Blackwell, 2010.

Malafouris, Lambros. "Beads for a Plastic Mind: The Blind Man's Stick (BMS) Hypothesis and the Active Nature of Material Culture." *Cambridge Archaeological Journal* 18, no. 3 (2008): 401–14.

——. *How Things Shape the Mind: A Theory of Material Engagement.* MIT Press, 2017.

——. "Mind and Material Engagement." *Phenomenology and the Cognitive Sciences* 18 (2019): 1–17.

Malafouris, Lambros, and M. D. Koukouti. "More Than a Body: A Material Engagement Approach." In *Intercorporeallity: Emerging Socialities in Interaction*, ed. Christian Meyer, J. Streek, and J. Scott Jordan. Oxford University Press, 2016.

Mannheim, Karl. *Ideology and Utopia.* Trans. Louis Wirth and Edward Shils. Harvest, 1936.

Manning, Erin. *Politics of Touch: Sense, Movement, Sovereignty.* University of Minnesota Press, 2007.

Marchand, Ernest. "Emerson and the Frontier." *American Literature* 3, no. 2 (1931): 149–74.

Marchand, Trevor H. J., ed. *Making Knowledge: Explorations of the Indissoluble Relation Between Mind, Environment, and Body.* Wiley-Blackwell, 2010.

——. *The Masons of Djenne.* Indiana University Press, 2009.

——. *Minaret Building and Apprenticeship in Yemen.* Curzon, 2001.

——. "Muscles, Morals, and Mind: Craft Apprenticeship and the Formation of Person." *British Journal of Educational Studies* 56 (2008): 245–71.

252 BIBLIOGRAPHY

——. *The Pursuit of Pleasurable Work: Craftwork in Twenty-First Century England*. Berghahn, 2021.

Marcuse, Herbert. *Eros and Civilization: A Philosophical Inquiry Into Freud*. Beacon, 1966.

Margetts, Martina. "The Post-craft Turn." In *Post-Craft*, ed. Alex Coles and Catharine Rossi, 3:41–52. Sternberg, 2022.

Marioni, Dante. "Meet the Artist: Dante Marioni." Interview by Tina Oldknow. Corning Museum of Glass, February 25, 2010. http://www.cmog.org/transcript/meet-artist-dante-marioni.

Marquis, Richard. "Chronology." http://www.richardmarquis.com/index.php?page=Chronology.

"Material Safety Data Sheet." Spruce Pine Batch Company. April 17, 2001.

Martineau, Harriett. "Birmingham Glass Works." *Household Words* 5, no. 105 (1852): 32–38.

Mauras, Hrabanus. *De Universo: The Peculiar Properties of Words and Their Mystical Significance, Volume Two, Books XII–XXII*. Trans. Priscilla Throop. MedievalMS, 2009.

Marx, Karl. *The Communist Manifesto*. Barron's Educational Series, 1972.

——. "Economic and Philosophic Manuscripts of 1844." In *The Marx-Engels Reader*, ed. Robert Tucker, 66–125. Norton, 1978.

Marx, Karl, and Friedrich Engels. "German Ideology." In *The Marx-Engels Reader*, ed. Robert Tucker, 146–200. Norton, 1978.

——. *The Marx-Engels Reader*. Ed. Robert Tucker. Norton, 1978.

"Maryland Products—Glass." *Baltimore*, February 1948, 59.

Mauss, Marcel. *Sociology and Psychology: Essays*. Trans. Ben Brewster. Routledge & Kegan Paul, 1979.

——. "Techniques of the Body." In *Incorporations*, ed. Jonathan Crary and Sandford Kwinter, 455–77. Zone, 1992.

Maxwell, J. Clerk. *Theory of Heat*. London: Longmans, Green, and Co., 1872.

McCray, W. Patrick. *Glassmaking in Renaissance Venice: The Fragile Craft*. Ashgate, 1999.

McDermott Hughes, David. *Energy Without Conscience: Oil, Climate Change, and Complicity*. Duke University Press, 2017.

Mead, Margaret. *Continuities and Discontinuities in Cultural Evolution*. Yale University Press, 1964.

BIBLIOGRAPHY ❦ 253

Melville, Herman. *Moby-Dick, or, The Whale*. Penguin, 1988.

Merleau-Ponty, Maurice. *Husserl at the Limits of Phenomenology*. Ed. Leonard Lawlor with Bettina Bergo. Northwestern University Press, 2002.

——. *The Phenomenology of Perception*. Trans. Colin Smith. Routledge, 1962.

——. *The Primacy of Perception*. Trans. James Edie. Northwestern University Press, 1964.

——. *Signs*. Trans. Richard C. McCleary. Northwestern University Press, 1964.

——. *The Visible and the Invisible*. Trans. Alphonso Lingis. Northwestern University Press, 1968.

Mill, John Stuart. "On Nature." In *Three Essays on Religion*. Rationalist Press, 1904.

Miller, Danny, ed. *Materiality*. Duke University Press, 2005.

Moore, Jason W. "The Capitalocene, Part I: On the Nature and Origins of Our Ecological Crisis." *Journal of Peasant Studies* 44, no. 3 (2017): 594–630.

Moran, Dermot. "Heidegger's Critique of Husserl's and Brentano's Accounts of Intentionality." In *Phenomenology: Critical Concepts in Philosophy*, 1:157–83. Routledge, 2004.

Morris, William. *News from Nowhere and Other Writings*. Penguin, 2004.

——. *Useful Work v. Useless Toil*. Penguin, 2008.

Morton, Timothy. *Hyperobjects: Philosophy and Ecology After the End of the World*. University of Minneapolis Press, 2013.

Mukerji, Chandra. "Toward a Sociology of Material Culture." In *The Sociology of Culture*, ed. Diana Crane. Basil Blackwell, 1994.

Nash, Gary. "Artisans and Politics in Eighteenth-Century Philadelphia." In *The Craftsman of Early America*, ed. Ian Quimby, 62–88. Norton, 1984.

Nash, Jennifer C. "Practicing Love: Black Feminism, Love-Politics, and Post-Intersectionality." *Meridians* 11, no. 2 (2011): 1–24.

Nash, June. *Crafts in the World Market: The Impact of Global Exchange on Middle American Artisans*. State University of New York Press, 1993.

Natiba. "On Native Land." Brooklyn Public Library. https://www.bklyn library.org/blog/2019/11/08/native-land.

Neimanis, Astrida. *Bodies of Water: Posthuman Feminist Phenomenology*. Bloomsbury, 2017.

254 &ơ BIBLIOGRAPHY

Neri, Antonio. *The World's Most Famous Book on Glassmaking.* Trans. Christopher Merrett. Society of Glass Technology, 2006.

Neri, Antonio. *Di'Alchimia.*

New Daggett, Cara. *The Birth of Energy: Fossil Fuels, Thermodynamics, and the Politics of Work.* Duke University Press, 2019.

Newman, Harold. *An Illustrated Dictionary of Glass.* Thames and Hudson, 1977.

Newman, William R. *Promethean Ambitions: Alchemy and the Quest to Perfect Nature.* University of Chicago Press, 2004.

Nordness, Lee. *Objects, U.S.A.: Works by Artist-Craftsmen in Ceramic, Enamel, Glass, Metal, Plastic, Mosaic, Wood, and Fiber.* Viking, 1970.

O'Brien, Jane Clifford. *Introduction to Occupational Therapy.* 4th ed. Elsevier Health Sciences, 2013.

Ocejo, Richard E. *Masters of Craft: Old Jobs in the New Urban Economy.* Princeton University Press, 2017.

O'Connor, Erin. "Becoming with Glass: Medium and Materiality in Embodied Knowledge." In *Craft and Design Practice from an Embodied Perspective*, ed. Camilla Groth and Nithikul Nimkulrat. Routledge, 2024.

——. "Embodied Knowledge: The Experience of Meaning and the Struggle Towards Proficiency in Glassblowing." *Ethnography* 6, no. 2 (2005): 183–204.

——. "Glassblowing Tools: Extending the Body Towards Practical Knowledge and Informing a Social World." *Qualitative Sociology* 29, no. 2 (2006): 177–93.

——. "Hot Glass: The Calorific Imagination of Glassblowing." In *Practicing Culture (Taking Culture Seriously)*, ed. Craig Calhoun and Richard Sennett, 57–81. Routledge, 2007.

——. "Inter- to Intracorporeality: The Haptic Hotshop Heat of a Glassblowing Studio." In *Studio Studies: Operations, Topologies, and Displacements*, ed. Ignacio Farías and Alex Wilkie, 105–19. Routledge, 2016.

——. "Materia Erotica: Making-Love Among Glassblowers." In *Leaving the Field? Methodological Insights from Ethnographic Exits*, ed. Robin Smith and Sara Delamont, 86–98. Manchester University Press, 2023.

——. "Touching Tacit Knowledge: Handwork as Ethnographic Method in Glassblowing." *Qualitative Research* 17, no. 2 (2017): 217–30.

BIBLIOGRAPHY ❧ 255

O'Connor, Erin, and Suzanne Peck. "The Prototype: Problem Work in the Relationship Between Designer, Artist, and Gaffer in Glassblowing." In *Craftwork as Problem Solving: Ethnographic Studies of Design and Making*, ed. Trevor Marchand. Ashgate, 2016.

O'Connor, Francis V., ed. *Art for the Millions: Essays from the 1930s by Artists and Administrators of the WPA Federal Art Project*. New York Graphic Society, 1973.

Ogden, Daryl. "The Architecture of Empire: 'Oriental' Gothic and the Problem of British Identity in Ruskin's Venice." *Victorian Literature and Culture* 25, no. 1 (1997): 109–20.

Oland, Dwight D. *Maryland Historical Magazine* 68 (1973): 255–72.

Oldknow, Tina. "Masters of Studio Glass: Erwin Eisch." Corning Museum of Glass, January 24, 2012. http://www.cmog.org/article/masters-studio -glass-erwin-eisch.

——. *Pilchuck: A Glass School*. Pilchuck Glass School, in association with the University of Washington Press, 1996.

Pagis, Michal. *Inward: Vipassana Meditation and the Embodiment of the Self*. University of Chicago Press, 2019.

Palmer, Arlene. "Glass Production in Eighteenth-Century America: The Wistarburgh Enterprise." *Winterthur Portfolio* 11 (1976): 75–101.

——. *The Wistarburgh Glassworks: The Beginning of Jersey Glassmaking*. Alloway Township Bicentennial Committee, 1976.

——. *The Wistars and Their Glass: 1739–1777*. Wheaton Historical Association, 1989.

Palmer-Schwind, Arlene. "The Glassmakers of Early America." In *The Craftsman of Early America*, ed. Ian Quimby, 158–89. Norton, 1984.

Parkinson, Michael. "The Rise of the Entrepreneurial European City: Strategic Responses to Economic Changes in the 1980s." *Ekistics* 58, no. 350(1) (1991): 299–307.

Parolin, L. L., and A. Mattozzi. Reprint of "Sensitive Translations: Sensitive Dimension and Knowledge Within Two Craftsmen's Workplaces." *Scandinavian Journal of Management* 29, no. 4 (2014).

Parsons, Talcott. "The American Family: Its Relations to Personality and to the Social Structure." In *Family, Socialization, and Interaction Process*, ed. Talcott Parsons and R. F. Bales, 3–33. Free Press, 1955.

——. "The Kinship System of the Contemporary United States." *American Anthropologist* 45, no. 1 (1943): 22–38.

256 <> BIBLIOGRAPHY

——. "The School Class as a Social System." *Harvard Educational Review*, Fall 1959.

Paxson, Heather. *The Life of Cheese: Crafting Food and Value in America.* University of California Press, 2012.

Pellatt, Apsley. *Curiosities of Glassmaking: with Details of the Processes and Productions of Ancient and Modern Ornamental Glass Manufacture.* London: David Bogue, 1849.

Peterson, Karin E. "How Things Become Art: Hierarchy, Status, and Cultural Practice in the Expansion of the American Canon." PhD diss., University of Virginia, 1999.

Peterson, Richard. "The Production of Culture Perspective." *Annual Review of Sociology* 33 (August 2004): 311–34.

Pink, Sarah. *Doing Sensory Ethnography.* 2nd ed. Sage, 2015.

Plato. *Protagaros and Meno.* Penguin, 1956.

——. *The Symposium.* Trans. Christopher Gill. Penguin, 1999.

——. *Timaeus.* Trans. Peter Kalkavage. Focus, 2001.

Pliny the Elder. *The Natural History.* Vol. X. Trans. John Bostock, ed. H. T. Riley. Harvard University Press, 1962.

Plumwood, Val. "Decolonizing Relationships with Nature." In *Decolonizing Nature: Strategies for Conservation in a Post-Colonial Era*, ed. William M. Adams and Martin Mulligan. Earthscan, 2003.

Polak, Ada. *Glass: Its Tradition and Its Makers.* G. P. Putnam's Sons, 1975.

Polanyi, Michael. *Personal Knowledge: Towards a Post-Critical Philosophy.* University of Chicago Press, 1962.

——. *The Study of Man.* University of Chicago Press, 1959.

——. *The Tacit Dimension.* Anchor, 1967.

Popper, Karl. *The Open Society and Its Enemies.* 2 vols. 4th rev. ed. Princeton University Press, 1963.

Povenelli, Elizabeth A. *Geontologies: A Requiem to Late Capitalism.* Duke University Press, 2017.

Powell, Harry J. *The Principles of Glass-Making.* Together with *Treatises on Crown and Sheet Glass* by Henry Chance and *Plate Glass* by H. G. Harris. London: George Bell and Sons, 1883.

Price, Jane, and Margrit Shildrick, eds. *Feminist Theory and the Body: A Reader.* Routledge, 1999.

BIBLIOGRAPHY ❧ 257

Putnam, Robert D. *Bowling Alone: The Collapse and Revival of American Community*. Simon & Schuster, 2000.

Pye, David. *The Nature and Art of Workmanship*. Cambridge University Press, 1968.

——. *The Nature of Design*. Reinhold, 1964.

Pyne, Stephen J. *Fire: A Brief History*. University of Washington Press, 2019.

——. "Fire in the Mind: Changing Understandings of Fire in Western Civilization." *Philosophical Transactions: Biological Sciences* 371, no. 1696 (June 2016): 1–8.

Quattlebaum, W. Dan. *Early American Glass*. Pasadena, California, 1939.

——. *John Frederick Amelung: Pioneer Glassmaker and His Products*. N.d.

Quimby, Ian, ed. *The Craftsman of Early America*. Norton, 1984.

Quynn, Dorothy Mackay. "Johann Friedrich Amelung at New Bremen." *Maryland Historical Magazine* 43 (September 1948).

Rabinow, Paul. *Reflections on Fieldwork in Morocco*. University of California Press, 1977.

Report of the Industrial Commission on the Relations and Conditions of Capital and Labor Employed in Manufactures and General Business: Including Testimony So Far as Taken November 1, 1900, and Digest of Testimony. [D. A. Hayes, President, Glass Bottle Blowers' Association.] *United States Congressional Record*, issue 4169, 1900.

Rilke, Rainer Maria. *Rilke's Book of Hours: Love Poems to God*. Trans. Anita Barrows and Joanna Macy. Riverhead, 1996.

Risatti, Howard. *A Theory of Craft: Function and Aesthetic Expression*. University of North Carolina Press, 2007.

Rock, Howard, Paul A. Gilje, and Robert Asher. *American Artisans: Crafting Society Identity, 1750–1850*. Johns Hopkins University Press, 1995.

Rodrigo, Pierre. "The Dynamic of Hexis in Aristotle's Philosophy," *Journal of the British Society for Phenomenology* 42, no. 1 (2011): 6–17.

Rosa, Harmut. *Social Acceleration: A New Theory of Modernity*. Columbia University Press, 2015.

Rotella, Carlo. *Good with Their Hands: Boxers, Bluesmen, and Other Characters from the Rust Belt*. University of California Press, 2002.

Rowley, Sue, ed. *Craft and Contemporary Theory*. Allen & Unwin, 1997.

258 ❧ BIBLIOGRAPHY

Ruskin, John. "Life Guards of New Life" [July 1877]. Letter 79 of *Fors Clavigera: Letters to the Workmen and Labourers of Great Britain*, ed. E. T. Cook and Alexander Wedderburn, 146–69. George Allen, 1907.

——. *The Seven Lamps of Architecture*. Noonday, 1974.

——. *The Stones of Venice*. Vol. 2: *The Sea Stories*. George Allen, 1906.

Rusu, Mihai Stelian. "Theorising Love in Sociological Thought: Classical Contributions to a Sociology of Love." *Journal of Classical Sociology* 18, no. 1 (2018): 3–20.

Sá Cavalcante Schuback, Marcia. "Heideggerian Love." In *Phenomenology of Eros*, ed. Jonna Bornemark and Marcia Sá Cavalcante Schuback. Södertörn University, 2012.

Sandler, Irving. *The Triumph of American Painting: A History of Abstract Expressionism*. Praeger, 1970.

Scharpf, Fritz W. *Crisis and Choice in European Social Democracy*. Cornell University Press, 1991.

Schlanger, Jeff, and Toshiko Takaezu. *Maija Grotell: Works Which Grow from Belief.* Studio Potter Books, 1996.

Schlereth, Timothy. "Artisans and Craftsmen: A Historical Perspective." In *The Craftsman of Early America*, ed. Ian Quimby, 34–61. Norton, 1984.

Schmid, Edward. *Advanced Glassworking Techniques*. Glass Mountain, 1997.

——. *Beginning Glassblowing*. Glass Mountain, 1998.

——. *Ed's Big Handbook of Glassblowing*. Glass Mountain, 1993.

——. *The Glassworker's Bathroom Reader*. Glass Mountain, 2006.

Scholes, Samuel R. *Modern Glass Practice*. Cahners, 1975.

Scott, Gary Alan, and William A. Welton. *Erotic Wisdom: Philosophy and Intermediacy in Plato's Symposium*. State University of New York Press, 2007.

Scott, James C. *Seeing Like a State: How Certain Schemes to Improve the Human Condition Have Failed*. Yale University Press, 1998.

Scoville, Warren. *Revolution in Glassmaking: Entrepreneurship and Technological Change in the American Industry*. Harvard University Press, 1948.

Sedgwick, Eve Kosofsky, *Touching Feeling: Affect, Pedagogy, Performativity*. Duke University Press, 2003.

Sennett, Richard. *The Craftsman*. Yale University Press, 2008.

——. *The Fall of Public Man*. Knopf, 1977.

BIBLIOGRAPHY ❧ 259

Sharpe, Christina. *In the Wake: On Blackness and Being*. Duke University Press, 2016.

Sheets-Johnstone, Maxine. *The Corporeal Turn: An Interdisciplinary Reader*. Imprint Academic, 2009.

——. *The Primacy of Movement*. John Benjamins, 2011.

——. *The Roots of Power: Animate Form and Gendered Bodies*. Open Court, 1994.

——. *The Roots of Thinking*. Temple University Press, 1990.

Shelly, Percy Bysshe. "Prometheus Unbound." In *The Major Works*, ed. Zachary Leader and Michael O'Neill, 229–313. Oxford University Press, 2003.

Shilling, Chris. *The Body and Social Theory*. Sage, 1993.

——, ed. *Embodying Sociology: Retrospect, Progress, and Prospects*. Blackwell, 2007.

Sidbury, James. "Slave Artisans in Richmond, Virginia, 1780–1810." In *American Artisans: Crafting Society Identity, 1750–1850*, ed. Howard Rock, Paul A. Gilje, and Robert Asher, 48–64. Johns Hopkins University Press, 1995.

Simmel, Georg. "On Love (a Fragment)" [1904]. In *On Women, Sexuality, and Love*, 153–92. Yale University Press, 1984.

Singer, Linda. "Merleau-Ponty on the Concept of Style." In *The Merleau-Ponty Aesthetics Reader: Philosophy and Painting*, ed. Galen A. Johnson, 233–44. Northwestern University Press, 1998.

Singh, Julietta. *Unthinking Mastery: Dehumanism and Decolonial Entanglements*. Duke University Press, 2018.

Singleton, John. "Japanese Folkcraft Pottery Apprenticeship: Cultural Patterns of an Educational Institution." In *Apprenticeship: From Theory to Method and Back Again*, ed. Michael W. Coy, 13–30. State University of New York Press, 1989.

Slivka, Rose. "The New Ceramic Presence" [1961]. In *The Craft Reader*, ed. Glenn Adamson, 515–33. Berg, 2010.

Sloterdijk, Peter. *Neither Sun nor Death*. Trans. Steve Corcoran. Semiotext(e), 2011.

Smith, Adam. *The Wealth of Nations*. University of Chicago Press, 1976.

Smith, John. *The Adventures of Captain John Smith*. https://tile.loc.gov/storage-services/public/gdcmassbookdig/adventuresofcaptoohawk/adventuresofcaptoohawk.pdf.

Smith, Pamela H., Amy R. W. Meyers, and Harold J. Cook, eds. *Ways of Making and Knowing: The Material Culture of Empirical Knowledge*. Bard Graduate Center, 2017.

Speak, Gill. "'El licenciado Vidriera' and the Glass Men of Early Modern Europe." *Modern Language Review* 85, no. 4 (1990): 850–65.

Spindler, George D. "Cultural Transmission." In *Culture in Process*, 2nd ed., ed. Alan R. Beals, with George D. Spindler and Louise Spindler. Holt, Rinehart and Winston, 1973.

——. *The Transmission of American Culture*. Harvard University Press, 1959.

Stanley-Smith, Cyril. "Notes." In *Pirotechnia* [1540], by Vannoccio Biringuccio, trans. Cyril Stanley-Smith. MIT Press, 1966.

Starosielski, Nicole. *Media Hot and Cold*. Duke University Press, 2022.

Steinhardt, Paul J. "A Quintessential Introduction to Dark Matter." *Philosophical Transactions of the Royal Society A: Mathematical, Physical, and Engineering Sciences* 361, no. 1812 (November 15, 2003): 2497–513.

Steinmetz, George, ed. *The Politics of Method in the Human Sciences: Positivism and Its Epistemological Others*. Duke University Press, 2005.

Stoller, Paul. *The Taste of Ethnographic Things: The Senses in Anthropology*. University of Pennsylvania Press, 1989.

Sudnow, David. *Ways of the Hand*. Harvard University Press, 1978.

Surak, Kristin. *Making Tea, Making Japan: Cultural Nationalism in Practice*. Stanford University Press, 2012.

Swidler, Anne. "Culture in Action: Symbols and Strategies." *American Sociological Review* 51 (April 1986).

——. *Talk of Love*. University of Chicago Press, 2001.

Tagliapietra, Lino. "Meet the Artist: Lino Tagliapietra." Interview by Tina Oldknow. Corning Museum of Glass, May 15, 2007.

Tait, Hugh. *Five Thousand Years of Glass*. Trustees of the British Museum, 1991.

Tatton-Brown, Veronica, and Carol Andrew. "Before the Invention of Glassblowing." In *Five Thousand Years of Glass*, ed. Hugh Tait, 21–61. Trustees of the British Museum, 1991.

Taylor, Frederick. *The Principles of Scientific Management*. Harper & Brothers, 1915.

Terrio, Susan J. *Crafting the Culture and History of French Chocolate*. University of California Press, 2000.

Thompson, E. P. *The Making of the English Working Class*. Vintage, 1963.

BIBLIOGRAPHY ❧ 261

Tice, Karin E. *Kuna Crafts, Gender, and the Global Economy*. University of Austin Press, 1995.

Trilling, Lionel. *Sincerity and Authenticity*. Oxford University Press, 1974.

Tsakirgis, B. "Fire and Smoke: Hearths, Braziers, and Chimneys in the Greek House." *British School at Athens Studies* 15 (2007): 225–31.

Tsing, Anna Lowenhaupt. *The Mushroom at the End of the World: On the Possibility of Life in Capitalist Ruins*. Princeton University Press, 2021.

Tyler, Lyon Gardiner. *The Cradle of the Republic: Jamestown and James River*. Whittet & Shepperson, 1900.

Veblen, Thorstein. *The Theory of the Leisure Class*. Oxford University Press, 2009.

Venkatesan, Soumhya. "Learning to Weave; Weaving to Learn . . . What?" In *Making Knowledge: Explorations of the Indissoluble Relation Between Mind, Body, and Environment*, ed. Trevor Marchand, 150–66. Wiley-Blackwell, 2010.

Vose, Ruth H. "From the Dark Ages to the Fall of Constantinople." In *The History of Glass*, ed. Dan Klein and Ward Lloyd, 39–65. Trustees of the British Museum, 1984.

Wacquant, Loïc. *Body and Soul: Notebooks of an Apprentice Boxer*. Oxford University Press, 2004.

——. "The Pugilistic Point of View: How Boxers Think and Feel About Their Trade." *Theory and Society* 24, no. 4 (1995): 489–535.

Waggoner, Shawn. "Fritz Dreisbach's 50 Years of Blowing Glass." *Glass Art* 29, no. 6 (November/December 2014): 8–13.

Wallach Scott, Joan. *The Glassworkers of Carmaux: French Craftsmen and Political Action in a Nineteenth-Century City*. Harvard University Press, 1974.

Waugh, Sidney. *The Art of Glass Making*. Dodd, Mead, 1939.

——. *The Making of Fine Glass*. Dodd, Mead, 1947.

Weber, Max. *The Protestant Ethic and the Spirit of Capitalism*. Routledge, 1997.

——. "Religious Rejection of the World and Their Directions." In *From Max Weber: Essays in Sociology*, ed. Hans H. Gerth and C. Wright Mills, 323–59. Oxford University Press, 1946.

Weddell, Kennard. "The Amelung Saga." Unpublished paper, Frederick Historical Society.

Weil, Simone. *Gravity and Grace*. Routledge, 1999.

——. *The Need for Roots*. Routledge, 1997.

Weiss, Gail. *Body Images: Embodiment as Intercorporeality*. Routledge, 1999.

White, Harrison, and Cynthia C. White. *Canvases and Careers: Institutional Change in the French Painting World*. Wiley, 1965.

Whitford, Frank. *Bauhaus*. Thames & Hudson, 1984.

Wilkinson-Weber, Clare M. *Embroidering Lives: Women's Work and Skill in the Lucknow Embroidery Industry*. State University of New York Press, 1999.

Williams, Terry. *The Cocaine Kids: The Inside Story of a Teenage Drug Ring*. DeCapo, 1990.

Williams, Terry, and Sarah Daynes. *On Ethnography*. Polity, 2018.

Wilson, Kenneth M. *American Glass, 1760–1930*. Vol. 1. Hudson Hills, 1994.

Wittmann, Otto. *Libbey Glass: A Tradition of 150 Years, 1818–1968*. Toledo Museum of Art, 1968.

——. *Toledo Glass National*. Toledo Museum of Art, 1966.

——. *Toledo Glass National II*. Toledo Museum of Art, 1968.

——. *Toledo Glass National III*. Toledo Museum of Art, 1970.

Wolcott, Harry F. "The Anthropology of Learning." *Anthropology and Education Quarterly* 13, no. 2 (Summer 1982): 83–108.

Woodward, Calvin M. *The Manual Training School, Comprising a Full Statement of Its Aims, Methods, and Results, with Figured Drawings of Shop Exercises in Woods and Metals*. Boston: D. C. Heath & Co., 1887.

Working, Lauren. *The Making of an Imperial Polity: Civility and America in the Jacobean Metropolis*. Cambridge University Press, 2020.

Yanagi, Soetsu. *The Unknown Craftsman: A Japanese Insight Into Beauty*. Kodansha, 2013.

Young, Iris Marion. *Throwing Like a Girl and Other Essays in Feminist Philosophy and Social Theory*. Indiana University Press, 1990.

Yusoff, Kathryn. *A Billion Black Anthropocenes or None*. University of Minnesota Press, 2019.

Zembala, Dennis. "Machines in the Glasshouse: The Transformation of Work in the Glass Industry, 1820–1915." PhD diss., George Washington University, 1984.

Zolberg, Vera. *Constructing a Sociology of the Arts*. Cambridge University Press, 1990.

INDEX

actor network, 23, *103*, 104
adaptation: anticipatory, 69–70, 81–84; intercorporeal, 106–7
Advanced Glassworking Techniques (Schmid), 55, 94, *100*, *103*
aesthetic theory, 57
aether, 146, 150
Agricola, Georgius, 41–42, *43*
Ahmed, Sarah, 174–75, 177, 228n16
air: complicity of air and breath with body, 131–32; "forgetting of" in Western thought, 23, 120, 122, 125, 157; hollowness, 131–33; remembering, 125, 132; required for fire, 125, 132. *See also* breath
Alaimo, Stacy, 109–10
alchemy, 33–34, 217n33; and sexuality, 166
alienation, 8–9, 196, 230n2
amateur, 70, 74–75, 81, 171, 183, 191
American glassmaking: Jamestown, 44, *46*, *48*, 46–49, 218nn38, 47; Midwestern industries, 52; protoindustrial, 93. *See also* New World

anachronism, 161
Anaximenes, 146
animal laborens, 196
annealing kiln, 3, 51, 130
Anthropocene, 8, 25
anticipation, 2, 61–62, 72–73; anticipatory adaptation, 69–70, 81–84; nonreflective, 82–84; by team members, 104
apprenticeship, 7, 22, 94, 111, 161; awareness, development of, 64–65; dynamic of, 23, 75; to glass itself, 17; restructuration of *habitus*, 65, 69–70, 82, 84. *See also* novice glassblower
arc from capacity to goal, 149–50, 158, 173–75
Arendt, Hannah, 8–9, 55, 130–32, 195–96
Aristotle, 24, 34, 66, 67, 146, 151; *hexeis*, 41, 226n8; substitution of *phronesis* for *mêtis*, 159–60; *Works: On the Heavens*, 200; *The Metaphysics*, 159
Armory shows, 16

264 ❦ INDEX

artisan rebellion, 47–48

Art of Glassmaking, The (Neri), 29, 33, 37–38, 44, 217n33

Arts and Crafts movement (Britain), 12, 22

aspirational aspects of glassblowing, 11, 150–51, 197–98

assistants, 40–41, *41*, 94, 97–100, *103*; blowing by, 99–100; glory hole doors worked by, *75*, 98, 100

Auden, W. H., 108–9

autochtony, 37, 200

autonomy, 125–28, 225n27; attributed to handwork, 127–28

avolio, 140

awareness, 220n1; focal, 64–65; subsidiary, 63–65, 68

Bachelard, Gaston, 8, 107, 109, 222n24

Bacon, Nathaniel, 48–49

"baptism by fire," 24, 117, 144, 150, 225n2, 226n11

Barad, Karen, 109

"batch" (ingredients of glass), 27–28, 56, 199

Baudelaire, Charles, 115

becoming, 6, 10–11, 24, 37–38, 56, 184, 198; Aristotle on, 146; "becoming glass," 109–10, 176–77; becoming hot, 109–10; becoming-towards, 150, 174, 178; as material dynamic, 132; elemental complicity, 112, 157,

161, 196–197; as mediation, 182; as method, 160; and *métis*, 156–58; and quintessence, 147–51, 226n10, 157; and storytelling, 198; and symcoming, 199; vitreous, 21–26, 176–77. *See also* glassy state; self

Beginning Glassblowing (Schmid), *75, 118*, 147, *148*

being (ontology), 67, 178; being body, 122, 125; being world, 67; being glassy, 9, 26; historicity of, 67; and labor, 128; and society, 173, 221n15, 221n18

"being with" (Dasein), 67

Bergren, Ann, 202, 227n20

Berkeley, William, 49

Bezalel (Book of Exodus), 38

Biringuccio, Vannoccio, 20, 41–42, *42*

Birmingham Glass Works, 31–32

bit, 70–72

Black Lives Matter, 12

blocking, 98

b(l)oom (unannealed glass), 180–84; *pyromenon*, 21, 180–81

"blowing big," 95

Blown Away (reality show), 13–14

blowpartners, 14, 59, 118, 140

blowpipe, 10, 115–16, 126; "cap and blow" method, *118*, 119–20, 124; enmouthment of blowtip, 116; in gathering process, 59–61; hazing joke, 117, 124; moile, 95–96. *See also* breath

INDEX ❧ 265

blowtorch, 95–96
body: body-as-posture, 119–20; complicity of air and breath with, 131–32; corporeality of, 7–8, 122–23; defined, 120–21; and formation of *habitus*, 67–68; and glassblowing, 5–9; hollow of, 131; intentionality of, 65–67; interaction with relationships, 6–7; as observable physical structure, 121–23; as site of social and cultural training, 67, 121, 223–24n4; techniques of, 67, 223–24n4; tools as extensions of, 63, 220–21n3. *See also* breath; intracorporeality
Body and Soul: Notebooks of an Apprentice Boxer (Wacquant), 6, 174
bottles, 126
Bourdieu, Pierre, 6–7, 11, 65–66, 82, 122, 149–50, 173
boxing, 6, 174
breath, 19–20, 128–33; as aspiration, 197; and autonomy of glassblowers, 125–28; "blowing balls," 129–32; "cap and blow" method, *118*, 119–20, 124; cavity in glass formed by, 33; complicity of air and breath with body, 131–32; and COVID-19, 10; "forgetting of air" in Western thought, 23, 120, 122, 125, 157; glassblowing postures supported by, 119–20; intangibility of, 23, 123; as part

of glassblower's *habitus*, 124; and practical knowledge, 120, 123–25, 127–28, 132–33; smoking, 133–35; vessel as relic of, 131; in yoga, 120. *See also* air; blowpipe; body; embodied knowledge
Brentano, Franz, 66
British Arts and Crafts movement, 12, 22
British Museum, 20
Brooklyn Flint Glass Works, 31, 103
"bubbles," 35
Butler, Judith, 122, 228n16
Butteri, Giovanni Maria, 42–44, *45*

Calhoun, Craig, 6
calorism, 109, 112
capitalism, 12, 42, 121–22, 224n5
Cartesian anthropomorphism, 22
"caught up" in practice, 21–22, 178
cavity formed in glass, 33
Chaos, 174–75
Charles VI, 176–77
Chihuly, Dale, 54, 195, 220n65
choreography/"dance" of glassblowing, 3, 5, 16, 31–32, 89, 168–72; heat's role in, 96; teamwork as, 104
chronos, 158
class issues, 12, 54
coldwork, 87, 107
collusio, 11
color, 98–100, *100*
"coming home," experience of, 21–22

266 ✤ INDEX

complicity: of air, breath, and the body, 131–32; elemental, 8, 24, 131, 157–59, 161, 196–99; between *habitus* and *field*, 174
consanguity, 25, 198
consciousness, 63, 65–67, 70; "cognitive" and "kinaesthetic," 66; relaxed, 222n24, 226n5; self-consciousness, 173–74
"cords," 35
Corning Glass Works, 52
corporeality, 7–8, 23, 122–23, 157. *See also* intercorporeality; intracorporeality; transcorporeality
cosmology, quintessential, 150, 159–60
COVID-19 pandemic, 10
craft: ambivalence about, 160; contemporary resurgence of, 10; crafting of self, 6, 11, 127–28; "craft" versus "art" debates, 4, 161; craftwork as project of "relatedness," 22–23, 67; nostalgia, 215n19; ontoepistemology of, 25; quintessential, 160; "story of," 9; as verb, 151
craftsman (*homo faber*), 8–9, 78, 132, 195–96
Craftsman, The (Sennett), 6, 92, 128, 160, 196, 225n27
Crawford, Matthew, 128
"crisis," 28
critique, culture of, 105
Crossley, Nick, 173

crystallus, 37
Crystal Palace (London's 1851 Great Exhibition), 31
culture, 6–7, 105, 132
Cummings, E. E., 161, 227n28
cup making, 3, 24, 144–46; initiation, 144–46, 150, 158, 199; with Murano maestro, 190–94
Czeresko, Deborah, 14

D'Annunzio, Gabriele, 20, 132, 195
De la Pirotechnia (Biringuccio), 41–42, *42*
Deleuze, Gilles, 132, 161, 175, 177–78
De Re Metallica (Agricola), 41–42, *43*
Descartes, Réne, 34
Detienne, Marcel, 156–57
De Universo (*De rerum naturis*) (Hrabanus Mauras), 38–39, *39*
Di Alchimia (Neri), 217n33
diamond shears, 71–72
Dilthey, Wilhelm, 67
"dis," as term, 160–61
"distributed agency," 23, 104
Donne, John, 137
"drama" of glassblowing, 33
Dreisbach, Fritz, 92
Durkheim, Emile, 173, 221n15

earth, 8–9, 177, 196, 229n22
Economic and Philosophical Manuscripts of 1844 (Marx), 127–28

Ed's Big Handbook of Glassblowing (Schmid), 55, *62*, *71*, 147

"efficiency," 121–22, 223–24n4, 224n5

"efflorescence," 176

Egypt, 37

Egyptians, 33

Eisch, Erwin, 54

ek-stasis, 74

elements, 24, 143–46, 149, 157–58; earth, water, air, fire, 144, 146, 149, 165; ethnographer of, 198; Love and Strife in dynamics of, 154, 175. *See also* quintessence

Eliade, Mircea, 123

embodied knowledge, 22, 189–92; and anticipation, 82–84; bodily intentionality, 65–66; breath immersed in, 120, 124; corpuscular, 23, 125, 127, 223n29; difference between novice and master, 68–69; efficacy of work, 61–63; focal awareness, 64–65; lived experience, 7, 64–65, 68–70; meaninglessness, experience of, 74–77; phenomenal structure of, 63; and the quintessential, 150; "rightness," sensation of, 59; as *sense-full*, 67; significance, 66, 70; spatial synthesis, 73–74; subsidiary awareness, 63–65, 68; temporality of, 74, 78, 133, 152–53, 158; tools as extensions of body, 63, 220–21n3. *See also*

breath; practical knowledge; skill acquisition

Empedocles, 146, 159, 165, 175, 200, 226n3

England, 44

entertainment, glassblowing as, 33

erotics, 23, 24, 168–72; b(l)oom (flower and furnace), 180–84; and Chaos, 174–75; Eros/eros, 173–75; flower and furnace, kinship of, 180–81, 183; Love and Strife, 154, 175; "love in the field" and ethics, 172–75; making love and "making love," 178, 184; politics of sexual differences, 183; power of, 175; queer versus heterosexual orientation, 175, 177–78; recognition, socioerotics of, 24, 173–74, 177–78, 181, 184; "socialized desire," 173, 177, 185; straight logic of production, 174, 177–78, 184; theoretical approaches, 172–75

ethnography, 90–91, 121; "coming home," experience of, 21–22; "crisis of objectivity," 21; elemental, 8, 198; "love in the field," 172; participation, 57–58

Etymologies (Isidore de Seville), 38

Euripides, 33

European working styles, 10

eusthochia (good eye), 156

excellence, 151–53

Exodus, Book of, 39

268 ∞ INDEX

extractive industries, 9, 177–78, 181, 199–200
"Eye and Mind" (Merleau-Ponty), 67

failures: of glassblowing, 2, 26, 74, 81, 105; hazing joke, 117, 124; at Jamestown and Wistarburgh, 48, 51–52; of mechanization, 126–27; and reverie, 23, 77–78, 81, 83. *See also* "falling off track" to "stay on track"; "globlet"
"falling off track" to "stay on track," 24, 150–52, 159, 160, 162. *See also* failures
"feathering," 119
field, 24, 69, 228n16; fieldnotes within, 178–79, 181; and *habitus*, 173–74; and orientations, 175
fire: air required for, 125, 132; as *anima*, 8; "baptism by," 24, 117, 144, 150, 225n2, 226n11; as element, 144, 146, 149, 165; individuation of, 54; problematics of, 56; portable, 184; pyrophilia, 29–30, 131; transformation by, 33–34, 36–37, 41–44, 47, 51
firefighters, 6
Flame of a Candle, The (Bachelard), 8
Flame, The (D'Annunzio), 20, 132, 195
"flux," 28
focal awareness, 64–65
"following the glass," 7, 30, 105
forge, Hephaestian, 181

fork (*forcello*), 140
"former," 28
Foucault, Michel, 122, 175
fragility, 19–20; tensility, 181–83
Fragments of a Poetics of Fire (Bachelard), 8
Francesco I de Medici, 44, 217n32
Frescobaldi, Leonardo, 17
Freud, Sigmund, 173
friendships, 14, 163–66
"fundamentals" of glassblowing, 24, 68, 70, 139, 146, 150, 158
furnace: as artificial "uterus," 35; continuous-yield, 52; early illustrations of, 38–45, *39, 40, 42, 43, 45,* 46, *50;* flower and furnace, kinship of, 180–81, 183; Murano furnaces, 191; Roman Empire, 38; salamanders, 28–29; superstitions, 35–36; Venetian, 41, *42. See also* glory hole

gaffers (bosses): amateurs as, 94–95; and blowing, 118–19; women as, 14
"garage," 51, 99
gathering, 24, 28, 143–44, 228n16; blowpipe in process of, 59–61; efficacy of, 61–63; "gathering big," 98; process of, 59–62, 97–98; retrieval, notion of, 69; sensation of heat, 69; successive moments of, 60; and "thingness," 131; twirling broomsticks as practice, 61; "understanding," 65–66, 67

INDEX ❧ 269

Geertz, Clifford, 7
German glassmaking, 92
Germanic tribes, 39–41, *39*
Gilio-Whitaker, Dina, 229n34
glass: apprenticeship to, 17; arc of
the life of, 19–20; b(l)oom
(unannealed glass), 21, 180–84;
dreams of, 163–64, 144;
"following the glass," 7, 30, 105;
fragility of, *19*, 20, 181–83;
histories of, 36–37, 54–55;
ingredients of, 19, 27–28, 56, 199;
malleability of, 99; as medium,
181–83; as participant, 7; as
poetic medium, 14, 17; small-
mouth ware, 224–25n21;
symgeologic dynamics of,
199–200; tensility of, 181–82;
terms for, 37; and
transformation, 19, 32; viscosity
of, 60, 97, 99–100
glassblowers: of color, 12; as makers
of both things and themselves,
11; *métis* practiced by, 159–60;
resistance to authority, 47–48;
"rock stars," 5, 16, 82, 158, 159;
women professionals, 13–14.
See also amateur; apprenticeship;
novice; proficiency
"glassblowers' disease" (oral
herpes), 116
glassblowing (glassmaking): ABCs
of the art, 24, 144–46;
aspirational aspects of, 11,
150–51, 197–98; "baptism by
fire," 24, 117, 144, 150, 225n2,

226n11; basic skills, 58; "blowing
balls," 129–32; and body, 5–9;
"catching the bug," 25–26, 31,
131–32; and changes in man's
relations, 42; as
choreography/"dance," 3, 5, 16,
31–32, 89, 96, 104, 105, 168–72;
class and race limitations, 12–13;
coldwork, 107; curriculum, 12,
143–44, 182; expense of, 12–13;
and extractive industries, 9,
177–78, 181, 199–200;
"fundamentals" of, 24, 68, 70,
139, 146, 150, 158; learning
processes, differences in, 111–12;
"magic" of, 29–30, 33; meaning
made through, 5–6; mentors, 4,
15, 99, 138, 141; origin stories,
36–37, 39; particular and whole
related, 73–75, 78; perceived as
archaic or irrelevant, 9–10; and
"plantation," 44; "reading" the
practice, 58, 59–65, 68, 70,
80–81; as relationship, 17, 181–82;
situated in divine cosmogony,
38–39, 41; social world of, 9–17;
steps in process, 59–62, 117–18;
unmooring of from land, 36–37,
40, 40–42, *43*, 56; urgency of, 5,
32. *See also* American
glassmaking; illustrations of
glassblowing
Glass Bottle Blowers' Association,
53–54
Glass Bottle Blowers' Union,
225n23

270 € INDEX

Glass: Its Tradition and Its Makers (Polak), 55, 195

Glass Notes: A Reference for the Glass Artist (Halem), 55

glassy state, 223n23; being-glassy, 9, 26; Glassy State, 51; *homo vitreous*, 176–77; "state of matter," 30, 38, 56; as a transformed "state of matter" and a "matter of State," 38; and vitrification, 37–38, 44, 51, 109, 176–77. *See also* becoming

"globlet," 23, 58, 79–80, *80*, 141, *142*

"globletta," 23–24, 141, *142*

glory, religious idea of, 52

glory hole, 51–56; as auxiliary furnaces, 51–52; back-and-forth dynamic with workbench, 52; "heats," 52; and industrialization, 52–54, 93; and mechanization of handwork, 126. *See also* furnace

"go missing," 28

Granet, Marcel, 123

Grasseni, Cristina, 155–156

"ground," reconfigured, 22, 35, 37, 54, 196

habitus, 6–7, 67, 81–84, 220–21n3; breath as part of glassblower's, 124'; and *field*, 173–74; and practical knowledge, 67, 82–84; restructuration of, 65, 69–70, 82, 84

Halem, Henry, 55

Hamlet (Shakespeare), 151

handwork: autonomy attributed to, 127–28, 225n27; mechanization of, 125–28

Haraway, Donna, 9, 161, 176–77, 198

Harper, Douglas, 128

Harrington, J. C., 218n38

Harrison, Caroline, 31, 34, 103

Haystack Mountain School of Crafts (Maine), 90

heart of glass, 25, 112, 194

hearth, Hestian, 181

heat: as dynamic of transfer, 110; as expedient of production, 112; and intracorporeality, 107–9, 176; of New York City, 96; role of in choreography of glassblowing, 96; tangible, 23

Hegel, G. W. F., 173

Heidegger, Martin, 9, 22, 66–67, 131

Hephaestus, 160–61, 183; forge of, 181

Heraclitus, 25, 27, 141, 146, 157

hermeneutics, 67

hero tale, 198

heteronormativity, 14, 229n25; straight logic of production, 174–75, 177–78, 184

hexeis, 41, 66, 226n8

"hidden curriculum," 182

Hilbert, Otto, 52

hollowness, 131–33, 184

Holy Roman Empire, 39

homo faber (craftsman), 8–9, 78, 195–96

homo vitreous, 176–77

INDEX ❧ 271

hotshop, 1, 3; friendships in, 14, 163–66; hotshop-studio dyad, 93, 112; "Hytta"/"Hütte," 93; origins of, 91–94; sets of relations in, 93; and "shop system," 93; studio, relation to, 92, 112; teamwork in, 94–97

Household Words, 31–32

Howell, James, 18

Hrabanus Mauras, 38–39, *39*

human condition, 17–21, 55, 127

Human Condition, The (Arendt), 8–9, 195–96

human/culture assemblages, 8

Husserl, Edmund, 66

hyalos, 37

illusio, 6

illustrations of glassblowing: divine cosmogony of sacred semblance in, 38–39, *39*; human-centered workshops, 41–42, *42*, *43*; landscape-oriented, *40*, 40–41

imagination, 8, 78

imperialism, 22, 37–39

implosion, 20–21, 125–26, 149

incalmo vessels, 95, 97–103, *103*; *moile*, 95–96

industrialization, 52–55, 93, 220n63; attempts to mechanize breath, 126–27; pressing machine, 126; studios as antithesis of, 10–12, 55

Ingold, Tim, 157

initiation, 24, 144–51

injuries, 28, 162

intentionality, 78, 93, 220n1; of body, 65–67; "enskillment" of vision, 156

intercorporeality, 23, 103–7, 109, 112. *See also* corporeality; intracorporeality

intra-action, 8, 109

intracorporeality, 7–9, 17, 23–24, 107–12, 123, 196–99; erotics of, 24, 178–79, 183–85; "following the glass," 7, 30, 105; glassy state, 109; immanence of, 110–12, 176–77; and *métis*, 157–60; ; and *porné*, 184; transcorporeality, 109–10, 112; vitreous, 176–79. *See also* corporeality; intercorporeality

Irigaray, Luce, 23, 125, 131, 180–81, 183, 229n27

Isidore de Seville, 38

Italy: imperialism, 37–38; "southern tradition" of glassmaking, 41. *See also* Murano (Venice)

Jamestown, Virginia, 44, *46*, *48*, 46–49, 218nn38, 47, 51; "Glassmaking at Jamestown" publication, 47

Jarves, Deming, 33, 35, 94, 96

Jordan, June, 172

kairos, 158

Kant, Immanuel, 57

"kinaesthetic consciousness," 66

Knights American Mechanical Dictionary, 52

272 ☙ INDEX

knowledge: propositional, and social construction of, 221n18. *See also* embodied knowledge; *métis*; practical knowledge

labor, 9, 130–31, 195–96, 230n2; division of, 93; ontology of, 128

Lande, Brian, 123

land/landscape: in Age of Discovery, 8, 196; in illustrations of glassblowing, *40*, 40–41; man divided from, 54, 55–56; as resource for glassmaking, 47, 50–51; unmooring of glassmaking from, 36–37, *40*, 40–42, *43*, 56

language, 54–55, 132, 149; "ABCs" of glassblowing as, 24, 144–46; "common," 145, 149; matterly constitution of, 105

Latour, Bruno, 23, 104

libido, 78, 173–74

Lispector, Clarice, 176, 178

Littleton, Harvey K., 54, 92, 195, 220n65

logos (reason), 146–47

Lorde, Audre, 172–76

"love in the field," 172

maestros, 94, 189–91

"magic" of working with glass, 29–30, 33

making: emergent versus imposed form, 175; as matter of *métis*, 157; meaning experienced through,

5–6; thinking related to, 7, 22, 128, 196

Making of the English Working Class, The (Thompson), 54

Mandeville, John, 39–41, *40*

Marchand, Trevor, 128

Marquis, Richard, 195

Martineau, Harriet, 31–32, 49

marver (steel work table), 4, 70–71

"marver and blow," 117–18, 124

marvering, 70–71, 99

Marx, Karl, 127–28, 230n2

master glassblower, 68–69, 126, 154

materiality: of breath, 124; human-culture dualism undone by, 9; of the incorporeal, 123, 224n10; listening to matter, 22; living, 25, 47, 56, 196; *mater* transformed into matter, 177–79, 185; mat(t)er, 177–78, 182, 185; "matterphor," 176–77; social ordering of material world, 6–7; "vibrant matter," 7

material-semiotics: of self, 38, 44, 47, 51, 56; of vitrification, 38, 44, 47–49, 56

matter: metal as coextensive to, 177–78

"matterphor," 176–77

Mauss, Marcel, 67, 121–24, 221n15, 223–24n4, 224n5; swimming, account of, 122, 124

meaning: materialist and posthuman turn, 7; in practice, 65–79; readings of, 68, 130–31;

INDEX ❧ 273

and sense making, 65; shaped through making, 5–7
meaninglessness, experience of, 74–77
Medea (Euripides), 33
media, logic of, 182–83
Medici, Cosimo I de', 44
Medici, Francesco I de', 44
Medici Glass Workshop, 217nn32, 33
Medici Glass Workshop, The (Butteri), 42–44, *45*
medium, glass as, 181–83
mentors, 4, 15, 97, 138, 141
Merleau-Ponty, Maurice, 66–67, 103, 122, 215n35, 220–21n3, 223n29
"metal" (molten glass), 28
Metaphysics, The (Aristotle), 159
mêtis, 24, 156–58, 227n20; central to *techne*, 158; as cunning intelligence, 157, 158; elemental complicity of, 24, 157–59, 161; eureka moments, 158–59; and intracorporeality, 157–60; making as matter of, 157; *phronesis* substituted for, 159–60; and transformation, 156–59
Mêtis (wife of Zeus), 156
#MeToo Movement, 14
Middle Ages, 39–41, *39*, 66
Mitelli, Giuseppe Maria, 19, *19*
modernity: "world alienation" as hallmark of, 8–9
moile, 95–96
mold methods of production, 52

more-than-human/nonhuman, 23, 106–7, 109–10, 177, 196, 198
Murano (Venice), 17–20, 24–25; tourism to, 55, 185–86, 189–95
murrine, 194
musicianship, 145, 220n1

Nano Morgante, 44
Nathan's Dark House (Bourgeois), 49–51, *50*
natural gas, 52
Natural History, The (Pliny), 36
"nature," Roman command of, 37
"nature's glass," 35
navigation, 84, 151–52
Neri, Antonio, 27, 29, 33, 37–38, 44, 217n33
New England Glass Company, 126
New Oxford English Dictionary, 120
New World, 22, 38, 42, 196; as Glassy State, 51. *See also* American glassmaking
New York Glass, 1–5, 12–15, 85–87; Advanced Glassblowing class, 137–39; annual gala, 98–99; beginning glassblowing classes, 57–58; founding of, 92; furnace superstitions, 35–36; glory hole, 51–52. *See also* studios
"nice round sphere," 120, 124–26
Nietzsche, Friedrich, 85
nitre (soda), 36–37
"Nocturnal Upon St. Lucy's Day, A" (Donne), 137

274 ❧ INDEX

novice glassblower, 4, 68–70, 147, *148*, 161, 198; "back at the beginning," 158; as capacity, 152; gathering, efficacy of, 61–63; informed by nonglassblowing experiences, 69–70; learning to see, 155–56; "reading" the glass, 65, 68; subsidiary awareness, 63–65, 68; "successive," versus "smooth" process, 61–62. *See also* apprenticeship

objectivity, 9; "crisis of," 21
observation, skills of, 13, 60, 125, 154. *See also* seeing
On the Fireline: Living and Dying with Wildland Firefighters (Desmond), 6
On the Heavens (Aristotle), 200
optical instruments, 37
Owens, M. J., 127, 225n23
Owens bottle machine, 127, 224–25n21, 225n23

Pagis, Michal, 123
"paper and blow," 117–18
Peanut Farm Glass Workshop, 91–92
Personal Knowledge (Polanyi), 63–64, 68
phenomenology, 22–23, 66, 160, 215n35
Phenomenology of Perception, The (Merleau-Ponty), 66
philosophy, wonder as origin of, 34
Phoenicia, 37
phronesis, 159–60, 226n8

Pilchuck Glass School, 12, 91–92, 220n65
"pipe warmers," 51
Plato, 24, 146, 149, 173–74
pleasure, 77–78
Pliny the Elder, 36–37, 217n23
Polak, Ada, 55, 195
Polanyi, Michael, 63–64, 68, 74
pornê, 184
"post-craft," 25
posthumanism, 7, 25
power, 175
Powhattan Confederacy, 47–49, *48*
practical knowledge, 6–7, 24, 195–99; and breath, 120, 123–25, 127–28, 132–33; corpuscular theory of, 125, 127, 157; and *habitus*, 66–67, 82–84; *phronesis*, 159–60, 226n8; and the quintessential, 146, 150, 159–60. *See also* embodied knowledge
"practicing culture," 6
Presocratics, 24, 144, 146, 149
pressing machine, 126
"primitive-religious" smithing, 35
production, 145; endurance of objects of, 9, 131, 195–96; as "making love," 178, 184; mold methods, 52; shop system, 52–54, 93, 220n63; straight logic of, 174, 177–78, 184
proficiency: corporeal sight, 83–84; excellence, shooting for, 151–53; heat's centrality to, 111; nonreflective anticipation, 82–84; in practice, 79–84

INDEX ❧ 275

Prometheus Bound (Aeschylus), 229n31

Prometheus Unbound (Shelley), 184, 229n31

Psychoanalysis of Fire, The (Bachelard), 8, 107, 109

psychoanalytic framework, 8, 173

punty, 70–71, 143

Pursuit of Pleasurable Work, The: Craftwork in Twenty-First Century England (Marchand), 128

pyromenon, 21, 180–81

pyrophilia, 29–30, 131

quartz mines, 199–200

queer orientations, 175, 177–78

quintessence, 24, 34, 137, 146–51, 157–61, 174, 199, 226n6, 11; aether, 146, 150; and arc from capacity to goal, 149–50, 158–59, 226n10; and becoming, 149–50, 157; cosmological, 150, 159–60; and excellence, 151–53; "irresistible analogy," 149–50; and practical knowledge, 146, 150, 159–60. *See also* elements

race, 12, 173

"reading" the glass, 18, 58, 59–65, 68, 70, 80–81

reason, 146–47, 159, 221n18

recognition, socioerotics of, 24, 173–74, 177–78, 181, 184

Reformation, 8, 42

relations: body's interaction with, 6–7; craftwork as project of

"relatedness," 22–23, 67; gendered, in glassblowing shop, 3–4, 5, 14; glassblowing as relationship, 17, 181–82; of humanity with earth, 9; of particular and whole, 73–75, 78; social, in glassblowing shop, 3–5. *See also* teamwork

repair work, 128

repetition, 111, 152–53, 158

restructuration, 65, 69–70, 82, 84

reverie, 23, 76–78, 81, 83, 105, 222n24

rhizomata, 146

Rhode Island School of Design, 92–93, 220n65

Rilke, Rainer Maria, 161, 227n27

River Belus, 36–37

"roast beef arm," 28

"rock star" glassblowers, 5, 16, 82, 158; pneuma and quintessence, 159

Roman Empire, 37–39

Romans, 10

"rui" glass discs, 41

salamanders, furnace, 28–29

salts, 28, 108, 176–78

Sanudo, Marin, 18

Sappho, 163

Saxony, 41

Schmid, Edward, 104, 161, 198; on ABCs of glassmaking, 144–46; *Works: Advanced Glassworking Techniques*, 55, 94, *100*, *103*; *Beginning Glassblowing*, 75, *118*, *148*; *Ed's Big Handbook of Glassblowing*, 55, *62*, *71*, 147

Scholastics, 66

Scientific American, 33

seeing, 37–38, 121, 155–58; "enskillment" of vision, 156; *eusthochia* (good eye), 156. *See also* observation, skills of

Seguso, 20

self: crafting of, 6, 11, 127–28, 153; material-semiotics of, 38, 44, 47, 51, 56. *See also* becoming

self-consciousness, 173–74

Sennett, Richard, 6, 92, 128, 196, 225n27

"setting the pot," 22, 196; causal logic of, 36–37; class analysis, 54; and early American glassworks, 44, *46*, 46–49, 51; imperial view of world, 37–38; man divided from landscape, 37, *40*, 40–42, *43*, 54, 55–56; Pliny the Elder's origin story, 36–37, 39; transformative power of pot, 41; and vitrification, 38, 44, 51, 157

settler colonialism, 22, 54, 185–86, 196; doctrine of colonization, 47; Jamestown, *36*, 44, 46–49, 218nn38, 47

sexuality. *See* erotics

Shakespeare, William, 151

Shelley, Percy Bysshe, 229n31

"shielding," 102

Shop Class as Soulcraft (Crawford), 128

shop system, 52–54, 92–93, 220n63; "shop," as term, 92

Signoretto, Pino, 154–55

"Sisters of Glass," 164–67, 178

situated learning, 6

skill acquisition, 8, 22–24, 141, 150, 160–61, 199; observational skills, 13, 60, 125, 154; and seeing, 156. *See also* apprenticeship; embodied knowledge; novice glassblower; practical knowledge; proficiency

"skinning," 98

slavery, 12, 218n47

Sloterdijk, Peter, 132

Smalls, Biggy (Notorious B.I.G.), 135

Smith, John, 44, 47, *48*

smoking, 133–35

social ordering, 6–7, 25

social rules (*field*), 174, 228n16

social sciences, 7, 67, 121–22

social world of glassblowing, 9–17; friendships, 14, 163–66

Socrates, S–O of, 146, 149

"stabilizer," 28

state: English "matters of state," 38, 44; Glassy State, 51; modern, 51

"state of matter," 30, 38

"steady," as term, 120

Stickelmire, John Joseph, 20–21

stoicheion, 146, 149

Stoics, 125, 161

storytelling, 198

studios: as antithesis of glass factory, 10–12, 91; collective workshops, 91; expenses of, 12, 88; hotshop, relation to, 92, 112;

INDEX ❧ 277

as movement against industrialization, 55; "studio" as adjective, 92. *See also* New York Glass

subsidiary awareness, 63–65, 68

supercooled liquid, glass as, 19, 30

Swedish glassmaking, 92

Swidler, Anne, 172

swimming, accounts of, 122–24

Symposium, The (Plato), 173

Tagliapietra, Lino, 54, 220n65

teamwork, 59, 94–97; as choreography, 104; and intercorporeality, 104–7; and intracorporeality, 107–10

techne, 24, 41, 56, 158

"Techniques of the Body" (Mauss), 67, 121

temporality of embodied knowledge, 74, 78, 122, 133, 152–53, 158

tensility, 181–83

Thales, 146

theater-glassblowing collaboration, 33

"thingness," 131

thinking, relation of to making, 7, 22, 128, 196

Thompson, E. P., 54

Toledo Group, 127

Toledo Workshop, 91

tools, as extensions of the body, 63, 124, 220–21n3

training, 67, 121–22, 223–24n4

transcendence, 226n5, 230n2

transcorporeality, 109–10, 112

transformation: of *mater* into matter, 177–79, 185; and *mêtis*, 156–59; problematics of, 34; "setting the pot" as, 41. *See also* becoming; glassy state

Tryal of Glasse, A (Harrington), 218n38

Vernant, Jean-Pierre, 156–57

Vespasian, 36, 217n23

vessel, glass sphere as, 125–26

Virginia Company of London, 44

virtuous work, 153, 159–60

viscosity, 60, 97, 99–100, 109

visual media, 155–56

visual perception, 74, 78

vitreous metabolism, 109

vitrification, 30; and glassy state, 38, 44, 51, 109, 176–77; logic of, 22, 37–38, 44, 51; material-semiotics of, 38, 44, 47–49, 56; and "setting the pot," 38, 44, 51, 157

vitrum, 37

vocational education, 128

void and plenum, logic of, 42

Voyage and Travels of Sir John Mandeville, Knight, The (Mandeville), 39–41, *40*

Wacquant, Loïc, 6, 174

warfare, alternatives to, 42

water, 8, 36–37, 143, 156, 158, 176

Weil, Simone, 161

Weiss, Gail, 23

Wheaton Village (New Jersey), 55

Wowinchopunk (Paspahegh werowance), 47–48, *48*

Wistar, Caspar, 49, 50, 218–19n48

Wistarburgh Glassworks (New Jersey), 49–51, *50*, 218–19n48, 219n55, 219n60

wonder, 34–35

work, distinguished from labor, 130–31

Working Knowledge (Harper), 128

"world alienation," 8–9

worldmaking, 37–38, 55–56, 157, 177–78; disappearance of living "world," 41–42; and socialized desire, 173, 185

yoga, 120, 123

Yoga: Immortality and Freedom (Eliade), 123

GPSR Authorized Representative: Easy Access System Europe, Mustamäe tee 50, 10621 Tallinn, Estonia, gpsr.requests@easproject.com

www.ingramcontent.com/pod-product-compliance
Lightning Source LLC
LaVergne TN
LVHW041628060925
820435LV00016B/134